CLAY TODAY

CLAY

MARTHA DREXLER LYNN

TODAY

Contemporary Ceramists and Their Work

A Catalogue of the

Howard and Gwen Laurie Smits Collection

at the

Los Angeles County

Museum of Art

LOS ANGELES COUNTY
MUSEUM OF ART

CHRONICLE BOOKS
SAN FRANCISCO

Front cover

Martin Smith

Bowl

c. 1979

Back cover

Arnold Zimmerman

Teapot with Blue Swirl

1982

Title page

Glen Lukens

Yellow Plate (detail)

1930s

Contents page

Paul Mathieu

Le Souci de soi

1984

Copublished by the Los Angeles County Museum of Art, 5905 Wilshire Boulevard, Los Angeles, California 90036, and Chronicle Books, 275 Fifth Street, San Francisco, California 94103.

Library of Congress Cataloging-in-Publication Data

Los Angeles County Museum of Art.

 Clay today: contemporary ceramists and their work: a catalogue of the Howard and Gwen Laurie Smits Collection at the Los Angeles County Museum of Art.

 p. cm.

 Includes bibliographical references.

 ISBN 0-87701-756-5 (Chronicle Books)

 1. Ceramic sculpture—20th century—United States—Catalogs. 2. Ceramic sculpture—20th century—England—Catalogs. 3. Smits, Howard—Art collections—Catalogs. 4. Smits, Gwen Laurie—Art collections—Catalogs. 5. Ceramic sculpture—Private collections—California—Los Angeles—Catalogs. 6. Los Angeles County Museum of Art—Catalogs. I. Title.

NK4008.L67 1990

730 ' .0973 ' 07479494—dc20 89-13731

 CIP

CONTENTS

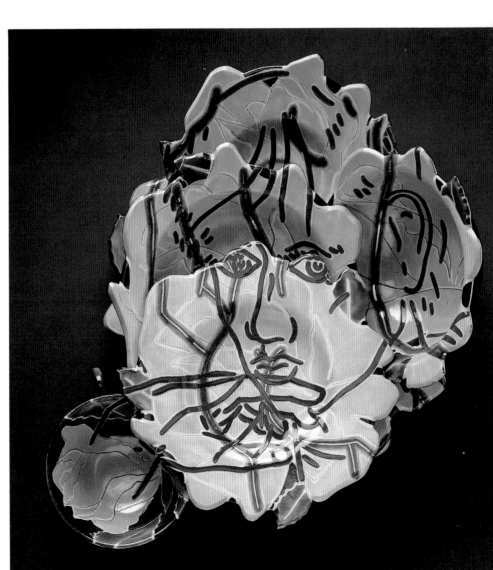

ARTISTS IN THE SMITS COLLECTION

Gertrud and Otto Natzler
Red Bottle
1957

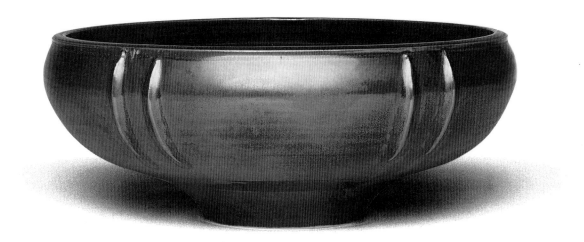

Laura Andreson
Bowl with Ridges
1980

F O R E W O R D

Howard and Gwen Laurie Smits' commitment to collecting vessel ceramics has greatly benefited the Los Angeles County Museum of Art and significantly enhanced its collections. Their interest in gathering works by living ceramists and their generosity in donating these works to the museum have earned them our deep gratitude.

In joining other of the museum's twentieth-century ceramics holdings (the Rose A. Sperry Collection of Gertrud and Otto Natzler vessels, Betty Asher's cup collection, as well as a number of individual gifts by local donors), the Smits Collection stands as the largest single gift of clay art to come to the museum to date. With so many of the twentieth century's developments in clay originating in Southern California, it is fitting that the Los Angeles County Museum of Art now has important accumulations in this area.

As a measure of Howard and Gwen Laurie Smits' dedication to supporting this medium, they have established a renewable endowment fund for future ceramics purchases. To acknowledge this gift, the museum has set aside permanent gallery space for the display of twentieth-century ceramics.

The publication of this catalogue is the result of two years of research and writing by Martha Drexler Lynn, assistant curator, Decorative Arts Department. Scholarship in contemporary ceramics has been limited, and the hope is that this catalogue will enrich the study of the area.

Earl A. Powell III
Director

ACKNOWLEDGMENTS

Since my first meeting with Howard and Gwen Laurie Smits at their home three years ago my respect for them and their collection has continued to grow. Not only does Gwen Laurie have a keen eye for ceramics, she also has a perspective on clay history that reveals her years of interest in the contemporary art world. As Gwen Laurie often tells me, her study and collecting would not be possible without Howard's patient and positive support. With that support the museum will continue to augment its twentieth-century ceramics holdings. For both Howard and Gwen Laurie I feel great affection and gratitude.

On the staff of the Los Angeles County Museum of Art I am especially grateful to Gregory A. Dobie for his meticulous and sensitive editing of the manuscript. I am also grateful to Jeffrey Conley for his superb photographs and to Amy McFarland for her elegant book design. I would also like to thank Barry Shifman, Jeffrey Herr, and Sherry Block for their endless patience in conducting research. To Anne Diederick and Larry Margolies in the research library I give special praise for their help in obtaining many obscure publications.

Other debts of gratitude within the museum are too numerous to recount, but I particularly want to thank Tim Schroder, former head of the Decorative Arts Department, who offered support and relief from other duties to allow me the time to research and write this catalogue. I also wish to thank Leslie Bowman, head of the Decorative Arts Department, and Susan Lindner, former secretary of the Decorative Arts Department, who cheerfully made corrections to the manuscript.

Finally I would like to express my appreciation to Mrs. Bernadotte Lester. Without her guidance this wonderful collection would not have found its way to the Los Angeles County Museum of Art and I would not have had the delight of knowing Howard and Gwen Laurie Smits.

Martha Drexler Lynn

FROM VESSEL TO VEHICLE

AN INTRODUCTION

When Howard and Gwen Laurie Smits began collecting ceramics in the 1970s, they focused on pieces that represented the vessel-related tradition of the contemporary clay movement. Their goal was to gather works by living artists. The result is a personal collection that captures the diversity, energy, and intellectual concerns of predominantly late twentieth-century potters.

In 1987 the Smitses gave a portion of their collection to the Los Angeles County Museum of Art. The museum's Howard and Gwen Laurie Smits Collection now consists of almost two hundred vessel-based forms, including works by 106 artists, most of whom are American, with the remainder mainly English. The collection is principally composed of works made from 1979 to 1988, although there are important midcentury pieces as well.

Several criteria were used in selecting the works that would come to the museum from the more than four hundred vessels offered by the Smitses. First was the desire to build a core representative of the seminal Southern California potters. Because an equally important group of works had been collected during the Smitses' travels to England and the Continent, the second criterion was to include a selection of pieces by important European, particularly English, artists. The fact that American and English studio ceramics have interwoven histories made the inclusion of these artists critical for understanding the development of the clay movement. The third criterion addressed the influences of one generation on the next. There are lineages established by locales, schools, teachers, and personal styles that associate trends found in Northern and Southern California, on the West Coast and East Coast, in the United States and Great Britain, in England and Japan, and in Europe and South America. Fourth, some works were chosen to capture a technique or moment, illuminating a specific genre. The fifth and final criterion was the desire to include many new artists. By incorporating these ceramists, not tried in the art-historical sense, both the Smitses and the museum perform that critical function of risking a value judgment. While the final assessment of these artists will not be made for years, it is from their works that the creative force of current clay can be measured.

This volume is also structured to meet several objectives. The first is to record the complete gift; the second, to serve as a tool for the emerging ceramist; and the last, to honor the working ceramists and their art.

Sixty-four of the 106 artists are featured in individual entries; these selections reflect the overall principles used in forming the collection. Each entry provides biographical information and a brief discussion of the artist's development. A picture of one of the artist's works accompanies the entry; this piece and others by that artist in the Smits Collection are discussed in the context of the artist's oeuvre.

Information gathering was direct. Living artists were contacted personally, and many granted interviews. Most were happy to share aesthetic and technical information and to talk about the medium in general.

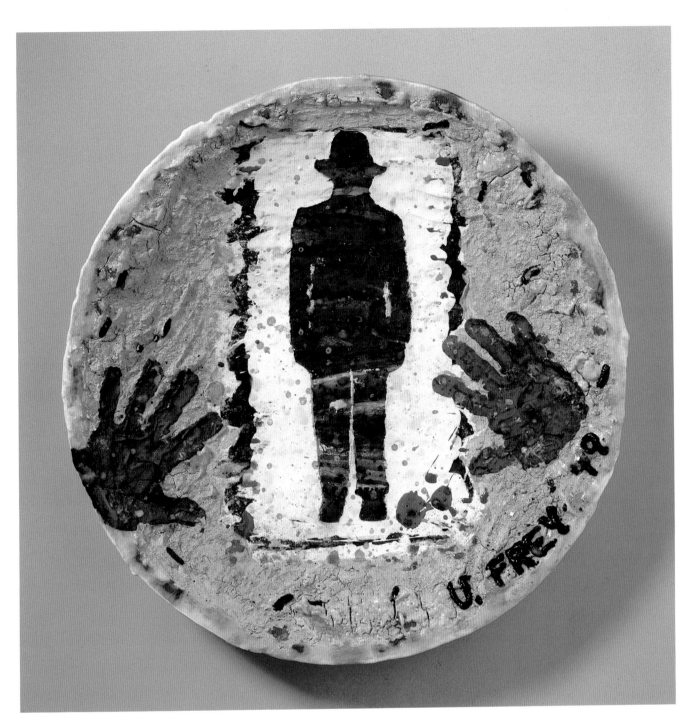

Viola Frey

Cracker Series 11

1979

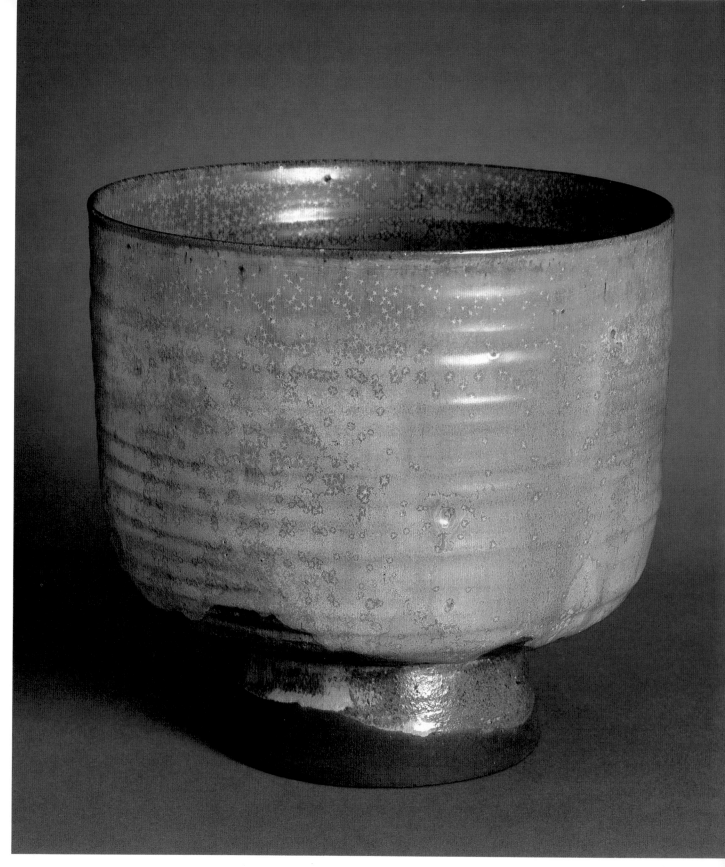

Beatrice Wood

Luster Glaze Footed Vessel

c. 1955

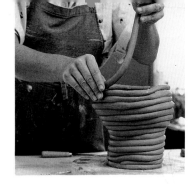

The following photographs illustrate various methods of working clay. Los Angeles ceramist Karen Koblitz demonstrates coil building, slab construction, and wheel throwing.

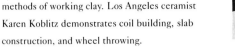

Coil building

The complete gift is listed in the illustrated catalogue, where marks are also pictured. Although most of the works were purchased new through galleries, a simple provenance is included. This volume also contains a bibliography, list of suggested readings, and glossary of terms necessary for the understanding of ceramic art. In presenting the material, no assumption is made about the reader's knowledge of ceramics, so basics about the medium are included, as well as a discussion of the more esoteric aspects.

While the Smits Collection concentrates on the vessel side of modern and contemporary ceramics, it also contains sculptural works. In this way the collection embodies the central conflict found in clay art of the past few decades. With ceramics the valuing of the end product has been clouded by associations of clay with craft. But clay forms can also have content, that is, subject matter beyond the exploration of functional issues. For example, Peter Voulkos's *Coffee Pot** is simply a well-crafted, functional vessel. His *Large Plate*, however, while still functionally linked to a plate form, suggests process and action through its torn and punctured surface. Still a plate, it is rendered nonfunctional by the artist's efforts to move past the form into another mode of expression. Content can also mean addressing political or social issues in functional or sculptural pieces. This is evident in the works of such artists as Robert Arneson, Richard Notkin, and Adrian Saxe. The function/content disparity leads to a curious clay nomenclature in which a great pot is crowned with the term *art*, implying that it has serious intellectual content, while a good, functional vessel is mere pottery, implying a lesser status. The best vessels can draw on a lineage that blends powerful content with functional references and thereby transcend their medium.

Because the Smits Collection contains works representative of both aspects, the conflict can be examined. Some potters simply wish to make well-crafted pots; others wish to defy traditional clay limits and enter the art world fray, with its unlimited artistic scope and demanding marketplace. This struggle is the leitmotiv of clay's development in American and English ceramics of the second half of the twentieth century.

Two major factors ignited this sometimes passionate battle. The first was the reluctance of the established art world to see clay as a serious medium, capable of expressing content. This was exacerbated by a second factor—the contrasting views held by potters themselves as to clay's potential. To some, products of European, English, and Far Eastern traditions, the clay vessel culture needed no expansion. Its history and formal restraints were judged sufficient. But a new perspective emerged with the American assertion of creative power in the 1950s. Under the onslaught of abstract expressionist clay art, function was rendered unimportant and clay was free to be sculptural. Affecting first the perceptions of the ceramics community and then the art world at large, clay became recognized as a vehicle for content once reserved only for particular mediums.[1] In order to appreciate this development as represented in the Smits Collection, a number of key concepts about clay, the potter's life-style, and ceramics history need to be examined.

*All objects in the Smits Collection are illustrated in the catalogue section.

Clay is a malleable material made from decomposing rock which is formed while wet into shapes that are then solidified through exposure to high temperatures. Clay can be coarse or fine-grained and can fall into such categories as earthenware, stoneware, and porcelain. Glaze can be applied to decorate it or to make it nonporous. Clay forms are functional or sculptural or somewhere in between. Random effects of the kiln, whether hoped for or feared, are caused by known chemical reactions or empirical accidents. The opening of the kiln can bring joy or heartbreak. All of these basic elements make the creation of clay art the result of multiple risks.

Artists who choose to work in clay enjoy the medium's versatility and challenges. As an age-old utilitarian and artistic medium clay can be coaxed into serving the basic function of containment as well as serving as a container for ideas. It is also an accessible medium. Ceramic objects are found everywhere in the everyday forms of tableware, knickknacks, and kitchen and bathroom fixtures.

Due to the characteristics of clay and clay techniques, a life-style specific to potters is discernible. Whether considered clay artists, ceramists, or potters, they are bound together by common experiences. Each, whether making vessel-related or sculptural forms, works within the limitations of the medium and wrestles with practical issues of clay body selection, the concocting of glazes, and the method of firing. The labor is messy and often strenuous. Like others in skill-based professions, those working in clay enjoy discussing specific techniques, eagerly sharing a blend of personal experience and common knowledge. The potter lives outside the nine-to-five world, working most often alone, with only self-discipline and will as motivators. This results in a seamless blending of work and life-style that is expressed in the frequent melding of studio and home. Each artist is also an entrepreneur, with the sale of works, perhaps augmented by teaching, providing income.

Perhaps because of the special nature of ceramics work, a romanticizing of the potter as artist and philosopher has occurred. These romantic images are themselves reflective of certain historical periods and have changed as the perception of clay's artistic potential has shifted.

For example, during the 1930s and 1940s on both sides of the Atlantic the potter was typically an artisan who chose a life grounded in the simple things. Thought of as one who had rejected the mainstream and its driving marketplace, the craftsman was seen as the embodiment of a better, unsullied life, as one who lived gently, quietly, and often, of necessity, frugally. This personal purity, it was thought, imparted to the objects created and to those who purchased them a certain distinction. By living with handcrafted, one-off items (works made from conception to completion by a single potter), it seemed possible to render the rush to twentieth-century conformity powerless. This feeling grew stronger as mass production of functional objects accelerated. Indeed, just as the cross was once used to ward off the devil, craft-related uniqueness appeared to postpone inevitable anonymity. For many, the potter's wheel became a latter-day Luddite sanctuary.[2] Potters partook of this idealization and often found it an additional cachet that enhanced

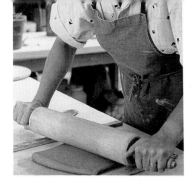

Slab construction

their market appeal. How much better it was to sell a pot that offered not only a respite from the day's strife but also absolution.

Many of these artisans viewed the mid-twentieth-century change in clay from the humble functional pot to the expressive sculptural pot as a threat to their life-style and values. Their fears were justified, for an altogether different romantic image of the potter soon developed. Initiated by the predominantly male abstract expressionist potters, such as Peter Voulkos, Paul Soldner, and Jerry Rothman, the macho sculptor/potter image emerged in the 1950s from the Otis Art Institute in Los Angeles. Working around the clock, making prodigious numbers of nonfunctional, large-scale, process-oriented, sculptural pieces, Otis artists often punctuated their working sessions with impromptu parties, wrestling matches, and all sorts of horsing around.[3] This new template for the ceramist's life-style incorporated a romantic sensibility that yearned for larger-than-life idols.

The image shifted again in the mid-1960s when the potter became the voice of social and political conscience. The emergence of the message pot demonstrated that the power of altering public opinion through art had been extended to ceramists. This image of the socially active clay artist continued until the 1970s, when another change occurred. As women in large numbers gained recognition for their contributions to all aspects of society, the clay life-style ceased to be linked just to macho men making large-scale works.[4] Instead, the clay community began offering a range of styles, including all of the earlier ones, but with the uniformity of romantic ideals blunted by a contemporary recognition of artistic multiplicity. There still remained, however, for all

Tatsuzō Shimaoka
Pair of Plates
1960s

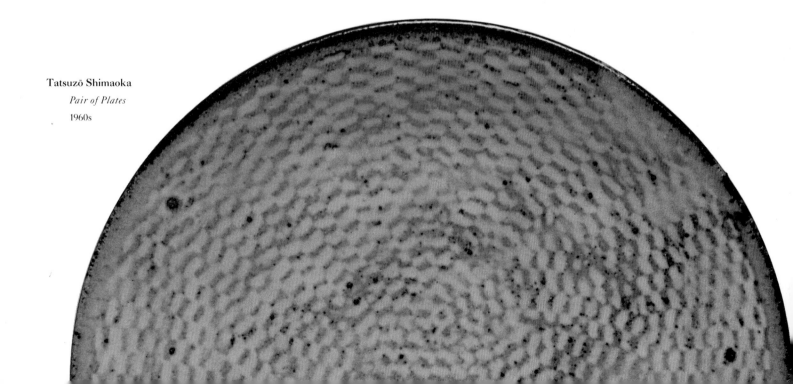

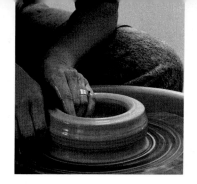
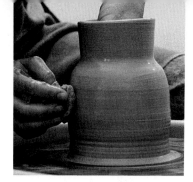

Wheel throwing

Right
Marilyn Levine
Two-Tone Bag (detail)
1974

Anna Silver
Vase with Handles
1986

ceramists a linkage provided by the bedrock of a common medium and its accompanying technique.

Ironically, it is by this common technique, expressed in the term *craft*, that the image of the ceramist has been most stereotyped. Traditionally craft means skill, and in the sense of an artisan it is a necessary talent to have. But it has also become linked since the second quarter of the twentieth century with the word *handicraft*, implying a home-based hobby. To confuse the meaning further, the phrase *arts and crafts* refers legitimately, on the one hand, to a time and style in the history of the decorative arts, and on the other hand, to a summer camp activity. These associations have led to the disparaging of the term and the medium and barred clay during the twentieth century from being accepted on equal footing with other art mediums.

Clay's acceptance into the established hierarchy of the arts is limited by another factor as well. Its link with function is perceived as precluding its ability to be art.[5] This limited perception, sometimes shared by potters themselves, continues to strain the uneasy relationship between craft and clay art. This notion is further developed in the modernist dictum that "form follows function," asserting the requirement that medium and purpose be congruent.[6] As ceramics are by tradition functional and have a history of imitation (as in the case of fifteenth-century Italian maiolica imitating Chinese porcelains), these modernist criteria not only barred clay from the list of sanctioned mediums, they also discredited ceramics history. The move away from these points of view represents the establishment of content and the artist, not the medium, as the deciding factors in labeling works of art.

In addition to the craft and function problems, a third factor that reinforced the separation of ceramics and art relates to how innovations in subject matter enter a clay artist's work. For example, ceramist Philip Cornelius's manipulation of paper-thin clay residue left by a slab roller led to his series of forms based on tin cans and paper cup constructions. This type of technique-based content enriches clay, for the clay artist can call upon aesthetic inspiration as well as process-generated creativity. In contrast with this, fine art is generally the result of an artist-engendered idea or feeling that is made real.

The final factor contributing to ceramic art's separateness is the use of clay as a basic medium in art education. Since the middle of the twentieth century in the United States clay has been a cheap, readily available material with which art students could explore questions of three-dimensional design.[7] Although this has allowed artists who were headed toward one of the other art mediums to ease into clay, as Viola Frey and Robert Arneson did, it has also led to the disregard of the medium as a serious one. Clay has been seen as just a practice or play material, dirty and functional.

One of clay's strengths has been the strongly associative qualities communicated through both the forms of vessels and the types of content connected with clay objects. This began in prehistory. Traditionally ceramic vessels served a variety of practical and symbolic functions. Always linked with food preparation and storage, as baskets and

gourds were, ceramic vessels came to be used for ceremonial purposes. The vessel form was equated with the human form and thereby came to be used for ritual purposes. It was through this process that the vessel first became a container for abstract ideas.

These functional and ceremonial antecedents underlie and intensify the multiple meanings found in contemporary vessel art. Potters, whether they make functional or sculptural works, are aware of this potent symbolic heritage. It has been referred to by Philip Rawson as "ceramic echoes."[8] This knowledge includes familiarity with the potential forms compatible with clay and the technical skill needed to work clay. Many contemporary ceramists (Adrian Saxe, Robert Turner, Betty Woodman, and others) study the history of their medium and use their knowledge to enrich their work. Potters also respect the utilitarian heritage implicit in vessels. Even clay sculptor Peter Voulkos threw functional pieces early in his career, and he continues to make stacking pots and plates that refer to clay's rich, functional past.

Additionally, clay vessels have the latent ability to engage the tactile senses and thereby communicate directly with the hand.[9] This element, present before the form conveys content, is an evocative source of meaning.

Although the Smits Collection's focus is on the transformation of clay in the twentieth century, ceramics, throughout history, have reflected society's changes. Up through the medieval period in Europe the making of vessels was handled by individual craftsmen or in small workshops. Initially the place of production was determined by the availability of raw materials—clay, water, and fuel—and the market was local. The workshops grew in number after the medieval period, responding to an increased demand for goods as well as improved means of transporting both raw materials and finished products. There also developed a market for luxury ceramics as desire for quality items from specific regions spread. With expanded market and delivery systems, the workshops began taking the first steps toward job specialization during the Renaissance. These workshops—now limited factories—gave way to larger, more specialized factories in the seventeenth

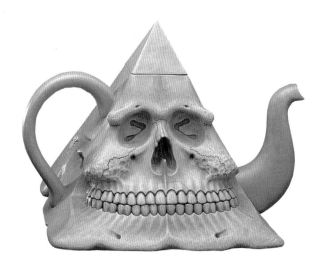

and eighteenth centuries. Hence there is a lineage of ceramics firms, from the family-owned Della Robbia pottery established in Florence in the 1400s to the royal-sponsored factories of Meissen, Germany, and Sèvres, France, founded in the early 1700s to the entrepreneurial Wedgwood pottery started in England by Josiah Wedgwood in the mid-eighteenth century. These giants produced (and some continue to produce) beautiful works that came to be used as status symbols by their owners. As the demand for such pieces grew, efficient manufacturing became the goal. The middle class's desire to emulate the rich led to the production of porcelainlike tablewares (such as Wedgwood's creamware line) and an increase in the number of dishes differentiated more by their hand-applied decoration than by their form.

By the nineteenth century factory-made ceramics became synonymous with machine-made utilitarian wares. Mass-produced ceramics lacked the craftsmanship and high-grade materials that had characterized the royal factory output of the late eighteenth century. No longer was clay a medium generally used for fine display pieces.

The production of quantities of everyday wares led to changes within factories. Ruled by cost, the tasks of design and decoration were divided, and specialized workers performed specified tasks. Each specialist knew an area but was not familiar with the total clay experience. This can be seen in the works produced by Wedgwood, in which artists already established in other mediums were hired to decorate predesigned tableware forms.[10]

At the beginning of the twentieth century functional ceramics were associated with mass-production tableware, figurines, industrial applications, and sanitary fixtures. Studio ceramics, as the small workshops came to be called, began to make a comeback, however. Benefiting from the arts and crafts movement in both England and the United States, studio work came to mean pieces produced by groups of artisans who were intent on making vessels that were functional as well as beautifully designed and decorated. Examples can be found in the work of Rookwood Pottery (established 1880) and Newcomb Pottery (established 1895) as well as in the output overseen by designer/potter Clarice Cliff (1899–1972) in the 1920s at the Royal Staffordshire Pottery. Individual tasks were specialized within the group according to ability; blanks were thrown by one person, decorating done by another, and so forth. Still not considered fine art, the works were beautiful and functional, but made no claim to having intellectual content.

At the same time a few members of the studio ceramics movement broke with the notion of being artisans only. Seeking instead to elevate the medium (and themselves), they returned to the artistic unity of conception, production, design, and marketing of ceramics last seen during the preindustrial period of European history.[11] By rejoining the potter with his material and craft, clay objects, whether functional or sculptural, achieved conceptual and formal consistency. In fact, the distinguishing aspect of the contemporary studio ceramics movement in both the United States and England has been the rejection of the segmented factory approach and the desire to reunite once again all aspects of creating clay objects.

Richard Notkin
Skeleton Teapot and *Four Skeleton Cups*
1980

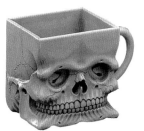

The progenitor of the English studio ceramics movement was Bernard Leach (1887–1979). His importance to the Smits Collection is primary, for his perception of the vessel serves as the departure point for contemporary American clay work. He directly touched the professional lives of potters Michael Cardew, Lucie Rie, and Peter Voulkos, and indirectly influenced many others.

Leach was born in Japan and spent his early years there. In 1903 he returned to England and studied etching for a brief time at the Slade School of Fine Art in London under Frank Brangwyn. Like other arts and crafts movement heirs, Leach was put off by the lack of creativity evident in commercially available ceramics. Subscribing to the early twentieth-century yearning for a return to the preindustrial, handmade wares that were believed capable of restoring quality to life, he fused his viewpoint with the Asian reverence for the plain pot. Borrowing from the oriental point of view, he envisioned the potter as an anonymous artisan who made simple, functional, often brown vessels. He believed the potter did not need to aspire to be an artist, for to be a potter was itself a noble calling. Taking this intoxicating mix of the Eastern lack of pretension and the Western moral imperative, he then seductively linked his view with the indigenous English tradition of slipware as practiced by the seventeenth-century potter Thomas Toft (d. 1679). (Toft was known for his rustic, naive, functionally based slipware, usually brown in color, which was decorated with charming drawings. As an indigenous artist he came to stand in Leach's mind for the native purity of English art unsullied by Continental affectation.) Leach combined this desire for authenticity, simplicity, and morality with a sense of national pride.

Leach established a pottery at St. Ives, Cornwall, in 1920, attracting such like-minded potters as Michael Cardew, Katharine Pleydell-Bouverie, and eventually his son, David. He also asked friend and fellow potter Shōji Hamada, who shared Leach's vision of the innate dignity of the simple brown pot, to join him. Hamada subsequently became, after his return to Japan in 1924, one of the founders of the Mingei group, which led the renaissance of the folk pottery tradition in Japan. Decades later Hamada was declared a living national treasure for his traditional vessels, and his workshop became a popular place for American ceramists to visit through the 1970s.

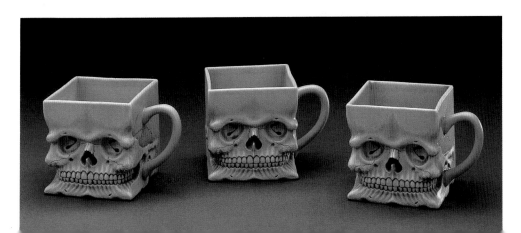

Phillip Maberry

Fish Platter

1985

Hamada, critic and scholar Sōetsu Yanagi, and potter Matsubayashi often accompanied Leach on periodic proselytizing journeys to the United States. The appeal of his ideas and the passion with which he preached them drew many to him. Adherents to this clay life-style still flourish both in the United States and the United Kingdom; among them his second wife, Janet, and David Leach, who continues to run the pottery. Michael Cardew's family has also remained true to this point of view, with son Seth Cardew still potting.

While Leach's lasting contribution was philosophical, he also was an early source of practical advice. Much of the experiential knowledge of working clay had been lost during the rise of factory ceramics, and there were few contemporary sources of information. In 1940 Leach published *A Potter's Book*. After a rousing treatise on the importance of honest pot making, he dispensed practical advice on clay bodies and urged the making of glazes from native soil. Most noteworthy was his directive on how to build a kiln. This represented a breakthrough for the further expansion of the studio pottery movement. Since the beginning of the industrial period kilns had been economically feasible only in factory settings. Leach made it possible for the potter to become self-sustaining, designing, producing, and marketing handmade wares from an individual studio.[12]

Laced throughout *A Potter's Book* were further statements of Leach's belief in the connection between pottery and morality.[13] To him a pot only had integrity if the potter had integrity, and whatever was inside the potter's soul would be expressed in the work. This notion is still relevant to many vessel potters and can be seen in the philosophy and work of Ken Ferguson.

Leach's contemporary William Staite Murray (1881–1962) promulgated a different view. To Murray the potter was on a par with every other artist and clay was an appropriate medium for all content and form. Taking as his inspiration the French studio ceramics movement (where clay artists were approaching parity with artists working in paint or metal) and as his example the London-based 1920s Bloomsbury group headed by Quentin Bell and Roger Fry (who were known for, among other things, their

Roy Lichtenstein
Six-Piece Place Setting
1966

redecorating of extant furniture forms in bright Fauve-influenced colors), Murray
asserted his belief that his vessels were art by marketing them at "prices which placed
the work beyond the reach of any but the rich art collectors who patronised the galler-
ies. . . ."[14] Sadly, due to the economic depression of the early 1930s, this notion could
not be sustained by the marketplace. The comparison in price between Leach's humble
brown pot and Murray's artistic brown pot left Murray the loser.

The depth of the conflict between these philosophies became clear when Murray
was offered an appointment as head of the Royal College of Art in London in 1925.
Leach supporters were shocked that Leach had not been offered the position. They
massed their power and had the decision reviewed by the governing body, which
decided to smooth things over by having Murray and Leach share the appointment.
Murray realized the impossibility of blending diametrically opposed principles and pro-
tested this solution. Consequently, because Murray had been offered the job first, the
overseers rescinded their offer to Leach.[15] Murray served for four years but was unable
to buck the Leach tide. After a few more years in England he left for Rhodesia (now
Zimbabwe) and never potted again.[16]

Time was needed in both England and the United States for Murray's view to pre-
vail. Ironically, it was through contact with the conservative Leach that American pot-
ters were able to find their way to Murray's concept and then pass it back to England.

Meanwhile, the development of ceramics in the United States was still being ruled
by stylistic indebtedness to European vessel traditions.[17] This continued due to the emi-
gration of studio potters from Europe. One such artisan was Maija Grotell (1899–1973)
of Finland. Trained by potter Alfred William Finch, Grotell immigrated to the United
States in 1927 and took up teaching, first at the Henry Street Settlement House in New
York and next at Rutgers University, New Brunswick, New Jersey. Eliel Saarinen invited
her to become head of the ceramics department at the Cranbrook Academy, Bloomfield
Hills, Michigan, in 1938. She accepted and developed Cranbrook into a major center for
studio ceramics. True to her European training Grotell instilled in her students a respect
for the craft of working clay, a talent for balancing aesthetics with function, and a rever-
ence for nuances of surface and form. In many ways she epitomized the modernist sensi-
bilities of understatement and functionality. These were passed on to her students, who
included Richard DeVore and John Glick.

Gertrud and Otto Natzler were other influential émigrés. In 1939 they left their
home in Vienna, moved to Southern California, and began teaching ceramics as well as
making and selling pots. Like other émigré potters, they had already achieved acclaim in
their own country before coming to the United States. Here they continued to explore
the integration of form and monochromatic glazes. In time the Natzlers became leaders
of the studio ceramics movement of Southern California.

Another important potter was French-born Marguerite Wildenhain (1896–1985),
who immigrated to Guerneville, California, after she had risen to prominence in both
Germany and Holland. A student at the Bauhaus for six years under Max Krehan and

sculptor Gerhard Marcks, she was known for her production of functional wares. During the early 1940s she taught at the California College of Arts and Crafts. In the 1950s, when the functional vessel was rejected by Voulkos, Wildenhain was one of the most vocal critics of this break from functionality and what she saw as the dignity of the craftsman's way of life.[18] Others followed her lead: Harrison McIntosh, who had been at the Otis Art Institute for a brief time during the early 1950s, was not drawn to Voulkos's expressive approach and spent a summer studying with Wildenhain at her Pond Farm. Many other potters who matured during the ascendence of the functional brown pot also remained true to its traditions.

There were also important native institutions and ceramists. One such institution was the New York State College of Ceramics at Alfred University, Alfred, New York. Founded in 1900 as a college for applied ceramic arts, Alfred steadily expanded from its technical base and began teaching clay as an art form.[19] Today its innovations in clays and glazes are often adopted by other schools and regions. To be an Alfred University graduate is to have a firm grounding in the techniques and skills of working clay. This grounding can be seen in such Alfred graduates as Andrea Gill, Karen Karnes, Judith Salomon, Robert Turner, and Betty Woodman.

On the West Coast two pioneering potters, Laura Andreson and Glen Lukens, were laying a technical and aesthetic foundation through teaching. The first, Andreson, began her work as a potter in 1936. Drawn to the medium through her knowledge of ceramics history, she found few sources of basic technical information. Working from indigenous materials, she resurrected techniques in order to create her pieces. Even fortuitous mistakes were a source of useful information. Always eager to expand her knowledge of ceramics, Andreson was influenced by Gertrud Natzler, from whom she took throwing lessons, and by the European (especially Scandinavian) ceramics tradition. The latter can be seen in the elegant forms and muted glazes of her creations. Through physical labor (which even involved digging her own clay) and thirty-eight years of teaching at the University of California, Los Angeles, Andreson passed on to the next generation of potters a respect for technique and ceramics traditions.

Glen Lukens too was interested in the functional form, but unlike Andreson, preferred bright colors. Not talented at throwing clay (by his own admission), he chose to press mold his pieces. More than anyone else working and teaching in the 1930s, he preached the basic physical enjoyment of clay and glazes. He urged his students at the University of Southern California to experiment and not be restricted by imported traditions. In this way he prefigured the fascination with the potential of clay as an expressive medium able to rise above its functional uses that Voulkos was to exploit twenty years later.[20]

The effect of other lesser-known California potters can also be seen

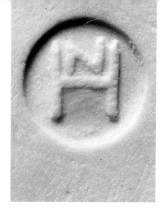

in the Smits Collection, mainly through their influence as teachers. Albert and Louisa King of Los Angeles taught both Laura Andreson and Harrison McIntosh to make glazes and porcelain forms similar to those found in ninth-century Chinese ceramics. Antonio Prieto of Mills College, Oakland, schooled Robert Arneson in sculptural techniques, and Herbert Sanders from California State University, San Jose, taught both Arneson and Philip Cornelius glaze chemistry. Lineages such as these are woven through successive generations of clay workers. But the major explosion in ceramics history was yet to come.

In the early 1950s Leach traveled throughout the United States, lecturing and teaching workshops.[21] Making an impassioned case for the integrity of potters and their work, he was a proselytizer for functional pottery. While his notion of pottery's power to enhance daily life appealed to the American democratic ethos, in other ways he misunderstood the American mentality. Leach felt, for example, that the American potter suffered from a crippling "lack of a tap root."[22] Far from being the liability he envisioned, this lack of a stylistic past was a strength, for without entrenched notions regarding clay, the American delight in change prevailed against imported stylistic restrictions. Overall, however, Leach's preaching expanded sympathy for the humble, handmade vessel.

An important meeting occurred between Leach and Peter Voulkos in 1952, two years before Voulkos left for California to begin what would become a turn away from the brown pot. This meeting took place at the Archie Bray Foundation in Helena, Montana. (Founded in 1951 as a center for advanced study in ceramics by brick and pipe maker Archie Bray [1886–1953] at his Western Clay Manufacturing Works, the foundation presented seminars and classes on clay-related topics.) Although Leach and Voulkos shared the Japanese respect for clay vessels, for Leach the primary lessons of that tradition were the ideal of the noble artisan/potter and a sense of cultural continuity, while for Voulkos the Japanese tradition taught the value of the moment, the process of working clay, and the random effects of the kiln. Seen today as a symbolic passing of the torch, this meeting summed up the differences between the established and the new.

Like all ceramists of the period Voulkos was thoroughly grounded in the aesthetic and technical realities of making functional pots, but he was ready to create his own ceramic statement. In 1953 he spent three weeks at the experimental Black Mountain College in Asheville, North Carolina. Invited by potters Karen Karnes and David Weinrib, he met the director, Josef Albers, creator of the Bauhaus basic course and color theory, poet and potter M. C. Richards, composers John Cage and Stefan Wolpe, dancer Merce Cunningham, and other American members of the avant-garde. Traveling to New York, he met Franz Kline and Willem de Kooning. There he had a chance to see firsthand, in studios and galleries, a new process art, abstract expressionism. Based on spontaneous individual expression, abstract expressionism ran counter to the representational concerns of artists of the 1930s and 1940s. Dubbed "action painting" by critic Harold Rosenberg, it was a uniquely American invention, valuing the process of creating art as much as the art itself. If recording the process of art making was all-important, Voulkos decided, then clay was the medium best suited to that goal.

Marks (left to right):

Nicholas Homoky

Hans Coper

Mary Rogers

Harrison McIntosh

Mineo Mizuno
Plate (detail)
1985

It was with this new concept in mind that he went to Los Angeles in 1954 at the invitation of Millard Sheets to head the newly formed ceramics department at the Otis Art Institute. Here he was presented with the opportunity of his life. Harnessing his prodigious energy and enthusiasm for working clay, Voulkos in a short time assembled a group of equally devoted new ceramics artists. His list of students eventually came to include many of the innovative California potters of the coming decades. Among them were Michael Frimkess, John Mason, Jerry Rothman, and Paul Soldner.

The Otis group worked clay with an intensity and passion that was captured in their pots. They made both functional and nonfunctional vessels, wall pieces, and sculptures. Traditions that focused on elegant vessels or simple pieces were ignored; the process, the experience of the potter working clay, was all. Voulkos admonished his students that they must first know themselves and then allow that knowledge to express itself directly on the material.[23] Working hard to explore the expressive potential of clay, the hours were long and intense. Kiln firings occurred at all hours, and work was valued just because it was produced, not for its ability to withstand firing.[24] Craft was ignored; the action captured in clay was all important. The brown pot was transformed into the expressive process pot.

Eventually, news of this movement reached the larger ceramics community. Rose Slivka, editor of *Craft Horizons*, wrote a seminal article in 1961 entitled "The New Ceramic Presence," in which she told the clay and craft worlds about the Otis revolution.[25] She noted the transformation of clay from traditional pot to sculptural form, pot or not. Slivka correctly identified this transcending of the medium as a fundamental break with the functional vessel tradition. Her article caused a furor.

This new movement, dubbed abstract expressionist clay, divided the ceramics world into two camps: Voulkos versus traditional potters. Similar to the schism between figurative and abstract painters that occurred in the early years of the twentieth century, this rift expressed two distinct artistic sensibilities.

While Voulkos's actions electrified the ceramics world in the United States, English ceramics had also changed, but at a much slower pace. Perhaps not surprising, those who had succeeded in expanding clay's applications were transplants from the Continent.

Lucie Rie, an Austrian potter, attempted to adopt Leach's approach after immigrating to England in 1938. It was disastrous for her fragile, deceptively simple thrown forms. Only after being joined by Hans Coper, a German émigré, did she follow her own ceramics instincts. Coper succeeded in achieving Murray's vision of the artist/potter and established a vocabulary of forms that he refined with elegant simplicity. Refusing to categorize himself as either a potter or a sculptor, he made sculptural pots.

A third illustrious émigré who spent a number of years in England was Ruth Duckworth. Having trained with sculptor Henry Moore after moving from her native Germany, she too came to feel that clay could be art. The prevailing English image of clay as a secondary medium proved overwhelming, however, so she, unlike Coper and Rie, rejected the restrictive atmosphere and immigrated to Chicago in 1964.[26]

Once clay had entered the sculptural world, it was just a matter of time before it would proceed to burst the confines of traditional ceramic subject matter. This was accomplished by one of Voulkos's later students, Robert Arneson. Still generally restricted by its twin limitations—function and craft—clay art was not expected or allowed to address issues of social concern or intellectual content. With clay still viewed as a secondary medium, Arneson was painfully aware of the lack of status experienced by clay artists. As a ceramics student at the California College of Arts and Crafts, he was not even allowed to take classes in painting and sculpture.[27] Voulkos had experienced a similar "medium prejudice" when the work at his solo exhibition in 1960 at the Museum of Modern Art in New York City was spurned by an art world still uncomfortable with clay as a medium for serious art.[28] This was just a fact of life for clay artists, but it galled Arneson. With his *No Return* bottle and *Funk John*, he demanded notice for his work as art, as something capable of carrying content. He also rejected the time-honored ceramic preoccupation with the craft of working clay. Funk art pieces were as a rule casually made, with little attention paid to surface niceties. Coupled with rude images, funk succeeded in offending almost everyone, and Arneson became the bad boy of clay.

In response to the funk movement's general disregard for the techniques of working clay, a group of Southern California ceramics artists (among them Ralph Bacerra, Mineo Mizuno, Richard Notkin, Elsa Rady, and Adrian Saxe) developed a "fetish finish" style. Valuing anew the craft of working clay, this group of artists was not linked by subject matter but rather by an attraction to perfectly finished clay surfaces. Often the surface was used in a trompe l'oeil manner on either vessel forms or sculptural pieces, and the surface finish aided in expressing content. With the fetish finish potters, the expressive pot became the message pot. Notkin's beautifully crafted works clearly illustrate this. The surfaces seduce the viewer into considering the subjects of nuclear war and the inevitability of death.

During the 1960s and early 1970s in England the Leach tradition was still prevalent. Most English ceramists preferred to remain within the limitations of the pure, functional vessel form. It was not until innovative work began in the mid-1970s at the Royal College of Art that clay in England achieved the respect Murray had once envisioned for it. Alison Britton, for instance, slab built vessel forms on which she painted decorative patterns. In her work the traditions of clay and painting were successfully combined. Martin Smith, after first specializing in raku, discovered the diamond drill and the resultant sharp edge he could achieve with it on his ceramic forms. Here growing out of a technical advance, content once again was affected by process.

During the 1970s and 1980s not all American potters were interested in avant-garde clay; some preferred to stay firmly within the vessel tradition. These traditionalists continued to work in their own styles, outside the range of fashionable "isms." Such artists as Richard DeVore, Ken Ferguson, and Robert Turner augmented functionality with philosophy. All three artists, drawing on their experience and complete control of technique, succeeded in keeping the brown pot heritage while elevating it to content status.

English ceramists gained attention in the early 1980s by adopting a new style of ornamentalism. Surrounded by a visually rich environment filled with architectural details, colorful symbols, and historical motifs, they had a ready source of images for their decorations. The English also pursued investigations into the relationship between commercial graphic arts and clay. This can be seen in works that feature manipulations in perspective, such as the teapots by Nicholas Homoky and Linda Gunn-Russell.

This renaissance attests to the passing of modernist constraints against color and ornamentation.[29] It is also an outgrowth of increased art-historical investigation into and appreciation of the signs and images found in non-European-based cultures.[30] The world is interrelated, and the potter's vocabulary now reflects this. This global mix makes the ornamented pot a culturally layered pot, demanding of the audience a multifaceted knowledge of history and art.

These elements are referred to generally as *postmodernist*. While often applied as a catchall for the merely trendy, the term refers to the rejection of the modernist dictums formulated in the 1920s and 1930s and labeled in architecture the International Style. Espousing monochromatism, form following function, and a hierarchy of acceptable art mediums, modernism eschewed decoration, color, and humor.[31]

Postmodernism revels in visual delight: color and pattern laced with multiple cross-cultural references. An example of this is found in the work of a Canadian, Paul Mathieu, who uses color as both a decorative tool and formal device in his *Le Souci de soi*. The color not only pleases the eye; it also serves as a structural element, holding Mathieu's composition/decomposition together. The sense of a whole made of bits easily rendered incomprehensible captures the uneasiness of postmodernism. Ralph Bacerra's *Teapot* is also actively postmodern in its mixing and matching of elements, cultures, and styles.

The interest in color and ornament has also led to the charming, purely decorative, pretty pot. Annette Corcoran makes graceful, finely crafted teapot forms. Mineo Mizuno, who explores various color theories, makes plates that are, among their other attributes, simply attractive. Turkish-born Alev Siesbye combines the vibrant colors of her homeland with the restrained and elegant designs of her adopted country of Denmark. All of these express the numerous and individual approaches to ceramics now possible.

The contemporary ceramic vessel world includes many variations of clay work. The brown pot, expressive pot, message pot, postmodern pot, and pretty pot all thrive. Many artists combine these styles in idiosyncratic ways to communicate content. This pluralism reflects growth in the attitudes held by ceramists and their audience and echoes the development of clay from craft into art. The Howard and Gwen Laurie Smits Collection at the Los Angeles County Museum of Art captures these developments and allows for the study and appreciation of the ceramics of our time.

1. Stone, bronze, tempera on wood, and oil-based paint on canvas (the fine arts) are culturally sanctioned mediums in the Western world. Functional objects made of clay, glass, and wood are traditionally considered minor arts.

2. The Luddites were a group of nineteenth-century political and social conservatives who roamed the English countryside smashing machines in an effort to halt the expansion of mechanization.

3. For more detail see Slivka 1978, pp. 21–52. In this affectionate portrait of Peter Voulkos's early years Slivka clearly depicts the freewheeling Otis life-style.

4. Ironically, pottery was often seen as "women's work," comparable with needlework. With the expansion of fine art's definition, all of the craft-based arts gained in appreciation.

5. Perreault 1982, p. 70.

6. The form follows function doctrine would not allow for such objects as Marilyn Levine's *Two-Tone Bag*. The piece looks like leather but isn't; the form appears to be functional but can't be used.

7. The same argument does not apply to drawings, for although they are used to work out details of paintings or sculptures, they can be ends in themselves too.

8. For a full discussion of this notion as well as other perceptive observations and approaches to ceramics through the ages see Rawson 1983.

9. Rawson 1984, pp. 19–22.

10. Thus the famous Jasperware *Portland Vase*. It was originally decorated by John Flaxman and produced in a limited number of fifty as a luxury item in the 1790s, but by 1838 it was redesigned for one-piece casting to allow for more efficient and hence cheaper production. The cast piece was less defined, and later versions further diluted the original design to meet market considerations.

11. Clark 1981a, pp. 13–15.

12. Bennett 1980, p. 11.

13. Leach's concept of the socially cleansing quality of practical pots is expressive of the twentieth-century belief in social engineering. Seen in the context of the built environment, this led to the belief, put into practice by the Bauhaus, that good design would make a better world. Ironically, this notion of one correct way is a hallmark of the modern movement that in turn promulgated the notion of clay as a secondary medium.

14. Bennett 1980, p. 10.

15. Frayling 1987, p. 110. See also Bennett 1980, p. 98.

16. Bennett 1980, p. 10. For a different perspective on Murray's decision to leave England, see Haslam 1984, pp. 57–59.

17. Clark 1987, p. 63.

18. Slivka 1978, p. 18. For a description of Wildenhain's craftsman philosophy see Wildenhain 1986, pp. 13–21.

19. For a full history of Alfred University see Bernstein 1986.

20. Levin 1982, p. [12].

21. In 1952 Hamada, Leach, and Yanagi made a stop in Los Angeles and held a demonstration at the Los Angeles County Museum of History, Science, and Art. Organized by Richard Petterson of Scripps College, eleven hundred people attended, among them Harrison McIntosh and Otto and Vivika Heino. For a discussion of this see Levin 1988, pp. 198–99.

22. Ibid., p. 187.

23. This notion of internal integrity being expressed in the work is a restatement of Leach's philosophy. But the *kind* of work that expressed integrity is where Voulkos and Leach differed.

24. For a reminiscence-filled essay see McCloud 1984.

25. Slivka 1961.

26. Harrod 1987a, p. 34.

27. Benezra 1985, p. 17.

28. Slivka 1978, p. 55.

29. Adolf Loos (Austria, 1870–1933) in his famous "Ornament and Crime" (1908; English translation in *The Architecture of Adolf Loos*, London: Arts Council of Great Britain, 1985) denounced ornament as sensual and wasteful of resources. His answer was to urge function. From such thoughts came the form follows function attitude adopted by International Style architects.

30. George Kubler explores these concepts in *The Shape of Time: Remarks on the History of Things* (New Haven: Yale University Press, 1962) and points out the inappropriateness of applying Italian Renaissance standards of artistic value to works created outside that culture.

31. Modernism, an aesthetic expression of a widely held belief in the virtue of social engineering, faith in science and the machine, and an optimistic vision of a rationalized future, has been recognized as no longer valid as its tenets have been shattered by such disparate events as the failure of the British "New Towns" scheme, in which the preplanned, built environment proved unappealing, and the publication of Rachel Carson's *Silent Spring*, in which the negative side of man's scientific tinkering with nature was highlighted.

This section focuses on sixty-four ceramists represented in the Smits Collection. Each entry presents the artist's name, country of birth, and year of birth (or life dates); where the artist (if alive) is currently active; the name, date, medium, dimensions, mark status, and registrar's number of a featured work (an M indicates the piece was donated to the museum; a TR that the piece is promised to the museum); and a brief biography of the artist and description of the work, accompanied by a photograph or photographs. A complete catalogue of the Smits Collection succeeds this section. (Please note that dimensions are given as height by diameter [Andreson's *Yellow Orange Bottle*], height by width by depth [Arneson's *Jackson Pollock*], or height by width by diameter [Ferguson's *Teapot*]. The latter format, used generally for teapots and coffee pots, includes the handle and spout in the measurement of width.)

Tony Marsh
White Vase (detail)
1982

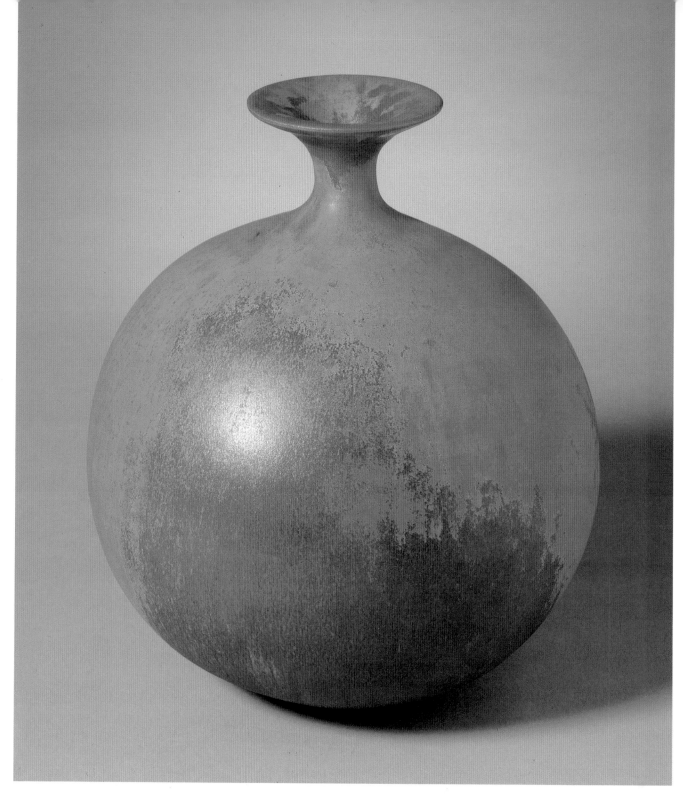

Yellow Orange Bottle

c. 1980

Porcelain, wheel-thrown and glazed

8½ x 7½ (diam.) in. (21.6 x 19.1 cm)

Marked

M.87.1.2

L A U R A A N D R E S O N

United States, b. 1902

Active in Los Angeles

Born in San Bernardino, California, Laura Andreson received her B.A. from the University of California, Los Angeles (UCLA), in 1932. She was introduced to historical pottery and pottery making by Olive Newcomb while at UCLA, started teaching a variety of subjects in the art department one year later, and was both teaching and working in ceramics by 1936. In 1937 she received her M.A. from Columbia University and also had her first exhibition, at the René Rosenthal Gallery in New York City. Since that time she has had more than two hundred shows.

When Andreson began teaching in the mid-1930s, there was little technical or even experiential information about working clay generally available. This led her to start what would become a lifelong investigation of clays and glazes. In this quest for practical information about the techniques of working clay, chance often played a part. For example, an accidental firing that resulted in a reduction atmosphere steered her toward further exploration of this method and its variable effects. The discovery of stoneware clay deposits in Northern California also affected her output.

Andreson's work can be divided into phases that correspond to her choice of clay bodies. The first phase was spent working with low-fire earthenware. This was before she knew how to wheel throw, so her work was slab built and slip cast. A class with Glen Lukens helped her improve her skills in these alternative methods of working clay.

Andreson's palette was, at first, filled with saturated colors and shiny glazes, the only type of glazes available. But she wanted to develop mat glazes that were closer to her own aesthetic, one that combined Scandinavian and oriental styles. She also wished to learn to throw and so took lessons in 1944 from fellow Los Angeles potter and master thrower Gertrud Natzler. To back up this training, Andreson urged one of her students to study with F. Carlton Ball at Mills College in Oakland and then return to teach her.

The year 1948 marked the beginning of the second phase of Andreson's work, stoneware production. Wheel throwing her forms and working at a higher firing temperature with accompanying new glazes gave her output a different look.

In 1957 she made her third change of course by turning to porcelain. Influenced by the work of Albert King, who had mastered the clay bodies of Chinese Song porcelains of the ninth century, Andreson began to explore the whiteness and precision possible with the medium. With porcelain she could throw elegant forms that offered a non-interactive surface for experimenting with glazes. Glaze was of sufficient importance that she worked to make the pot suit the envisioned covering.[1] She particularly liked crystalline, copper red, celadon, and luster glazes.

In 1970 Andreson retired from UCLA after having taught there for thirty-eight years. She now works in her studio, throwing functional vessels in porcelain and glazing them with colors and textures that express her successful combining of the Scandinavian sense of clean lines and the oriental interest in surface nuance.

All but one of the works in the Smits Collection date from the most recent period of her oeuvre. They exhibit a controlled throwing ability matched with subtle mat glazes and are expressive of the concerns that have guided her career as a potter and teacher.

1. Andreson 1982, p. [6].

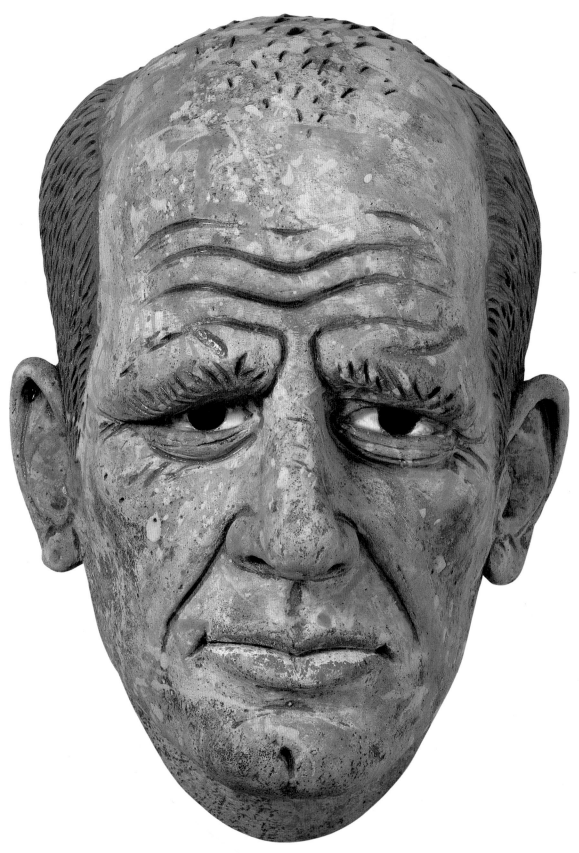

Jackson Pollock

1983

White earthenware, molded and glazed

15 x 11½ x 8 in. (38.1 x 29.2 x 20.3 cm)

Marked

M.87.1.9

ROBERT ARNESON

United States, b. 1930

Active in Benicia, California

Born in Benicia, California, Robert Arneson, then a self-taught artist, was contributing weekly cartoons to the *Benicia Herald* by the time he was seventeen. He attended the College of Marin in Kentfield, California, from 1949 to 1951, where he received a "D" in his first ceramics course. He was considered talented enough, however, to be encouraged to apply for a place at the California College of Arts and Crafts, Oakland (CCAC). Accepted with a partial scholarship, he shifted his focus from cartooning to art education. During these years he took summer classes at a number of other institutions, including a course in glaze technology from Alfred University-trained Herbert Sanders offered at California State University, San Jose. Back at CCAC he worked with Edith Heath, learning about industrial ceramics and ceramics technique. In 1954 he received his B.A. After a brief stint teaching, Arneson returned to school, studying under Antonio Prieto at Mills College, Oakland. He graduated with an M.F.A. in 1958. He presently is head of the ceramics department at the University of California, Davis.

It was during the late 1950s that Arneson met Peter Voulkos. To Arneson, what Voulkos had to say about clay had nothing to do with what vessel potters were doing.[1] This stance is understandable, for Arneson was still at Mills learning how to be a technically accomplished potter, focusing on traditional forms and craft abilities. His M.F.A. show featured well-thrown vessel forms related in genre to the brown pot. Arneson's point of view was being radicalized, however. This was sparked by the evident contrast in treatment of ceramics artists versus artists working in the mediums of paint, metal, stone, and wood.

The explosion of abstract expressionism in clay, as interpreted by Voulkos and others in Los Angeles at the Otis Art Institute, as well as the art of Jasper Johns and Claes Oldenburg, in which social norms were questioned, fueled Arneson's interest in issues that rattled the conformity and apathy associated with the 1950s.

His first public, radical step occurred innocently enough in 1961 when he was demonstrating pottery techniques at the California State Fair. There he threw a quart-sized bottle that he sealed with a clay cap, adding the molded phrase "NO RETURN" to the shoulder. Without preconception he had made the leap from functional potter to iconoclast. This act was his declaration of independence from the "tyranny" of the functional vessel, from the notion that art could not be made out of clay, and from the ranks of the ceramics establishment. He expanded upon this idea and, often using everyday objects as subject matter, began to make sculptural ceramics loaded with critical social comment.

In 1962 Arneson was offered a job teaching design in the College of Agriculture at the University of California, Davis. This developed into an opportunity to establish a new ceramics department based on the notion that clay was just as worthy a medium as any other. Working with artists from other disciplines, among them Roy De Forest, Manuel Neri, Wayne Thiebaud, and William T. Wiley, Arneson had a platform from which to proselytize, and soon a following for his work and ideas developed.

In 1963 he made another seminal work. Asked to participate in the *California Sculpture* exhibition at Kaiser Center, Oakland, he was to show in the company of John Mason and Peter Voulkos. The challenge of standing with this ground-breaking "older generation" made him think about the need to create something unique. He dreamed up the ultimate ceramic. Playing off the reality of ceramic kitchen and bathroom fixtures, he presented the *Funk John*: a toilet with a turdlike handle and worn, furry seat, the bowl filled with excrement. Meant to shock, it also was intended to show that ceramics was a medium capable of expressing anything, high or low, and that the intent and content of the form should establish its relative value. The work caused an uproar and was removed at the request of curator John Coplans, but the point had been made. He proceeded to spin off a number of related pieces, always extending the Voulkos notion of each ceramist needing to think from himself out. By introducing outrageous subject matter, Arneson opened up the conceptual content potential of clay.

In the mid-1960s Arneson changed his clay medium. He began to experiment with white earthenware clay and low-fire, commercial glazes, used with success by James Melchert and Ron Nagle at the San Francisco Art Institute. He continued to be the leader of the funk movement in ceramics, making creative use of everyday objects often juxtaposed with outrageous or even grisly images to express his antiestablishment thoughts.

In the 1970s he turned to the traditional art of portraiture. Often using himself as the subject, he created powerful works that continued his barrage of potent social comment. By taking a figurative approach, he sharpened his vocabulary and became more sophisticated in his messages. To accomplish this, Arneson made another technical change: he developed an expressionless self-portrait in four different sizes and made multiple molds from them. These multiples were then used in series, in direct contrast with the time-honored tradition of one-off portraiture.

Another range of subject matter for Arneson at this time became images of artists who were his heroes. Marcel Duchamp as his alter ego Rrose Sélavy, Pablo Picasso with an itch, and a raw Francis Bacon appeared. This trend has continued into the 1980s, but the subject matter has been tempered by a personal fight with illness and public furor over a commission for a bust of San Francisco's slain mayor George Moscone.[2] Arneson's work now addresses issues of war and death, personally felt but impersonally presented. This has added a depth to his output that places it beyond the "bad boy of ceramics" category. The anger that engendered his first strident actions, that "relentless pursuit of artistic power in order to feel manly and superior,"[3] has cooled, and he now receives the respect of the art world he once scorned.

In *Jackson Pollock*, Arneson, using his background as a cartoonist, has extrapolated the essence of Pollock's face, presenting it not as a caricature but as a larger-than-life representation. Made from a mold and painted over with various glazes to articulate the surface, the piece can be compared with second-century Roman bust portraiture in which the anxiety of the period, and in this case the individual, is caught. The rework-

1. Benezra 1985, p. 15.

2. "In 1978 Mayor Moscone and his colleague, the gay-rights activist [and Supervisor] Harvey Milk, were gunned down in their offices in San Francisco City Hall by former Supervisor Dan White. . . . White received a reduced sentence, for voluntary manslaughter. His lawyers had built up the so-called Twinkie defense, saying that White had eaten too much junk food and that the resulting hypoglycemia had brought on temporary insanity. The response of the gay community to the verdict was angry and violent. . . . a riot at City Hall resulted in 119 injuries and over one million dollars in damage." (Clark 1987, pp. 185–86.) Arneson's *Portrait of George*, commissioned for San Francisco's memorial Moscone Convention Center, made reference to the explosive events, and was so controversial that it was rejected by the city.

3. Kuspit 1986, p. 67.

ing of the surface is reminiscent of Arneson's current draftsmanship technique, which is based on the loose painting style that Pollock pioneered.

R U D Y A U T I O

United States, b. 1926
Active in Helena, Montana

Born in Butte, Montana, Rudy Autio studied, along with Peter Voulkos, under Frances Senska at Montana State University, Bozeman, receiving his B.S. in 1950. He then took his B.F.A. at Washington State University, Pullman, in 1952. Upon graduation he was asked to become resident potter at the newly founded Archie Bray Foundation in Helena, Montana.[1] He accepted and began working there with Peter Voulkos.

Because of the nascent quality of the foundation Autio and Voulkos made everything from functional pottery to "souvenir enamel-on-copper ashtrays for a convention at the Yellowstone Park Lodge."[2] But both men wanted to explore larger issues in clay. Voulkos left for Los Angeles in 1954 to head the new ceramics department at Otis Art Institute; Autio continued in Helena and turned his talents to the creation of ceramic wall pieces. One of his early projects was a thirty-foot-long commission for the First Methodist Church of Great Falls, Montana.

In the early 1960s Autio began to make figurative work. Using the vessel form, on which he would draw in a manner reminiscent of both the Fauves and Jean Dubuffet,[3] he developed a style that combined the volumetric and structural aspects implied in a vessel form with the pictorial elements of painting. As his work changed, he continued to integrate these elements to achieve true sculptural blending.

During the 1970s Autio made only a small number of ceramics. In 1981 he visited the Arabia factory in Helsinki, Finland, and was asked to become artist-in-residence. He worked mostly in porcelain, with the factory setting helping to overcome many of the technical difficulties inherent in working with this medium. After returning to the United States in 1982, he shifted from porcelain to the more easily workable stoneware.

Since then Autio's painting style has become better integrated and polished. His colors have brightened, and he no longer draws out the figures before making the vessel. Instead, after the form is created, he lets the vessel suggest the appropriate figures.

In *Salt Creek Games* Autio hand built in lateral sections a medium-sized vessel decorated with drawings of humans cavorting with a horse. Using a gestural line, he defined the figures in black and colored them for depth. This play between line and color on the one hand and decoration and form on the other gives the piece a lively quality. In his more recent works he has begun to explore the further nuance of the interior of the vessel.

1. See introduction for more information regarding the Archie Bray Foundation. Autio was its first director, followed by Ken Ferguson, David Shaner, David Cornell, and, currently, Kurt Weiser.
2. Kangas 1983b, p. 9.
3. Clark 1981a, p. 36.

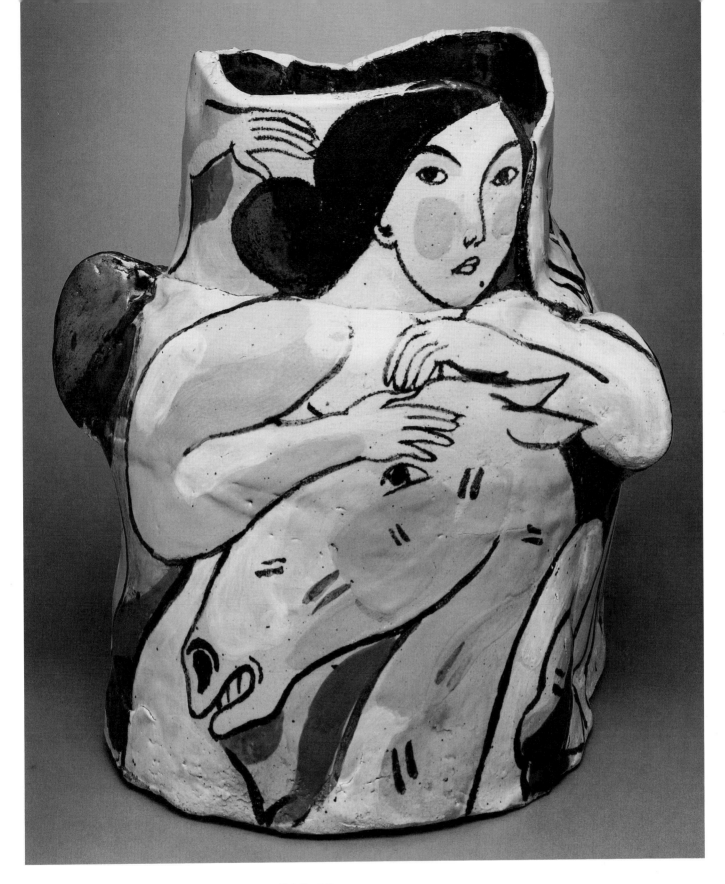

Salt Creek Games
1983
Stoneware, hand-built and glazed
14 1/2 x 13 x 12 in. (36.8 x 33 x 30.5 cm)
Marked
M.87.1.10

RALPH BACERRA

United States, b. 1938
Active in Los Angeles

Born in Garden Grove, California, Ralph Bacerra received his B.F.A. from the Chouinard Art Institute in Los Angeles in 1961 under Otto and Vivika Heino. He then served as head of the ceramics department from 1963 to 1972. In 1983 he became chairman of the ceramics department at the Otis Art Institute in Los Angeles.

Under the Heinos, Bacerra learned to value technical clay-working skills. He has based his teachings on that bedrock and is one of the proponents of the Southern California "fetish finish" style.[1] Due to his position at Chouinard a new generation now bears his stamp of thorough technical grounding: Mineo Mizuno, Ed O'Reilly, Don Pilcher, Elsa Rady, and Adrian Saxe among them. He now works on both vessel and wall pieces in which he creates sophisticated and intricate surface patterns akin to jigsaw puzzles. He has also developed ceramic stove top tiles for use in induction heat cooking.

Much of Bacerra's decorative aesthetic is informed by oriental cultures, in particular the colors and patterns found in Imari and Kutani wares from Japan, Persian miniatures, and Chinese Tang ceramics. Nonceramic sources, such as Japanese fabric designs and the works of Dutch graphic artist W. C. Escher, have also provided inspiration.[2] While most of his work has been within the vessel or tile format, he has also experimented with sculptural forms.

The blue-and-white porcelain *Fish Soup Tureen* is related to seventeenth- and eighteenth-century Chinese export ware. Beautifully thrown, with underglaze cobalt, Bacerra included humor by having a fish form pierce the belly of the piece.

In *Large Bowl* traditional nineteenth-century Imari tones were intensified by the layering of colors and metallic lusters, which allowed for a buildup in the depth of pattern. Fired several times and then painted, the bowl shows the complexity of Bacerra's current work.

In *Teapot* a hand-building technique was used. Here the colors and mottled background are postmodern in style. Clearly not made to function (the pot has a pointed bottom that fits into a triangular base), the piece is concerned with decoration and a fresh exploration of the teapot form.

In all three objects the craftsmanship is superb. Their beauty of surface is beguiling and virtuosic. Bacerra continues to work in highly complex surface patterns on larger, drumlike forms.

1. Fetish finish pieces have a perfectly crafted look; funk works, in contrast, reflect a disregard for fine craftsmanship.
2. Clark 1987, p. 254.

Large Bowl

1981

Porcelain, wheel-thrown, with underglaze and

overglaze painting, lusters, and enamels

5 x 17½ (diam.) in. (12.7 x 44.5 cm)

Marked

M.87.1.12

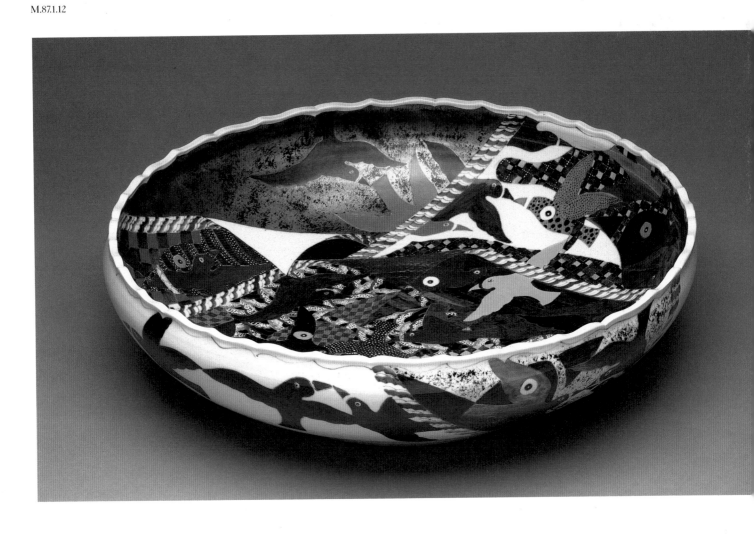

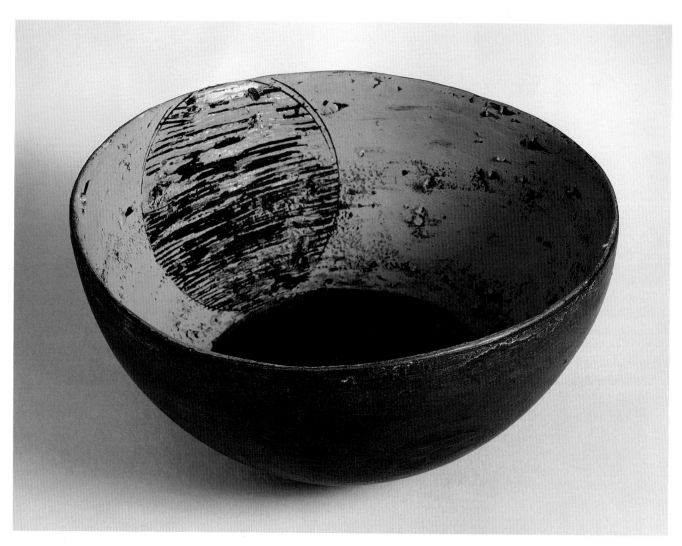

Black Yolk
1981
White earthenware, slip-cast, with engobe
3¹/₂ x 7 (diam.) in. (8.9 x 17.8 cm)
M.87.1.18

CHRISTINA BERTONI

United States, b. 1945
Active in Pascoag, Rhode Island

Born in Ann Arbor, Michigan, Christina Bertoni took her B.F.A. in painting from the University of Michigan in 1967. After two years with the Peace Corps in Botswana she attended the Cranbrook Academy of Art in Bloomfield Hills, Michigan. Having launched her career in painting, she graduated in 1976 with an M.F.A. in ceramics. She is presently on the faculty of the Rhode Island School of Design, Providence.

Bertoni was affected by the work of Mike Powers and Rudolf Staffel as well as that of Jacqueline Rice, who showed Bertoni "the magical and the 'subconscious' possibilities of clay as well as the great variety of artists working with it."[1] From her teacher Richard DeVore she absorbed an interest in examining the many dualities of life. Additionally, one of Bertoni's potent, early influences was the symbolism of the Roman Catholic Church. The personal exploration of science and spirituality presently informs her work.

The most evident of these influences in Bertoni's output is the concept of duality: life and art, positive and negative, harmony and chaos. The vessel form offers her an avenue for the investigation of the contrasting notions of inside and outside. This interrelationship is augmented by her pieces' wobbly bases, which cause the vessels to tip back and forth, giving the viewer an opportunity to see and experience both the inside and outside at once. Bertoni reveals her painting background in her treatment of three-dimensional forms. Creating textures with engobe in an impasto manner, she addresses her pieces as if they were flat canvases.

In *Black Yolk* and *Double Yolk* Bertoni expresses all of these interests and techniques. The ambiguousness of the perspective, the jumping from round to flat and from inside to out, is clear. Over the past several years her work has progressed from flat surfaces to vessels with spatial illusions to three-dimensional vessel sculptures.

1. Bertoni 1984, p. 67.

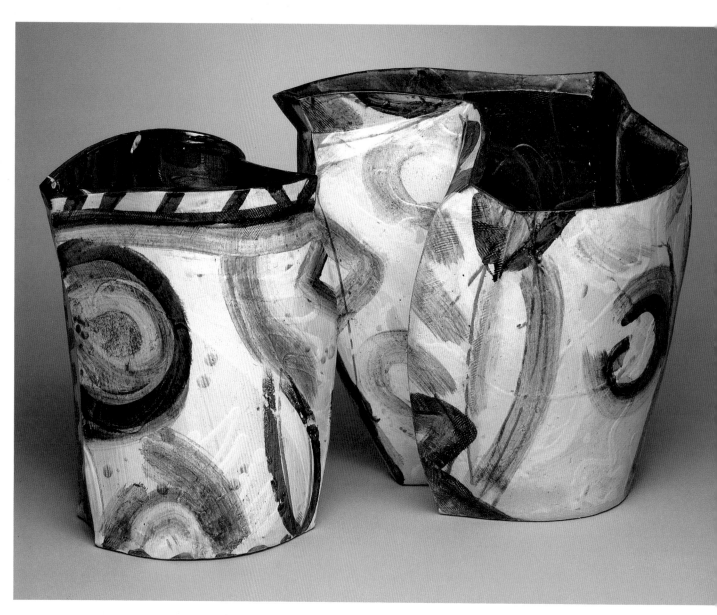

Two-Part Vessel

1987

Earthenware, slab-constructed, with slip and oxides

a. 14 x 13½ x 11 in. (35.6 x 34.3 x 27.9 cm)

b. 12 x 8½ x 8 in. (30.5 x 21.6 x 20.3 cm)

Marked

TR.9282.6a-b

ALISON BRITTON

United Kingdom, b. 1948

Active in London

Born in Harrow, London, Alison Britton was attracted to clay and its potential when she was twelve. In 1966 she attended the Leeds College of Art and then continued her studies at the Central School of Art and Design from 1967 to 1970. She received her M.A. at the Royal College of Art (RCA), London. One of her tutors there was Hans Coper, who, along with Lucie Rie, was not wedded to the brown pot aesthetic espoused by Bernard Leach and others. Perhaps from this type of then unorthodox exposure, Britton and classmates Jill Crowley, Elizabeth Fritsch, and Jacqueline Poncelet felt free to move toward an architectonic and ornamented style.

Britton augments her work as potter by teaching at the RCA and working as a curator and critic of ceramics. Her own clay art deals with the inherent inner and outer dichotomies found in the space-containing vessel form. She strives to create objects that delight and surprise with their ever-changing profiles. To accomplish this, she deliberately eschews the centrality implied in wheel-thrown pots, preferring to make asymmetrically constructed vessels. Her pieces provide different profiles depending upon the perspective, with no one view allowing for total illumination. In recent work she has extended this style by making double compositions that allow for the interplay of two forms relating in space with each other. The featured work, *Two-Part Vessel*, clearly illustrates this.

A variety of influences enrich Britton's work, including early Greek pottery, American Indian ceramics, and Egyptian vessels. From the paintings of Jackson Pollock she learned how to make a cohesive decorative pattern without having to rely on geometric grids.

In *Asymmetrical Pot* Britton denies the center and presents the viewer with an ingeniously balanced, lopsided form. The surface is decorated with loosely painted, repetitive squiggles. Based on a jug shape, the handle has been dropped and the spout transformed into a compartment equal in value to the other chambers. She emphasizes the slab construction by applying lines that serve to articulate the thickness and right-angle quality of each slab. Her interest in structural issues is clear.

Untitled
1983
Earthenware, slab-constructed, glazed,
and burnished
15½ x 11 (diam.) in. (39.4 x 27.9 cm)
Marked
M.87.1.21

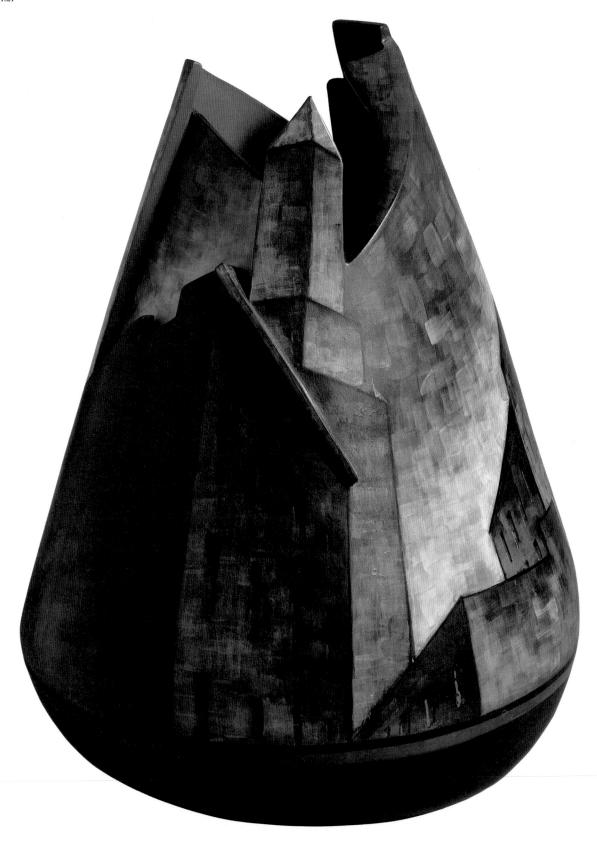

L I D Y A B U Z I O

Uruguay, b. 1948

Active in New York City

Born in Montevideo, Uruguay, Lidya Buzio grew up in a family of artisans and jewelers. Related by marriage to painter Joaquin Torres-Garcia, the arts were always a part of her life. In 1964 she studied painting and drawing with José Montes and Guillermo Fernandez. She then worked for a year with José Collell, who was greatly influenced by the art of Pablo Picasso. Buzio moved to New York City in 1972 to work on a Torres-Garcia retrospective at the Guggenheim Museum and began studying fresco with Julio Alpuy.

Buzio constructs her vessels from earthenware slabs of unfired clay and then applies various colored slips. Each piece is burnished and fired, then waxed with lard and mineral oil. This gives her work a surface approaching that found in fresco painting.

Much of her output incorporates pre-Columbian, Greek, and Chinese images. Progressing from painting still lifes on clay to incorporating architectonic elements of New York cityscapes into her vessels, she has been able to integrate surface with form. She accomplishes her goal of pictorial representation on a three-dimensional surface through skillful use of both monochromatic and polychromatic coloration.

As her work has developed, it has become more complex and layered, resulting in increased tension between form and surface. The recent addition of clay projections extends her usual spherical, conical, and triangular vessel shapes into space in an interactive three-dimensional way. Line, tone, rhythm, and proportion, added to imagery, merge to make painterly ceramic forms.

Although *Untitled* and *Roofscape* are vessels, they obscure that fact through their pictorial presence and size. The careful burnishing of the surface adds a soft texture to the forms just as sunlight enhances actual buildings.

Large Plate

1970

Stoneware, wheel-thrown, with sgraffito decoration

3 x 16 (diam.) in. (7.6 x 40.6 cm)

Marked

M.87.1.22

M I C H A E L C A R D E W

United Kingdom, 1901–83

Born in 1901 at Wimbledon, London, Michael Cardew is reported to have learned to throw pottery from W. Fishley Holland of Braunton Pottery in Devon while on a summer vacation.[1] He later attended school at Exeter College, Oxford, from 1916 to 1920 and worked with Bernard Leach at the St. Ives Pottery in Cornwall from 1920 to 1923. Cardew established Winchcombe Pottery in 1924 and made earthenware pots there until 1938. The next year he established Wenford Bridge Pottery in Cornwall. The same year he was appointed to teach pottery at Achimota College on the Gold Coast of Africa. There (in what is now Ghana) Cardew founded the Vumë Pottery. In 1947 he was appointed senior pottery officer in Nigeria. He remained there until 1970, when his health forced his return to Wenford Bridge, where he taught and conducted workshops. He died at Truro, Cornwall, on February 11, 1983.[2]

A functional potter who worked within the English slipware tradition, Cardew made two important contributions to vessel ceramics. Through the slipware idiom he was able to take traditional forms and combine them with contemporary decorative images to the enrichment of both. His second contribution was to pottery in West Africa.

Cardew worked in stoneware and used the random effects inherent in wood-burning kilns to good advantage. While familiar with the style of Shōji Hamada, with whom he had worked while studying with Leach, Cardew did not bow to that tradition, preferring to build upon his own English heritage of slipware. He did, however, adopt some of the working style seen in Japanese folk ceramics, such as their practice of undertaking firings that lasted for several days. His approach was also reminiscent of that of craftsmen found in the medieval period in Northern Europe. Like them, he performed all functions, from digging clay and concocting natural glazes to firing finished pieces.

Cardew was attracted to the challenge of working in Africa. Whether drawn by the romantic lure of running a pottery in a preindustrial society or believing, as William Staite Murray did, that England offered little to the artist/potter, he spent a major portion of his career teaching Africans how to wheel throw, build kilns, and fire their own work to make hygienic, affordable, functional ceramics.

Large Plate, made after Cardew's resettlement in England, shows his return to working with slipware based on seventeenth-century English pieces. He dashed a trail of slip into the center of this wheel-thrown and glazed piece and then decorated the edge in a similar manner. Although in form it seems functional, its weight and powerful decoration indicate that it was designed to be a display piece, enjoyed for the fine tradition it represents.

1. Bennett 1980, p. 80.

2. Dates supplied by Seth Cardew, letter to author, 24 March 1987.

49

CARMEN COLLELL

Spain, b. 1957
Active in Barcelona

Born in Vic, Barcelona, Carmen Collell's early teachers were Julio Alpuy and Guillermo Gonzalez, who taught her painting and drawing. Her first formal instructor in ceramics was Lidya Buzio, who had also studied with Alpuy. Buzio and Collell were linked too by José Collell, Buzio's teacher and Carmen's uncle. Influenced by painter Joaquin Torres-Garcia, José Collell used fresco techniques coupled with a constructivist approach.

Carmen Collell uses muted and subtle earth tones, reflecting the landscape and quality of light found in her native Spain. Her decorative vocabulary is based on abstractions of the human figure and other natural forms. Each piece is constructed from slabs of clay, then painted and glazed. After their final firing they are hand burnished. This time-consuming technique gives them a glow and touch that reinforce the soft quality of the decoration and shape.

Using contours associated with the streamlined style of the 1930s and 1940s, Collell works in an historicizing manner, borrowing forms from the past and reworking them. She then adds her interest in the ancient technique of fresco, which imparts to her output a timeless quality. These elements attest to the influence of her uncle and Buzio. In *Teapot* and *Teacups and Saucers* she moves beyond their work to create an integration of elements that has a contemporary blend of form and surface. This notion of pulling together a variety of elements is an expression of postmodernism and the international and multimedia nature of today's ceramics.

Teapot and *Teacups and Saucers* were designed, manufactured, and produced in a limited number for the Garth Clark Gallery. While potters often work in series, creating groups of related objects, by making pieces that are hand decorated and produced in numbers, Collell's output here is related in manufacturing technique to that of Dorothy Hafner and falls somewhere between production work and true studio ceramics. Collell also makes one-off vessel forms, in which similar decorative and pictorial elements are used.

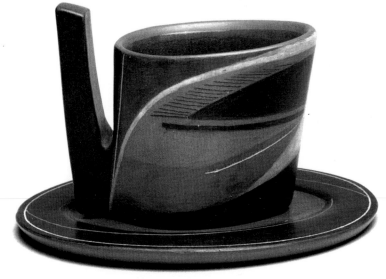

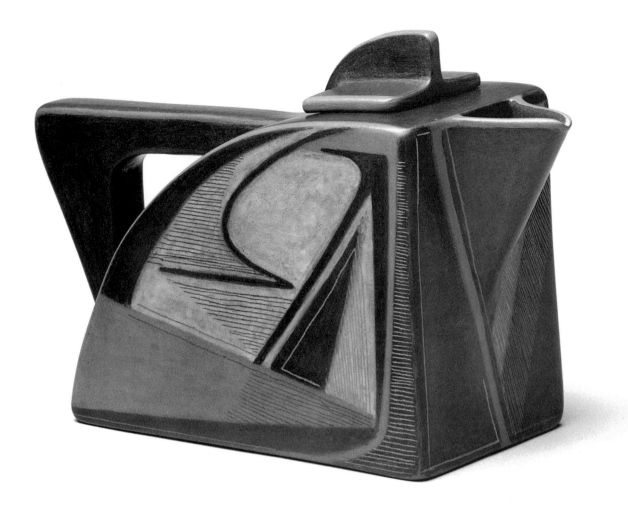

Teapot

1985

Earthenware, slab-constructed, glazed,
and burnished

6 x 10 x 3⅝ in. (15.2 x 25.4 x 9.2 cm)

Marked

M.87.1.24a-b

Teacups and Saucers

1984

Earthenware, slab-constructed, glazed,
and burnished

a. teacup (each): 3 x 3¼ x 2½ in. (7.6 x 8.3 x 6.4 cm)

b. saucer (each): ¼ x 4⅛ x 2¾ in. (.6 x 10.5 x 7 cm)

Marked

M.87.1.25a-b; .26a-b

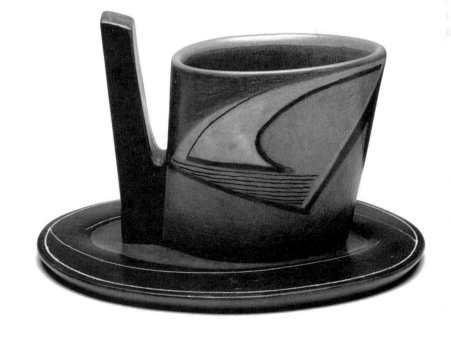

Spade-Shaped Vase

c. 1969

Stoneware, wheel-thrown, altered, and assembled,

with engobe

11½ x 8¼ x 3½ in. (29.2 x 21 x 8.9 cm)

Marked

M.87.1.27

HANS COPER

Germany, 1920–81

Born in 1920 in Chemnitz, Lower Saxony, Hans Coper was the second son of a middle-class, Jewish textile manager and his Gentile wife. After a pleasant bourgeois childhood the political realities of the era caused Coper and his family to move several times. The specter of the Nazis eventually drove his father to commit suicide and his older brother to immigrate to Argentina. Coper, helped by the Quakers, left Germany in 1939 for England. After a time in an internment camp, a common experience for many German-speaking refugees, he had the good fortune to be offered a chance to work with fellow émigré Lucie Rie. Rie had come to the United Kingdom from Austria several years earlier and, as part of the war effort, was making ceramic buttons. Coper had not worked in ceramics before but had studied textile engineering and knew about design. From Rie he learned the skills and art of making ceramics.

Happily, Coper and Rie found that they had similar aesthetic concerns, perhaps reflecting a middle-European interest in sophisticated form and surface. Their friendship and intermittent working relationship lasted until his death in 1981.

Coper was successful in his ceramics work even though his objects had more in common with William Staite Murray's art pottery than the brown pots promoted by Bernard Leach. After World War II Coper's work was featured in several exhibitions, often with Rie's. From 1956 on he had shows on the Continent, in the United States, and in England. In 1966 he began teaching at the Royal College of Art in London, where he continued to pursue his individual aesthetic.

Coper made simple forms, even when he assembled multiple elements to create a single shape. The pieces were each glazed a number of times, with numerous applications of engobe building both texture and a sense of time and wear. Most glazes were mat manganese dioxide, resulting in black-, brown-, or bone-colored vessels.

Coper's vessel forms, even when small, were monumental, and they extended the boundaries of functional form into the sculptural realm. His works made reference to Cycladic cult figurines and included anthropomorphic allusions. His great artistic mentors were the sculptors Alberto Giacometti and Constantin Brancusi. In their output he found reductionist form used to its expressive best. Not driven to attain the status of sculptor himself, Coper is quoted as saying "that making pots was less absurd than making sculpture."[1]

In *Spade-Shaped Vase* Coper created an imposing work that is only about a foot high. While essentially a pot, it also reads as sculpture. In *Dog Bone* he constructed a form related to the ancient art of the Cyclades. While small in scale, it too has a strength beyond its size. *Candle Holder* is organically based, with a podlike, rounded shape. The textured, skinlike surfaces of all three pieces look etched by time.

1. Britton 1984, p. 39.

China Maru Teapot
1985
Porcelain, slab-constructed and glazed
10¾ x 19 x 4¼ in. (27.3 x 48.3 x 10.8 cm)
Marked
M.87.1.32a-b

PHILIP CORNELIUS

United States, b. 1934
Active in Pasadena

Born in San Bernardino, California, Philip Cornelius was first introduced to art in the United States Armed Services library.[1] This led him to take his B.A. in ceramics from California State University, San Jose, in 1960. There he studied under Herbert Sanders, from whom he learned glaze chemistry. In 1962 he spent a year at the Brooklyn Museum Art School in New York. Upon his return to California he completed an M.F.A. at Claremont Graduate School under Paul Soldner. He is presently a professor of art at Pasadena City College.

Most of Cornelius's early works were created from stoneware. They were wheel-thrown and/or assembled pieces, loosely crafted and functionally based. This was to be expected from a potter who began working during the heyday of the clay abstract expressionist movement.

In 1971 Cornelius noticed that the stoneware clay he used to make large, flat forms left a thin layer behind when lifted from the bat. Intrigued with this and curious about what might be made from these thin sheets, he cut up a paper coffee cup and used it as a template. He soon discovered that the clay was strong enough to be formed into self-supporting vessels. Using paper goods and tin cans and other metal containers as models, he discovered "thinware."[2] As is often the case in ceramics, technical exploration exposed inherent qualities within the clay and led to a new avenue of artistic expression.

Cornelius continues to work with thinware but has extended his technique to porcelain. In this medium he makes whimsical teapot extrapolations with vestigial spouts, handles, and lids. Recently he has begun to add appendages to these forms. This notion too grew out of his playing with the material: he created pleasing shapes by molding pieces of thinware porcelain over his knee. By adding this further dimension to his work, he succeeds in making the new pieces architectonic, as his early stoneware pots were.

Cornelius is also probing the results of charcoal firings. Starting first with stoneware bodies, he has expanded this approach and now uses it on his porcelain pieces. This has led to interesting effects on such objects as *China Maru Teapot*. In this piece, named for a Zen garden, Cornelius has used his charcoal-firing technique to achieve flash markings along the bottom. This contrasts with the blue-and-white porcelain that is formed into an improbably thin and undulating teapot form. The spout is shrunken to the size of a cigarette and is reminiscent of guns mounted on a naval ship. Similar contrasts in reference can be found in *Lake Ontario*. Here the form is placed model-like on a display rack. By giving the piece its own context, Cornelius continues his exploration of the functionally related object as art object.

1. Burstein 1982, p. 13.
2. Herman 1981, p. 40.

Triptyque 4

1986

Porcelain, wheel-thrown and trimmed, with engobe

12 x 3½ (diam.) in. (30.5 x 8.9 cm)

Marked

M.87.1.35a-b

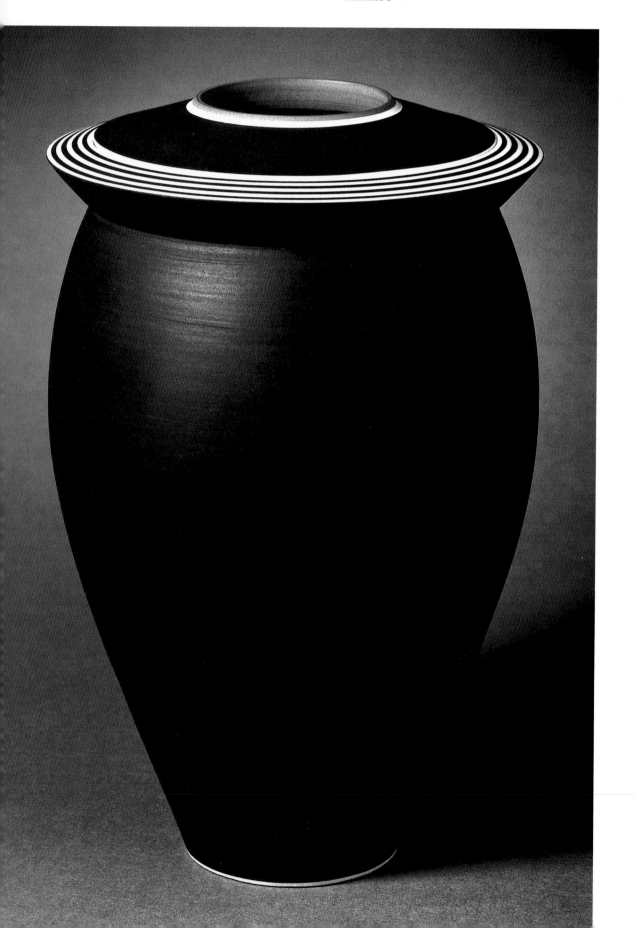

ROSELINE DELISLE

Canada, b. 1952

Active in Venice, California

Born in Rimouski, Quebec, Roseline Delisle received her *diplome d'etude professionnelle* in 1973 from the College du Vieux Montreal. There she learned ceramics with industrial production as the goal. But Delisle's interests led her to explore one-off work, focusing especially on the aesthetic of vessel profiles. Of her output she states: "You cannot put blueberry preserves in them. . . . If you make functional bowls forever, it gets boring."[1]

In 1978 Delisle set up a studio in Venice, California. In 1985 she received a commission from the J. Paul Getty Center for the History of Art and Humanities in Santa Monica, California, to create vessels for their entrance area and a tea service for museum use. Laboring over the vessels for the entry moved her to make her work larger and imparted to it a new strength. Over time her pieces have become less concerned with complex profiles and more focused on simple, rounded forms. These evoke images of water towers, bombs, spaceships, and tornadoes.[2]

Delisle works within the vessel format, concentrating on closed vessels made of porcelain. Her recent work has used the color palette of black and white set off by bright blue. *Jarre Simple 3* is petite and elegant, executed with flawless craftsmanship. Equally well crafted is the *Triptyque 4*, with its title referring to the piece's three parts: the rings at the top, the main body of the work, and the angular shoulder area. Both are from the latest period in her work in terms of simplicity of form and fascination with contrasting colors.

1. Delisle 1988, p. 18.
2. Ibid.

RICHARD DEVORE

United States, b. 1933

Active in Fort Collins, Colorado

Born in Toledo, Ohio, Richard DeVore received his B.Ed. in 1955 from the University of Toledo. He then studied under Maija Grotell at the Cranbrook Academy in Bloomfield Hills, Michigan, where he got his M.F.A. in 1957. After teaching at Michigan's Flint Junior College, he was chosen by Grotell to succeed her when she retired. He taught at Cranbrook from 1966 to 1978, when he moved to Colorado State University at Fort Collins.

During the 1960s DeVore explored a variety of ceramic forms and techniques. In 1969 he turned to what is now his main interest: tall, open, bowl-shaped vessels. His works communicate an exploration of the dualities of male/female, front/back, and light/ dark. In looking at the naked, skinlike surfaces of his androgynous vessels, the viewer may feel voyeuristic, as if violating a person's privacy. Additionally, DeVore gives his pieces the human element of a "correct," frontal orientation.

DeVore is a master at building an unobtrusive geometric balance, a rigorous unifying structure, into what seem to be randomly proportioned works. Each vessel is created only after a series of drawings are completed in which all of the volumetric relationships and structural nuances are established. His drawings, included in *Richard DeVore 1972-1982*, clearly show this analytical aspect.[1] The interest in balanced geometry is belied by the anthropomorphic surfaces and folds of the vessels. The seemingly random holes and dimples are, in fact, evidence of the underlying structure.

Tall Bowl was formed by throwing the first two inches of the base using a dry throwing technique and then hand building the rest. This combination of wheel and hand building gives the work an inexactitude that imparts an aura of vulnerability. After a number of glazes were applied and fired, the pot was wrapped in oil-soaked newspaper, ignited, and then plunged into a lidded drum, which created a reduction atmosphere. All of this has produced a surface that mimics bald, stretched, and aging flesh.

In *Small Bowl with Fold* and *Irregular Bowl* DeVore combines images of the skin of man with landscapes, the skin of the earth. The rims become horizons, with rises, ridges, and other topographical features.

1. Nordland 1983, p. 5.

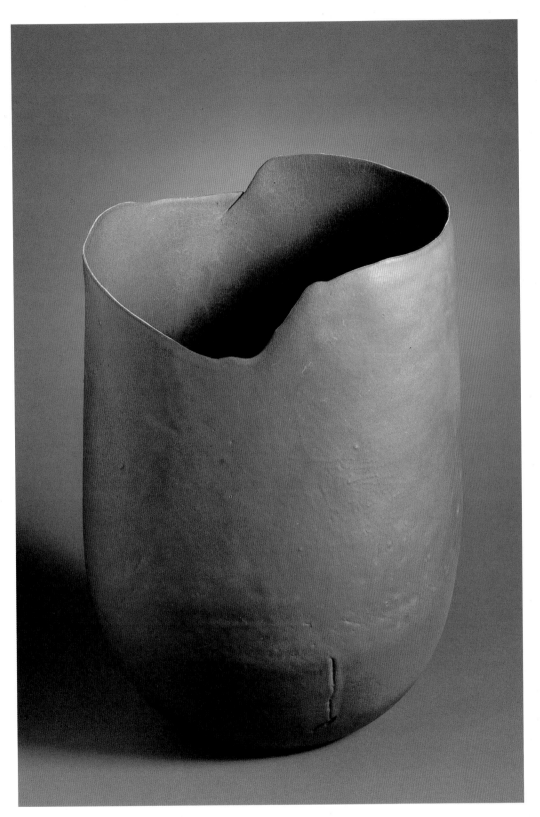

Tall Bowl
1979
Stoneware, wheel-thrown and hand-built, with
multiple glazes and firings
15½ x 10¼ x 8½ in. (39.4 x 26 x 21.6 cm)
M.87.1.38

RICK · DILLINGHAM

United States, b. 1952

Active in Santa Fe

Born in Lake Forest, Illinois, Rick Dillingham studied at the California College of Arts and Crafts, Oakland, and received his B.F.A. from the University of New Mexico, Albuquerque, in 1974. In 1976 he completed his M.F.A. at California's Claremont Graduate School. Having first worked with a potter's wheel as early as 1965, he drifted away from that mode of construction because of his experience with repairing broken pottery for the anthropology museum at the University of New Mexico. This ignited two passions: an abiding interest in the archaeology and pottery of Southwest Indians and a fascination with the notion of the shard.[1] He was also influenced by teacher Hal Riegger and ceramist Beatrice Wood. This combination of factors has led to his unusual method of working ceramics.

Dillingham first fabricates his pieces by hand building, using either slab construction or coiling. He then burnishes them in the greenware stage before firing. After firing he breaks the bisque objects and decorates some of them randomly with metallic materials. The final vessel is then reassembled from these shards, producing a patchwork effect that plays linear geometry off the soft curves of the vessel form. Additional metallic leaf is added at this stage. The concern is not with function, but rather with the pot as a record of man.

Dillingham's ongoing interest in this archaeological point of view has lent his art an unusual depth and authenticity. As links with the past he uses clay from his environs and rejects traditional kiln firing in favor of raku or dung firing without a kiln. He combines historical knowledge, ethnic interest, and philosophical content to create vessels that express the enduring lineage of pots about pots over time.[2]

Tall Vase and *Black-and-White Sphere Vase* are both representative of shapes that have intrigued Dillingham throughout his work as a ceramist. They are good examples of his work with hand-building techniques, the shard, and applied metallic materials.

1. The notion of a complete work being made up of shards (sherds) is discussed in Perrone 1987, pp. 5, 9, 11.

2. See the Linda Gunn-Russell entry, note two, for an explanation of contemporary clay's concern with pots about pots.

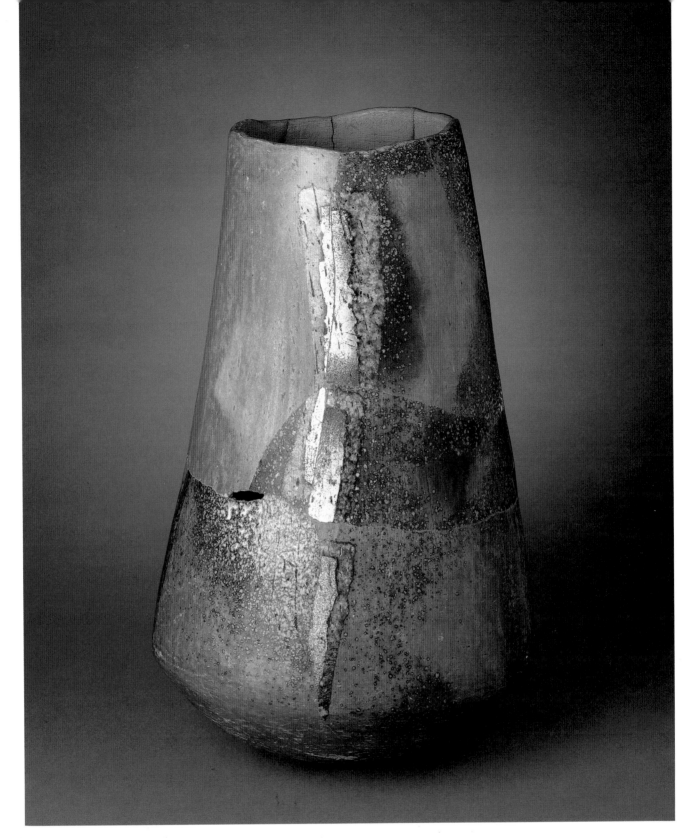

Tall Vase

1978

Earthenware, hand-built, fired, broken, and

assembled, with gold leaf

16¼ x 9¾ (diam.) in. (41.3 x 24.8 cm)

Marked

M.87.1.39

RUTH DUCKWORTH

Germany, b. 1919
Active in Chicago

Born in Hamburg, Germany, Ruth Duckworth immigrated to England in 1935 and attended the Liverpool School of Art from 1936 to 1940. As the result of a legal claim filed against the German government for loss of education (having been denied admittance to art school because she was Jewish), Duckworth was awarded enough money to buy her first kiln.[1]

After graduation she worked as a sculptor and, to make ends meet, as a tombstone carver. Around 1955 she made her first sculpture in clay and, acting on a suggestion from Lucie Rie, attended the Hammersmith School of Art and then the Central School of Arts and Crafts in London to learn glazes. She stayed until 1958. Duckworth found that English ceramists were still seeing clay only from the Bernard Leach perspective and that her sculptural approach was not appreciated, so, in 1964, she moved to the United States, took a teaching job at the University of Chicago, and established her studio.[2]

Duckworth has always been drawn to the sculptural side of clay and frequently works in the traditional sculptural mediums of bronze and other metals, but she is also intrigued by the vessel form and its requirements. Her sculptural work gives her vessels, even when they are on a small scale, a sense of power. She is also known for her large-scale wall sculptures, in which clay is used to create pattern and texture.

Bowl with Lid and Many Rocks is one of Duckworth's small-scale sculptural vessels that achieves a monumental presence. Executed in porcelain and glazed in colors that range from brown to pale pink, the form is mysterious in its expression of inside versus outside. The lid allows only a glimpse of the four mounds that are held in the body of the vessel, leaving them ambiguous in their meaning: are they simply rocks or possibly eggs safely enclosed in a womblike form?

Bowl is also porcelain, but this time Duckworth used an inlay technique. As is typical of her work, the form is expressive of enfolding, with the two top slabs pressed together much as one's hands are when picking up the piece.

1. Clark 1987, p. 262.
2. See introduction for more information.

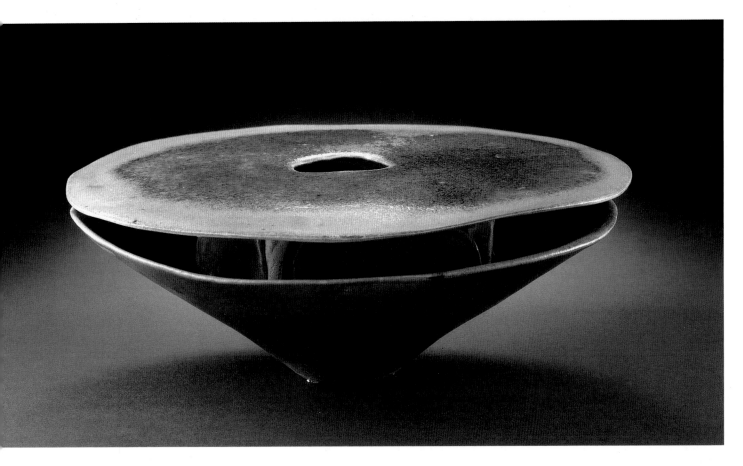

Bowl with Lid and Many Rocks
1981
Porcelain, glazed and reduction-fired
3 x 8½ (diam.) in. (7.6 x 21.6 cm)
M.87.1.41a-b

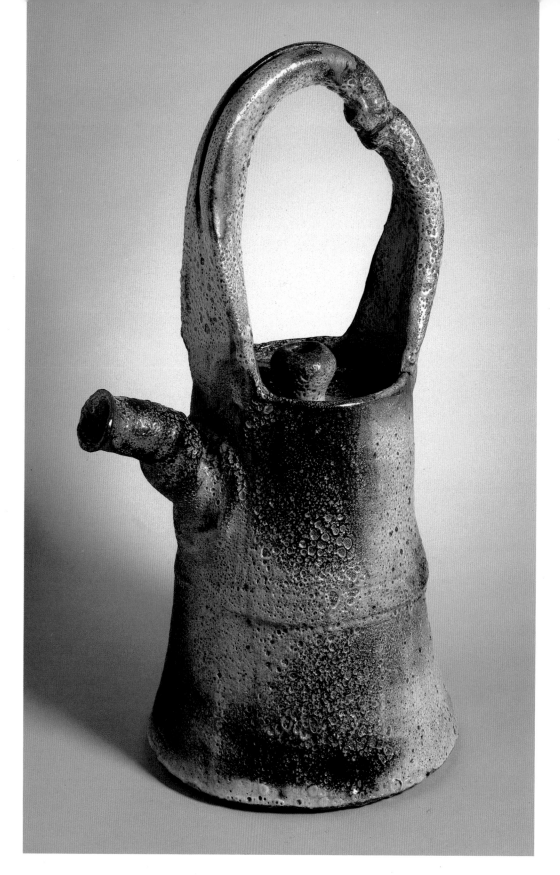

Teapot

1983

Stoneware, wheel-thrown, altered, and wood-fired

23 x 13¾ x 10½ (diam.) in. (58.4 x 34.9 x 26.7 cm)

Marked

M.87.1.43a-b

KEN FERGUSON

United States, b. 1928

Active in Shawnee, Kansas

Born in Elwood, Indiana, Ken Ferguson studied at the American Academy of Art in Chicago and then the Carnegie Institute in Pittsburgh, receiving his B.F.A. in 1952. In 1954 he earned his M.F.A. from the New York State College of Ceramics at Alfred University, where he studied under Charles Harder. Subsequently, he taught at the Carnegie Institute, Alfred University, and the Archie Bray Foundation in Helena, Montana. In the early 1960s he began to develop the ceramics department for the Kansas City Art Institute.

Ferguson embodies the transitions that the late twentieth-century ceramist has experienced. His work has developed from tight, functional pots to expressive pots with functional references. Deeply influenced by Japanese Oribe ware, he uses references to body folds and limp flesh, all within the format of a utilitarian pot. He has also used drawn decoration for his plates, recently producing a number that contain sensual images of women.

Ferguson's work combines his two main tenets: the belief in the need for a high level of technical ability to make a good pot and, equally important, the belief that the potter needs to be a good person with a sense of integrity. For Ferguson the integrity of the potter is something that comes "right through your hands and into your pots."[1] In this way he exemplifies the Bernard Leach linkage of artisan and works produced by that artisan.

All of this can be seen in *Teapot*. Here an oversized, ostensibly functional vessel is sheathed in a pitted, skinlike glaze; a brownware teapot metamorphosed into human flesh. The spout rudely protrudes like a half-erect male member, the handle twists as if it had muscle and sinew beneath the "skin," and the pot surface sags with the weight of time and gravity. Bringing both philosophical and technical notions to bear (especially the creative use of fire's random effects), Ferguson creates pots about pots that also illuminate the frailties of man.

1. Melcher 1979, p. 4.

VIOLA FREY

United States, b. 1933
Active in Oakland

Born in Lodi, California, Viola Frey was first exposed to art in high school. Finding that she had a liking for the subject, she took several courses in painting, drawing, watercolor, and ceramics at a local community college. In 1952 she attended Stockton Delta College for one year, moving on to the California College of Arts and Crafts (CCAC), Oakland, in 1953. There she received her B.F.A. in painting. Although she studied under Richard Diebenkorn, Frey found that the concerns that interested her were being addressed more often in the pot shop than in painting classes.

In 1956 Frey left for Tulane University in New Orleans, where she received her M.F.A. in 1958. At Tulane, Mark Rothko introduced her to the idea of color as sensation. Also while at Tulane she worked under abstract expressionist ceramist Catherine Choy, eventually following her to Port Chester, New York, at the Clay Art Center. Frey returned to San Francisco in 1960 and resumed her course work at CCAC.

Since her childhood Frey has been drawn to the junkyard for inspiration. Defining her as a *bricoleur*, Garth Clark uses a concept taken from Claude Lévi-Strauss's *The Savage Mind*.[1] A bricoleur is a collector of everyday things who takes disparate pieces and creates a new whole. Frey selects bits of cultural debris and assembles the various images, signs, and trivia into a snapshot of the moment. Her work draws from the mosaic of daily life.

Frey produces three general types of work: figurine-based forms that often incorporate vessel shapes; plates; and large, menacing figures with outsized feet and hands. The Smits Collection contains examples from the first two categories.

In *Journey Teapot* a rooster vessel is ridden by a male figure, with a girl and dog balanced on the lid. Serving as a vestigial handle, a young woman hangs off the back of the rooster as she looks down at her dog. Part of a series of pieces, this vessel seems both content and discontent to be a teapot. The surface is enlivened by the color technique of painting nervous lines in dark and light tones that both oscillate and serve to articulate the form. One attempts to look closer only to have the piece fragment and blur. This series of small figurative works served as a transition to Frey's huge, standing, sculptural figures.

In the *Cracker Series II* plate Frey uses a couple of her favorite motifs: gloves and a dark-suited man in a doorway. In her iconography the glove is an ominous symbol as well as representative of a functional tool, in this case the artist's hand. The suit itself is the modern equivalent of a toga, "universal, readily identifiable clothing . . . representing Everyman, who, unable to confront the human condition, exits through the doorway into . . . what?"[2] The use of the plate form is related to the ceramics tradition of plates as flat containers. Here the containment occurs as several three-dimensional items are captured and placed within the plate format. Frey also uses a heavily textured surface, like those of Jean Dubuffet, to further nullify the functionality of the form. The juxtaposed and disparate "signs" for man, door, and glove are part of the bricoleur use of found images.

1. Clark 1981b, p. 7.
2. Jan 1985, p. 423.

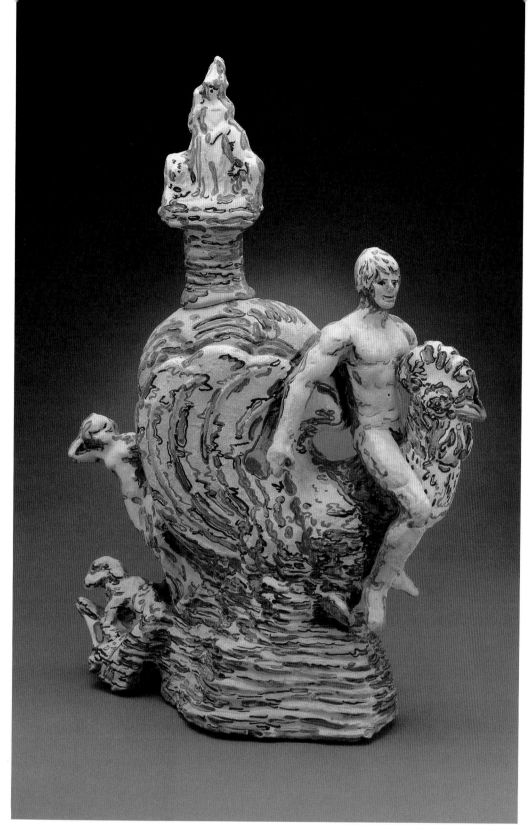

Journey Teapot

1975–76

White earthenware, with low-fire glaze

14-3/4 x 10-1/2 x 5 in. (37.5 x 26.7 x 12.7 cm)

M.87.1.45a-b

MICHAEL FRIMKESS

United States, b. 1937

Active in Venice, California

Born in Los Angeles in 1937, Michael Frimkess was admitted to the Otis Art Institute at the precocious age of fifteen. For the first two years he studied sculpture, but after having a "revelation" about pot throwing while under the influence of the drug peyote, he decided to join the ceramics department under Peter Voulkos.[1] There Frimkess worked with fellow students Billy Al Bengston, John Mason, Malcolm McClain, Kenneth Price, Jerry Rothman, Paul Soldner, and Henry Takemoto. This group became the core of the West Coast ceramics movement, the set that stretched the boundaries of clay art. Frimkess focused much of his time on expanding the range of ceramic vessels while also producing metal sculptures.

Exposed to classical Greek vessels on a trip to the Metropolitan Museum of Art in New York City in the mid-1960s, Frimkess was inspired to learn the difficult technique of wheel throwing hard clay without water. In becoming proficient at this, he was able to create traditional earthenware pieces with walls as thin as those usually achieved only in porcelain. He did not, however, decorate his classical pots with classical subject matter. Instead, he presented social comment in comic book fashion. The standard form with nonstandard decoration caused viewers to look twice. "Jazz musicians played riffs on K'ang Hsi vases. Cyclists pedalled across Volute Kraters. Labels for a fictionary firm of Gilbey's and Benson were placed on Panathenaic Amphorae. Uncle Sam pursued third world maidens across ginger jars with rape on his mind while various godheads and super-heroes looked on."[2] By commenting on present-day situations in the guise of yesterday, Frimkess created a sophisticated banter between art history and pop culture.

Teapot is not typical of his work as it has none of the drawing/social comment decoration on the surface. The exterior glaze is copper red; the white interior glaze provides a counterpoint. The piece is remarkably light and illustrates Frimkess's mastery of the hard clay throwing technique and interest in traditional forms. Moving from the expressive pot to the message pot, he has turned his ceramics into playful pieces with a freewheeling sensibility.

1. Frimkess 1982, pp. 7–8.
2. Clark 1982, p. 3.

Teapot

1979

Stoneware, wheel-thrown, with copper red glaze and
white slip

4³/₄ x 9¹/₂ x 7 (diam.) in. (12.1 x 24.1 x 17.8 cm)

Marked

M.87.1.47a-b

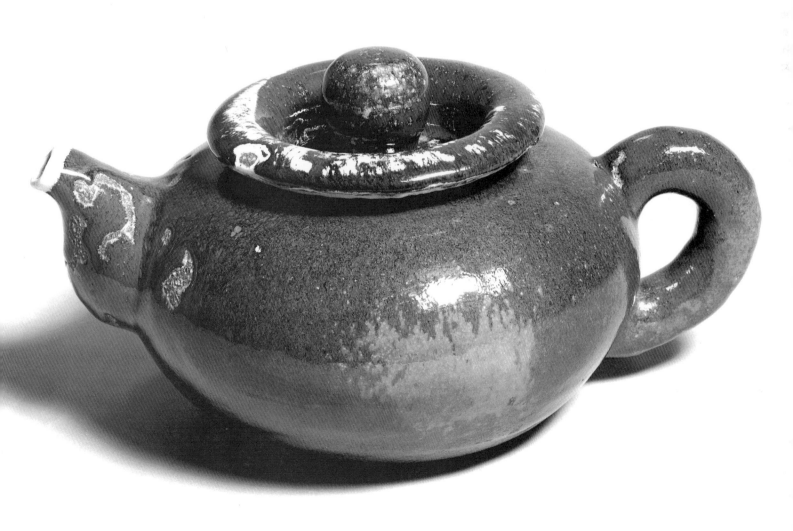

Fish Soup Tureen
1984
Terra-cotta, hand-built and fired, with vitreous
engobe
11 x 20 x 9 in. (27.9 x 50.8 x 22.9 cm)
Marked
M.87.1.48a-b

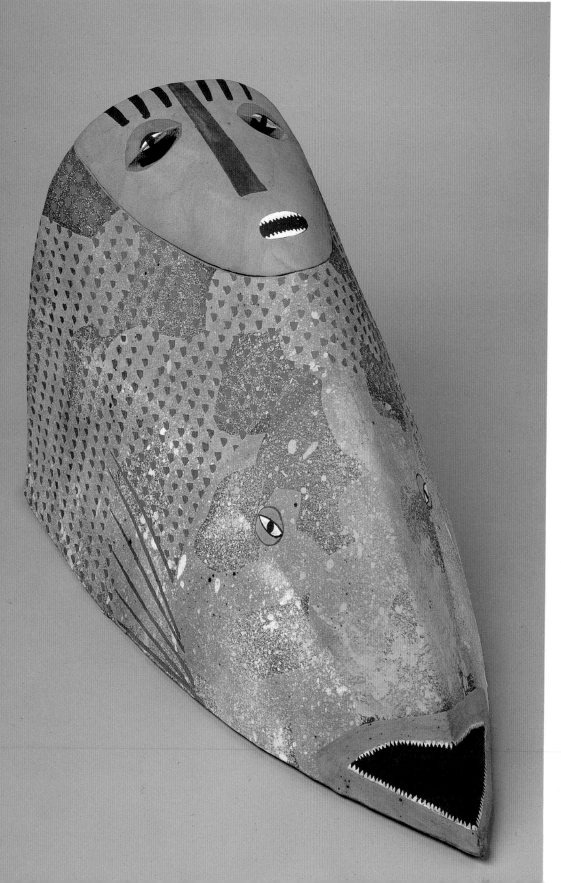

ANDREA GILL

United States, b. 1948

Active in Alfred, New York

Born in Newark, New Jersey, Andrea Gill studied painting at the Rhode Island School of Design, Providence, receiving her B.F.A. in 1971. Drawn to ceramics at an early age, she, on a whim, inveigled her way after undergraduate school into her first job, with a Cape Cod potter, by stating confidently that she knew all about pot making. In fact, she knew little, but after quickly reading through Daniel Rhodes's *Clay and Glazes for the Potter*, she knew enough to get by until she actually learned the basics.[1] After this experience she decided to do graduate work in ceramics, attending both the Kansas City Art Institute and Alfred University. She presently teaches at the New York State College of Ceramics at Alfred University.

While at the Kansas City Art Institute, Gill worked with both Ken Ferguson and Jacqueline Rice. It was here that she met fellow ceramist and future husband, John Gill. She also met Wayne Higby and Betty Woodman and got to know their work.

Gill's focus is on the interplay of surface and external profile. Most often working with the vessel form presented in an anthropomorphic manner, her pieces feature decorated surfaces. Having first studied painting, this interest in surface decoration and texture is understandable. Historical styles have also influenced her work. Travel to Italy and Spain exposed her to fifteenth-century, tin-glazed maiolica and other historical low-fire ceramics applications.

Inspired by a fishing tackle box seen in the Hemphill Collection of Folk Art, *Fish Soup Tureen* was hand built with slab-construction techniques, press molding, and engobe. The overall form is pyramidal. The snout of a fish is drawn on the front; a targetlike face appears on the back. The lid has two stylized faces: one on the inside glazed to match the shiny interior and the other on the outside in a mat finish. Gill used thick, colored slips to embellish and articulate the surface, building up several layers to indicate the scales, eyes, and gills. The pictorial influences of Pablo Picasso and such totemic art as Eskimo carvings can be seen.

1. Wechsler 1981, p. 77.

JOHN GLICK

United States, b. 1938

Active in Farmington, Michigan

Born in Detroit, John Glick received his B.F.A. in 1960 from Wayne State University, Detroit, having studied under William Pitney. He earned his M.F.A. in 1962 from the Cranbrook Academy, Bloomfield Hills, Michigan, where he worked under Finnish-born Maija Grotell. In addition to these two influences his developing aesthetic was shaped by the Japanese ceramic styles of Shōji Hamada and Bernard Leach. Two years out of school he started the Plum Tree Pottery, where he continues to make functional vessels for direct sale to the public. He also writes, lectures, and conducts workshops about ceramics.

Glick often decorates his primarily functional work with loose, gestural applications of glaze. Although his output is traditional, with evident ties to the Orient, he is clearly making a twentieth-century statement in his process-revealing method of decoration. He is able to enliven these elements through his sense of playfulness and consummate skill in manipulating clay.

Part of his technique involves the creation of his own tools to accomplish specific tasks, such as constructing wooden ribs to expand the sides of a pot. This approach to pot making, that of an individualistic artisan, places Glick in the craftsman milieu revered during the 1950s and 1960s. Using glazes that are shiny and spontaneously applied, he creates pots that are solid and unpretentious.

In *Large Low Bowl* a grand, wheel-thrown form is glazed with a number of colors ranging from brown to lavender. The stoneware body, fired to cone 10 in a reduction atmosphere, shows Glick's interest in surface mottling (caused by iron flecks coming to the surface during firing). While based on a functional prototype, this piece, by virtue of its size, crosses over into being a decorative display work.

Large Low Bowl

1981

Stoneware, wheel-thrown and glazed

5¼ x 18¾ (diam.) in. (13.3 x 47.6 cm)

Marked

M.87.1.51

LINDA GUNN-RUSSELL

United Kingdom, b. 1953
Active in London

Born in London, Linda Gunn-Russell attended the Camberwell School of Art and Crafts from 1971 to 1975. Her approach to ceramics was influenced by teachers Glenys Barton, John Forde, Ian Godfrey, Colin Pearson, and Janice Tchalenko.[1] She also was affected by the works of British ceramist Clarice Cliff, Roy Lichtenstein, and Henri Matisse, as well as by the patterns found in Japanese kimonos and Islamic miniatures. Swayed by the trends of the 1970s, Gunn-Russell was involved with the quirky ceramics of that time. She slip cast cheery, functional forms, such as teapots shaped like strawberries and milk jugs in the form of toucans.

In the 1980s Gunn-Russell has turned to a series of "body pots." In these she combines humor and an anthropomorphic sensibility with functionally based objects. Her method is first to draw shapes and then to slab build them. This allows her to maintain a graphic sensibility that provides a contrast with the three-dimensional aspects of her pieces. Visual puns are used in her references to the teapot and in the witty contest of real versus visual volume and sensuous curves versus hard-edged, angular forms. This play of perspective in pots shows an awareness of the work of ceramist Elizabeth Fritsch, who, in the 1970s, also explored this notion.

Teapot is real in pictorial terms but not in ceramic terms. It does not exist in space as a true pot would. The lid is an abstraction, and the base is almost a linear rendering. This is a pot about a pot and about the traditional volumetric and structural concerns of the potter.[2] The surface decoration is reminiscent of that favored by the postmodern group of designers and architects called Memphis/Milano, which frequently uses 1950s-inspired plastic laminates.

1. Orient 1985. The author has drawn extensively from this essay.
2. Anatol Orient writes in Orient 1985: "As a gallery owner, I am often asked why artists create tea pots that don't pour, or objects that appear to be vases yet won't hold water. One answer, ubiquitous in this age of increasingly sculptural ceramics . . . is that these tea pots, jugs, and bowls are about *looking* at jugs, bowls, and tea pots."

Teapot

1985

Red earthenware, slab-built, sanded, glazed,

and fired

12 x 7 x 1½ in. (30.5 x 17.8 x 3.8 cm)

Marked

M.87.1.52

CHRISTOPHER GUSTIN

United States, b. 1952

Active in South Dartmouth, Massachusetts

Born in Chicago, Christopher Gustin began his study of art under John Mason at the University of California, Irvine. He continued his education at the Kansas City Art Institute, receiving a B.F.A. in 1975, and at the New York State College of Ceramics, Alfred University, receiving an M.F.A. in 1977.

Many experiences and people have shaped Gustin's work. Having first been exposed to clay at a Los Angeles community studio, he spent a year and a half managing Wildwood Ceramics in Pasadena. While he attended the Kansas City Art Institute, he worked with fellow students Andrea and John Gill, Ed O'Reilly, and Akio Takamori. When he later attended Alfred University, he explored the figurative aspects of pot making under the guidance of Kylliki Salmenhaara, a visiting artist from Finland. Gustin was influenced by several professors as well, among them Victor Babu, Ken Ferguson, Jacqueline Rice, and George Timock. From Ferguson especially, Gustin learned the importance of being confident about one's work. This meant having a clear understanding of technique and a sense of personal integrity. This linking of work and character reflects the Bernard Leach ideal of the dignity of pot and potter.

Much of the work Gustin has done recently deals with the process and action of vessel making. In his output the vessel is a metaphor for the human body. In *Pink Vessel* there is both an anthropomorphic and organic quality, with the form appearing to grow and expand. The limits imposed by functionality were given lip service as he began making "radical and abstract investigations into . . . space."[1] He used incised lines to articulate the various segments that create the form and sandblasted the surface to pit the glaze and soften the texture. As in the work of Ferguson the vessel form is used as a forum to explore aspects of the human body and the ceramic body.

1. Clark 1987, p. 271.

Pink Vessel
1986
Stoneware, wheel-thrown, altered, sandblasted, and
reduction-fired
20½ x 10 (diam.) in. (52.1 x 25.4 cm)
Marked
M.87.1.53

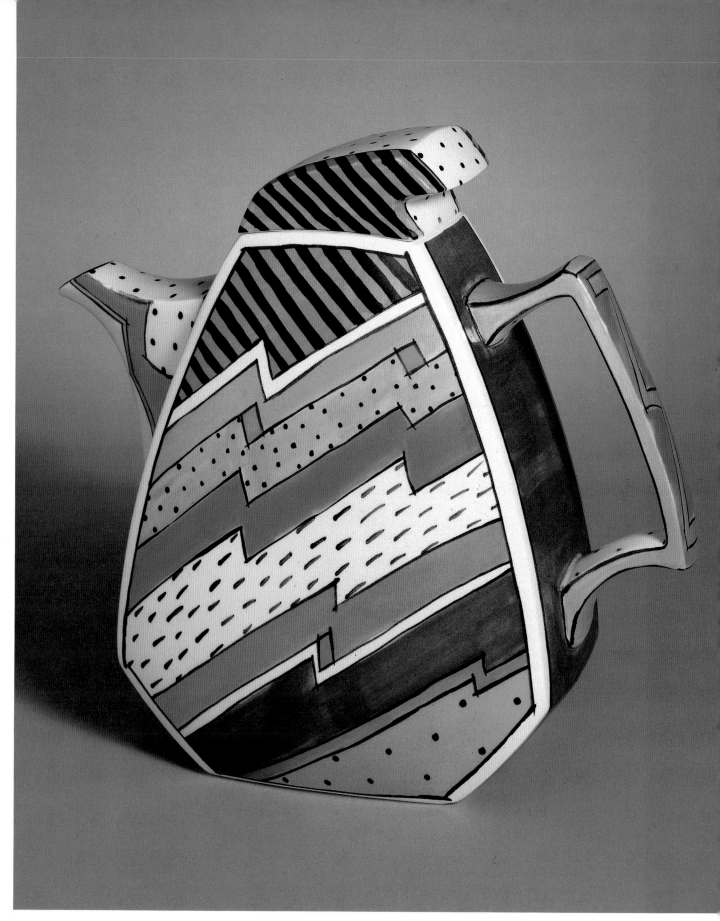

Sonar Coffee Pot

1983

Porcelain, slip-cast, painted, and glazed

11 x 15 x 3¾ in. (27.9 x 38.1 x 9.5 cm)

Marked

M.87.1.54a-b

DOROTHY HAFNER

United States, b. 1952
Active in New York City

Born in Woodbridge, Connecticut, Dorothy
Hafner earned her B.S. in fine arts from Skidmore College, Saratoga, New York, in 1974.
She designs and produces tableware in limited series for both display and functional pur-
poses for ceramics firms as well as her own studio. Since 1979 she has been a designer for
Tiffany and Company; since 1982 with Rosenthal. Her work and system of producing
series porcelains is similar to that of British potter Clarice Cliff in the 1920s and 1930s.[1]

Hafner's aesthetic and sense of color are derived from Japanese fabrics and ceramics
as well as the sophisticated hubbub of life in New York City. Her interest in design
issues involving pattern and color interrelationships reveals a late twentieth-century
concern with ornamentation. Sleek forms and motif assemblages are additional factors
in her successful, playful, postmodern synthesis.

Hafner often allows the decoration of her pieces to influence their shape. Drawing
from many past sources, be they high culture (eighteenth-century French design) or low
culture (twentieth-century pop icons), her forms provide a comfortable matrix for her
fresh and light-hearted work. Not since the end of the nineteenth century has this inter-
est in the decorative function of utilitarian ware been emphasized so strongly.

By maintaining her own workshop, Hafner is continuing in the tradition of historical
potteries that use universal blanks in versatile forms that are then decorated with a num-
ber of pattern variants. It is this limited number of decorative schemes and their hand
application that separate her work from large-scale factory production.

Sonar Coffee Pot was not originally made as a prototype, but became one when it was
adopted by Rosenthal as part of its studio production line. It is interesting to note that
due to the investment needed to establish a new line, large manufacturers are often
unwilling to stray from proven designs. The adoption of this piece and others in this
series by Rosenthal is evidence of the marketability of the postmodern aesthetic.

1. See Clark 1987, p. 271, for addi-
tional information.

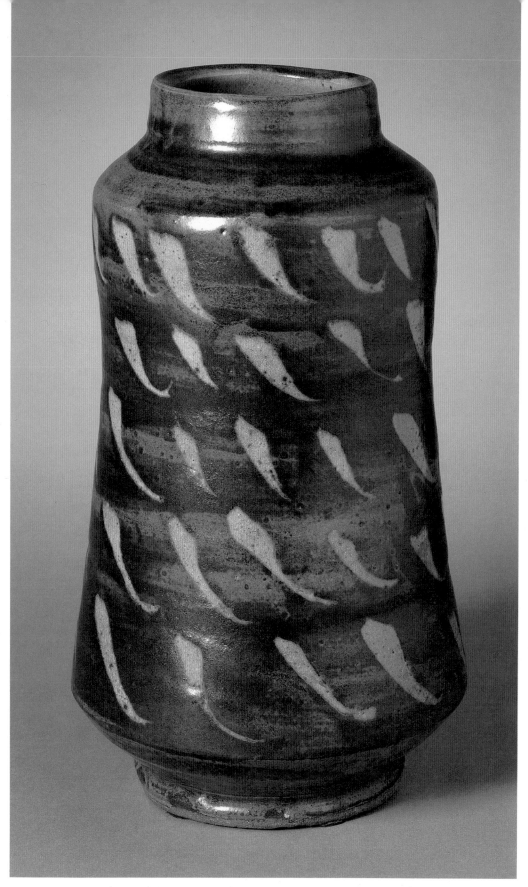

Tall Vase with Falling Leaves Design

1970s

Stoneware, with wax resist brush strokes

10½ x 6½ (diam.) in. (26.7 x 16.5 cm)

M.87.1.56

SHŌJI HAMADA

Japan, 1894–1978

Born in Tokyo, Shōji Hamada graduated from the ceramics department at Tokyo Technical College, having studied with artist-potter Itaya Hazan.[1] He attended the Kyoto Ceramic Experimental Institute from 1916 to 1920, worked with Bernard Leach in England from 1920 to 1923, and established a pottery in the area of Mashiko in the Tochigi Prefecture in 1924. In 1926 Hamada, Kanjirō Kawai, and Sōetsu Yanagi founded the Japanese Craft Society, the Mingei-kai.[2] This group promoted folk traditions and, specifically, folk ceramics. Implicit in this was a commitment to the simple life fashioned after Zen Buddhist precepts. For his work in this field Hamada was designated a living national treasure in 1955.

Hamada's importance to the Western studio ceramics movement began with his association with Leach. In 1920 Hamada joined Leach at the newly established St. Ives pottery, bringing his knowledge of the Japanese approach to ceramics to the West. Together they overcame both technical problems and aesthetic hostility in establishing the brown pot tradition in England.[3]

Hamada's Japanese workshop produced handmade, functional wares from the 1920s to the 1970s. The working routine involved the throwing, firing, decorating, and glazing of large numbers of pieces. When a firing was held, it was an event that lasted several days, with the wood-fired kiln being stoked and tended around the clock.

Hamada, as was traditional, employed apprentices who worked in his style. The output of one well-known assistant, Tatsuzō Shimaoka, is also represented in the Smits Collection. Pots thrown by Hamada himself were highly valued and placed in individual boxes upon completion. Other pieces were sold as being from the Hamada workshop.

Tall Vase with Falling Leaves Design is an example of the liveliness of brush strokes valued by the Japanese folk tradition. The casual glaze cover as well as the loose decorations attest to the acceptance of chance and random action as important components of this pottery tradition. *Bottle with Brush Marks* features a white slip that has been applied to the body and then coarsely brushed away from the stoneware clay.

1. Moes 1979, p. 31.

2. Yanagi 1984, p. 94.

3. See introduction for more information.

Blue Weed Vase

1980

Porcelain, wheel-thrown and reduction-fired, with
iron blue glaze

4 x 6¼ (diam.) in. (10.2 x 15.9 cm)

Marked

M.87.1.58

OTTO HEINO

United States, b. 1915

Active in Ojai, California

VIVIKA HEINO

United States, b. 1910

Active in Ojai, California

Born in Caledonia, New York, Vivika Timeriasieff attended Rochester City Normal School. In 1933 she graduated from the Colorado College of Education (now the University of Northern Colorado), moved to San Francisco, and then settled in Los Angeles. There she attended summer school at the University of Southern California (USC) under Glen Lukens, becoming his lab assistant. After being urged by Charles Harder, dean of Alfred University, to continue her studies there, she moved to New York, receiving an M.A. in low-fire ceramics in 1944. As a teacher at the League of New Hampshire Craftsman she met Otto Heino in 1948.

Otto was born in East Hampton, Connecticut. After World War II he studied ceramics under the GI Bill at the League of New Hampshire Craftsman. In 1950 he and Vivika were married; two years later they moved to California. Vivika taught ceramics at various places, including USC while Lukens was on sabbatical. In 1955 Otto and Vivika began teaching in the ceramics department at Chouinard Art Institute in Los Angeles. In 1963 they again went East. Vivika taught at the Rhode Island School of Design; Otto established a pottery. Subsequently, they returned to California and settled in Ojai in 1973, where they continue to maintain a studio.

The Heinos have been leading potters in the West for almost forty years. Their original work in clay formulation and glaze chemistry as well as their experimentation with kiln building is well known. Over the years Vivika has taught many who have become ceramists of note. One of her most celebrated students is Ralph Bacerra. He credits her for instilling in him a respect for the craft and discipline necessary for working successfully in clay. He has passed this reverence and knowledge on to his students, among them Mineo Mizuno, Elsa Rady, Adrian Saxe, and Peter Shire.

The Heinos work separately and as a team. Vivika creates delicate forms in porcelain; Otto produces larger pieces. For both, oriental ceramics as well as Scandinavian ware have served as inspiration.

Otto and Vivika Heino embody the brown pot aesthetic, in which there is dignity in being a vessel potter. Not drawn to the sculptural revolution that occurred around them, they have continued to make functional, well-crafted vessels. *Blue Weed Vase*, with its perfectly crafted shape and lively blue-and-brown glaze, exemplifies this.

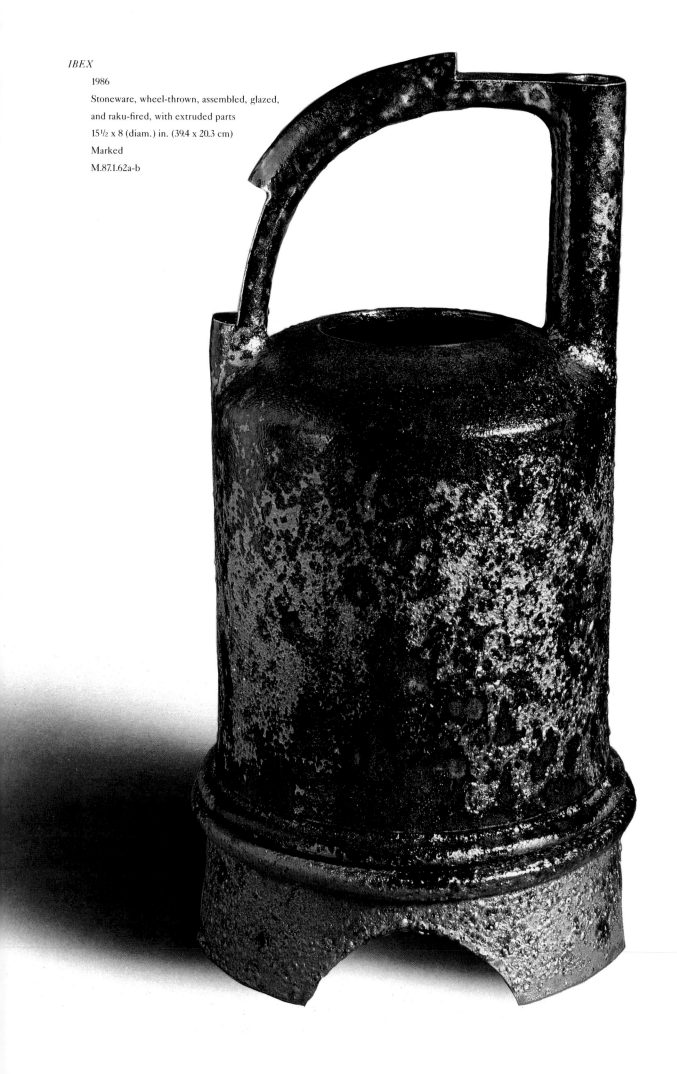

IBEX

1986

Stoneware, wheel-thrown, assembled, glazed,
and raku-fired, with extruded parts

15½ x 8 (diam.) in. (39.4 x 20.3 cm)

Marked

M.87.1.62a-b

ANNE HIRONDELLE

United States, b. 1944

Active in Port Townsend, Washington

Born in Vancouver, Washington, Anne Hirondelle came to ceramics by a circuitous route. After receiving her B.A. in English from the University of Puget Sound in Tacoma, Washington, she took an M.A. in counseling psychology at Stanford University in California. After trying law school, she started attending classes at the Factory of Visual Arts in Seattle. This whetted her interest in clay, and she proceeded to complete her B.F.A. in ceramics at the University of Washington, Seattle, in 1976. Encouraged by Robert Sperry and others, Hirondelle then set up her studio in Port Townsend. In 1984, after a period of experimentation (with its accompanying failures and false turns), she began the series of works from which this piece comes.

Hirondelle works most comfortably within the vessel format. Her work is architectural and geometric, yet she is aware of the necessity of retaining a natural component within her aesthetic. Raku has intrigued her, perhaps because of the random nature of the process. This chance quality provides a counterpoint to her controlled forms.

Most of Hirondelle's work begins with drawings, in which she sorts out design issues. To construct her pots, she throws and extrudes and then assembles the various components. Building from traditional notions about vessels, she gives them a crisp clarity and architectural power expressive of late twentieth-century design. All of her pieces are tied to the reality of function; only her use of oversized forms makes it clear that they are, in fact, for contemplation.

In *IBEX*, so named because the handle is reminiscent of the horns of a wild goat, all of these characteristics are evident. The work has a strong architectonic sense and a controlled geometry. The raku glaze is pitted, adding a slight contrast of imperfection to the formality of the piece. Its cool, intellectual relationships and subtle color and texture place this work within the modern milieu. In more recent works Hirondelle has softened the clear geometry of her forms by incorporating appendages that are more casually modeled.

NICHOLAS HOMOKY

Hungary, b. 1950

Active in Bristol, England

Born in Sárvár, Hungary, Nicholas Homoky attended the Royal College of Art (RCA) in London during the 1970s. He studied painting, sculpture, graphics, and draftsmanship. All of these are evident as elements in his subsequent work in ceramics. He "finally chose to work with clay because it seemed to be the only medium capable of being as purely expressive as it was functional."[1] At first he was interested in clay sculpture but came to realize that a pot was also sculpture.

Homoky is fascinated with opposites: line versus form, black versus white, the appearance of function versus the lack of functionality. His pieces are hand constructed or wheel thrown in a silky porcelain that lends them a cool elegance. Slight irregularities in the placement of the decorative lines and a sense of whimsy create a counterpoint to the flawless surfaces.

Homoky first draws each piece and then executes it in clay. He refers to this as evidence of his having the "double vision of a potter and a draftsman."[2] He even strives to have his porcelain surfaces emulate the texture of paper. In decorating his works, he uses inlaid clay in thin strips that read like pencil lines. This notion came out of his exposure to inlaid Korean pots while a student at the RCA.

White Teapot is from a series of similar pieces in which Homoky plays form against line and perspective. One almost wants to cut out the teapot encased in the porcelain. *White Pedestal Bowl Vase*, a wheel-thrown form not altered as is sometimes Homoky's style, is inlaid with strong, black lines that create and separate spaces. In recent work he uses brown earthenware with white inlaid slip.

1. Homoky 1981b, p. 12.
2. Homoky 1981a, p. 69.

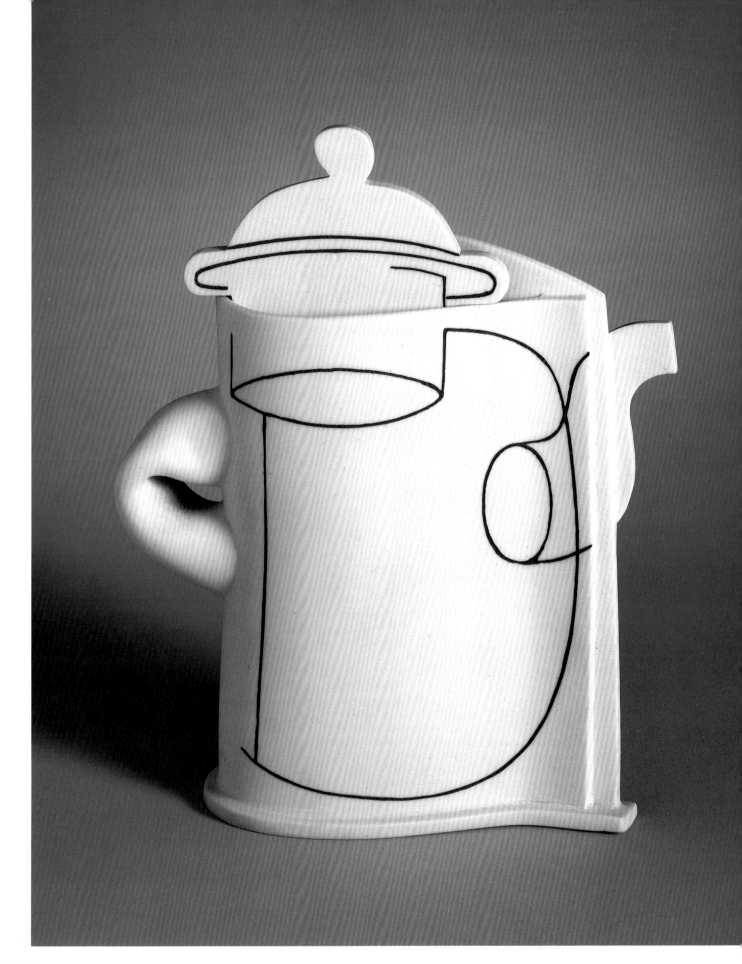

White Teapot

1980

Porcelain, hand-built, inlaid, and polished

7¹⁄₈ x 6¹⁄₄ x 1³⁄₄ in. (18.1 x 15.9 x 4.4 cm)

Marked

M.87.1.64a-b

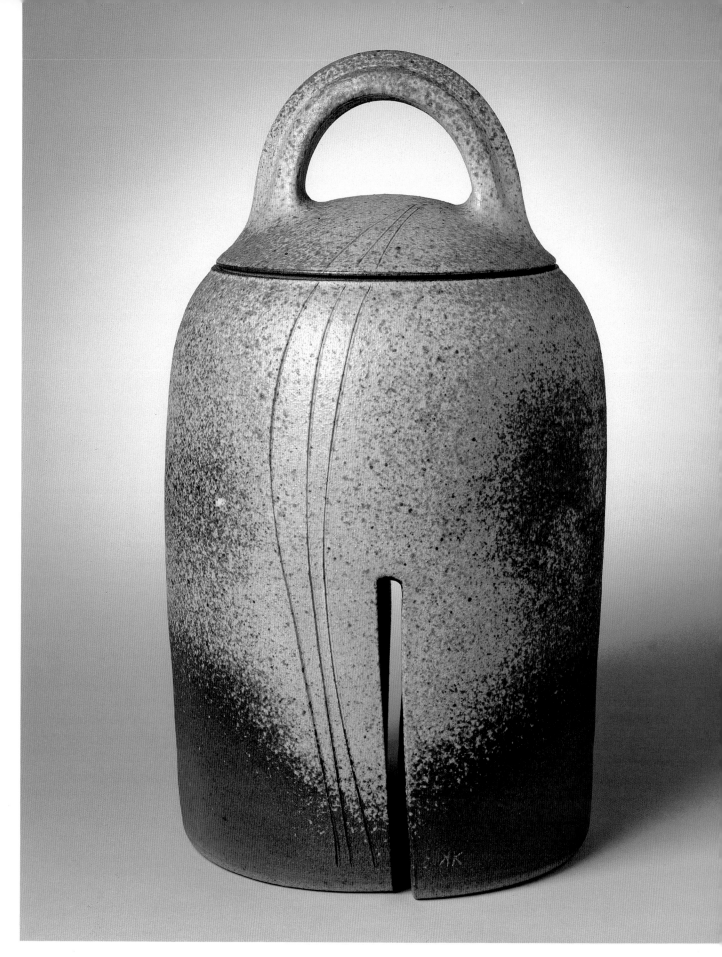

Vessel

1987

Stoneware, wheel-thrown, glazed, and wood-fired

16½ x 10½ (diam.) in. (41.9 x 26.7 cm)

Marked

TR.9282.5a-b

KAREN KARNES

United States, b. 1925

Active in Morgan, Vermont

Born in New York City, Karen Karnes studied at Brooklyn College and the New York State College of Ceramics at Alfred University. From 1952 to 1954 she and her then husband, David Weinrib, were potters-in-residence at Black Mountain College, Asheville, North Carolina. There they organized a number of symposia whose participants included Shōji Hamada, Bernard Leach, Marguerite Wildenhain, and Sōetsu Yanagi. It was at one of these events that Peter Voulkos was first exposed to the new trends in American art of the 1950s. In 1954 Karnes moved to Stony Point, New York, where she lived until 1979. After a time in Wales as well as West Danville, Vermont, she eventually established a studio in Morgan, Vermont.

Before 1979 Karnes focused on the production of multiple, functional, predominantly salt-glazed pieces. Since 1979 she has worked with wood-fired finishes and color flashings on one-off vessel forms that transcend function. A Michael Cardew traditionalist, she "grows from an appreciation of the universal past of . . . her art."[1] Always independent of academic or stylistic affiliations, her forms now have a monumental presence.

In *Vessel* a lidded form was wheel thrown from stoneware and then slit from the bottom, which destroyed the implied function of the piece. For structural reasons and maintenance of functionality, however, Karnes placed the actual bottom of the container at the top of the cut. With the central slit and the slight deformation that occurred during firing, the piece appears to have striding legs. This human reference, the sense of hand seen in the throwing lines, and the softness of the stoneware add individualism and interest to what started as a basic pot.

1. Clark 1981a, p. 43.

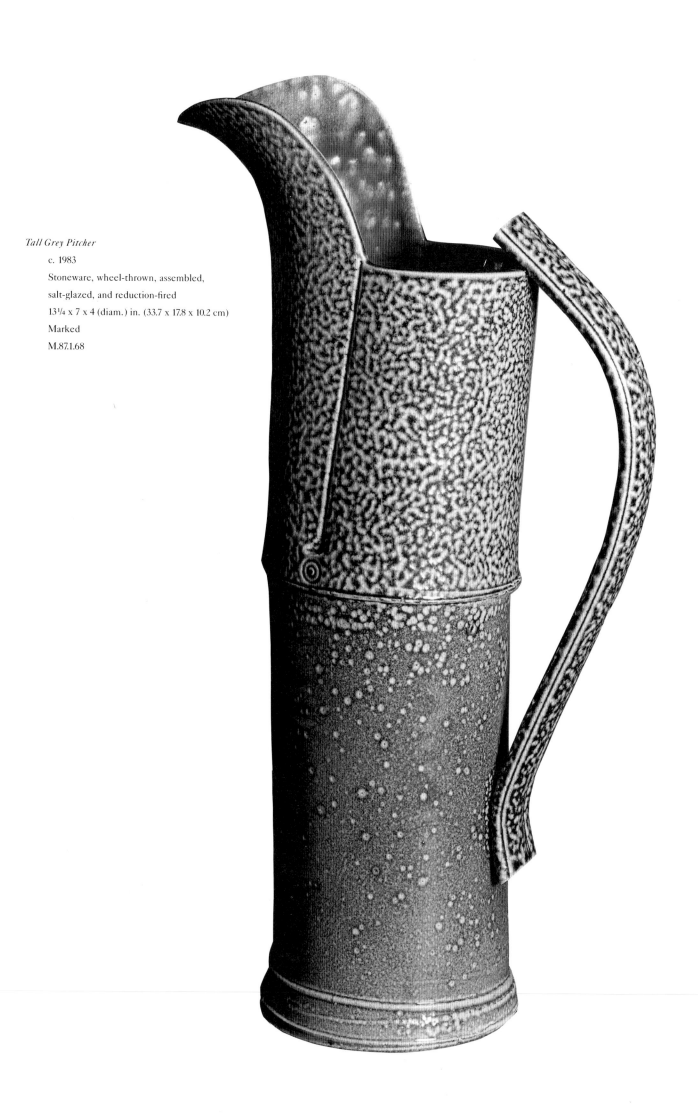

Tall Grey Pitcher

c. 1983

Stoneware, wheel-thrown, assembled,

salt-glazed, and reduction-fired

13¼ x 7 x 4 (diam.) in. (33.7 x 17.8 x 10.2 cm)

Marked

M.87.1.68

W A L T E R K E E L E R

United Kingdom, b. 1942
Active in Penallt, Wales

Born in 1942 in London, Walter Keeler trained at the Harrow School of Art under Victor Margrie and Michael Casson. He was an apostle of Bernard Leach and found Leach's *A Potter's Book* to be a practical, philosophical guide. In the late 1960s he saw the salt-glazed pottery collection of Rosemary and Denise Wren displayed at the Craftsmen Potters Shop in London. This prompted him to work with that demanding technique. In 1965 he established his first studio in Bledlow Ridge, Buckinghamshire, but moved to Penallt in Wales in 1976. There he committed himself to only working in salt glazes. Much of the technology he had to rediscover and fashion to his own needs.

Not only does Keeler draw from the British tradition of functional pottery, he also pulls from the present, finding inspiration in archaeology, oil containers and other industrial artifacts, and even howitzers (for use as spouts of teapots). This eclecticism is late twentieth century in style and remarkable to find in a potter who prefers Leachean limitations and chooses to stay out of urban centers. While essentially a functional potter (except for a brief departure in the beginning of his career), Keeler modifies function by spicing it up with a sense of humor, creating "subtly deviant" pottery.[1] This can be seen in his teapots, which are tilted back as if about to take off and have spouts that are almost rude in their scale and assertiveness.

Tall Grey Pitcher is typical of Keeler's work. It is a functional, jauntily sloped, wheel-thrown vessel with an extruded handle. The pitcher's form is derived from that of a badly joined stovepipe. A chop of two concentric circles, rather like "neolithic 'cup marks'," is placed rivetlike on the side seam.[2] This element appears to be integral to the structure but serves instead as a visual counterpoint to the already established volumetric sense of the vessel. All the Keeler hallmarks are present: true function laced with assembled references carried out with a touch of humor.

1. Briers 1988, p. 28.
2. Ibid., p. 33.

KAREN KOBLITZ

United States, b. 1951

Active in Venice, California

Born in Hollywood, Karen Koblitz first became interested in ceramics while studying at California State University, Northridge, in 1968. In 1970 she took a trip to Florence, Italy, and was introduced to Renaissance maiolica and Della Robbia ware. Upon returning to California, she took her B.F.A. from the California College of Arts and Crafts in Oakland in 1973. Koblitz traveled to Japan after graduation, where she visited the Tatsmura Silk Company in Kyoto. She moved to Madison, Wisconsin, in 1974 and studied there for a while with Don Reitz, also learning mold making from Bruce Breckenridge.

After teaching for a number of years, Koblitz felt she had to decide whether to be a teacher or a full-time artist. Her decision was to return to California and support herself through her art. Along these lines, she completed a large commission in 1987 for the Cranston Securities Company of Los Angeles, a two-part wall mural made of tiles inspired by Mimbres pottery. She continued to make smaller table and wall pieces as well.

Koblitz's work carries traces from a number of nonceramics artists, among them Paul Cézanne, Gustav Klimt, Henri Matisse, John Peto, and Miriam Schapiro. Ceramists, including Robert Arneson, Bernard Palissy, and Richard Shaw, have also been influential. Additionally, hints of Japanese fabrics, Flemish still lifes, eighteenth-century Wedgwood Wheildon ware, and facades of Mayan temples can be seen in her output. She is a true child of the postmodern era, using other times and cultures as relevant material for contemporary statements.

Still Life with Pitcher and Hedge Apple incorporates many of these influences. The vessel and fruit forms were slip cast in low-fire white clay, incised when leather hard with patterns, bisquited to cone 04, and glazed with selected commercial glazes. The "fabric," slab-rolled, nylon-reinforced white clay, was impressed while wet with linoleum blocks carved with patterns. The piece was then "rumpled," allowed to dry, and fired. Each component was painted in order to enliven the decorative pattern covering the surface.

Koblitz has constructed a number of pieces in this series of brightly colored table tableaux. Although they refer to function, they really are assemblages, odes to the decorative potential of everyday objects.

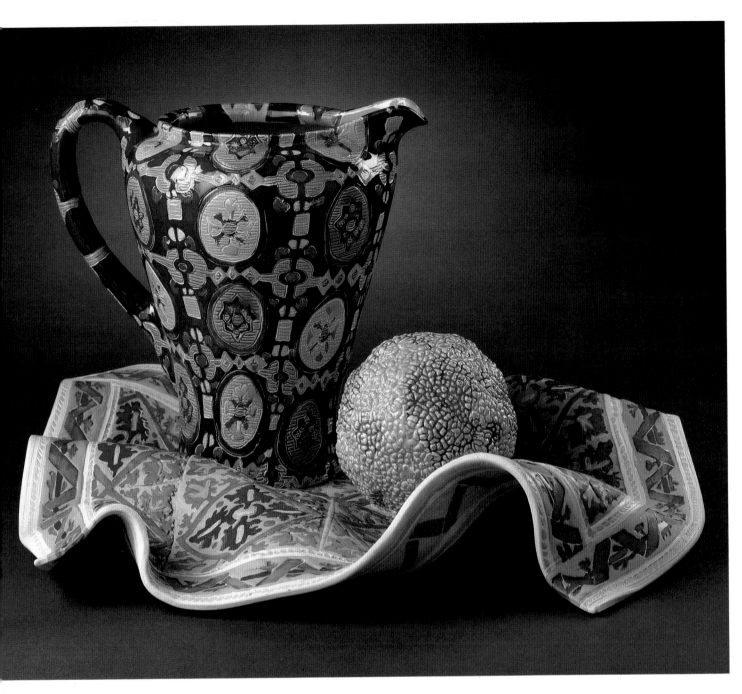

Still Life with Pitcher and Hedge Apple
1985
Low-fire white clay, slip-cast, slab-constructed, and
assembled, with multiple glazes
7¾ x 13½ x 10 in. (19.7 x 34.3 x 25.4 cm)
Marked
M.87.1.71a-b

MARILYN LEVINE

Canada, b. 1935
Active in Oakland

Born in Medicine Hat, Alberta, Marilyn Levine first studied chemistry, receiving a B.S. in 1957 and an M.S. in 1959. As an elective she took a life drawing class. After moving to Regina, Saskatchewan, she audited ceramics courses in lieu of seeking work in chemistry. Ceramics became a passion, and in 1968 she secured a Canada Council grant and traveled to Los Angeles to visit the West Coast ceramic movement principals: John Mason, James Melchert, Ron Nagle, Jerry Rothman, and Peter Voulkos. After a period of initial confusion about their work she came to understand more about clay's potential.[1]

Levine started teaching pottery at the University of Regina in 1969. It was at this time that she became interested in ceramics as a medium for sculptural forms and moved away from strict functionalism. After a brief stint at the University of Utah as a professor of art she moved to Oakland, earning an M.F.A. at the University of California, Berkeley, in 1971. Upon graduation she established her studio in Oakland.

While still in Regina, Levine was greatly influenced by Jack Sures, a Canadian potter who had studied in the United States. Working with him kindled her interest in slab construction. In 1965 they began experimenting with high-fire reduction. Sures also exposed her to the notion of reinforcing slabs with nylon fibers for greater plasticity. Through a unique confluence of circumstances Levine was able to work with a sympathetic chemist from the Du Pont Corporation, and she became the first ceramist to perfect the use of fibers in clay.

Two-Tone Bag and *Leather Ceramic Mug* are typical of Levine's work. The notion of objects that can express time is one that has long interested her. In *Two-Tone Bag* she records the "trace" of human life by focusing on unintentional marks.[2] Evidence of time and use, a history of sorts, is communicated through the creation of physical detail that seems more intense than in the actual object. Leery of new and fashionable items, she prefers to focus on the humanness that can be found in older, everyday things. While using the imagery first introduced by the funk movement, her technique of detailed craftsmanship is the antithesis of that approach.

In *Two-Tone Bag* the "metal" fittings and zipper are also clay, the former having been cast and the latter having been press molded. The stitching, looking more emphatic than that on a real carryall, was accomplished by cutting the various parts with a modified tracing wheel. Her construction method is similar to that used for the actual object, except where that is not possible due to the qualities of clay.[3]

Leather Ceramic Mug is a traditional, functional form that is clearly not meant to be used. The overly masculine, leatherlike, ammunition-holding object makes an antimilitary statement within the form of an innocuous mug.

1. Levin 1985, p. 42.

2. "An acquaintance of mine, Marc Treib, described pretty neatly the two types of impact man has on the world, 'intent' and 'trace,' as he called them. He defined 'intent' as the results of man's acting consciously. This would include design, building and other purposeful action. 'Trace' on the other hand is the accumulation of the marks left by the realization of man's intent, such as trampled grass, grease spots and dirt. In trace, he says, we find richness, a humanity often omitted in intent. Trace always tells a story. My work is involved with the story told by trace." Levine 1972, p. 84.

3. For a detailed description of Levine's construction methods see Levin 1985, pp. 43–44.

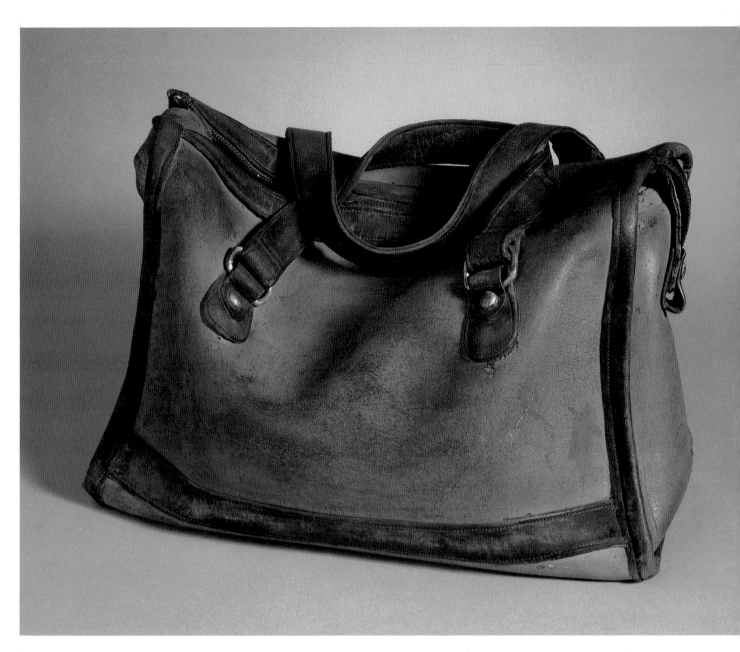

Two-Tone Bag

1974

Stoneware, slab-constructed, with nylon fiber

reinforcement, engobe, and lusters

9 x 14¹/₂ x 10 in. (22.9 x 36.8 x 25.4 cm)

Marked

M.87.1.77

GLEN LUKENS

United States, 1887–1967

Born in Cowgill, Missouri, Glen Lukens studied agriculture at Oregon State University, Corvallis. He found himself drawn to the field of art and went to study at the Art Institute of Chicago under Myrtle French. After a stint teaching ceramics to help rehabilitate World War I veterans, he moved to California and, in 1924, began teaching crafts in Fullerton. In 1936 he became professor of ceramics at the University of Southern California (USC), initiating their program within the art and architecture school. He had among his students F. Carlton Ball, Vivika Heino, and Beatrice Wood.

In 1945 Lukens moved to Haiti in order to teach ceramics. He returned to the United States in the mid-1950s to find that the ceramics world had drastically changed, with a battle raging between vessel makers and clay sculptors. He continued to mine the vessel format but also explored working with slumped and molded glass.

Lukens was known for his pioneering work with glazes and clay bodies. At the time he was working at USC, there were few source books on clay technology available (a problem also encountered by Laura Andreson at the University of California, Los Angeles). Lukens was the first to discover and expand the use of indigenous clays and glaze materials.

Like others who came twenty years later, Lukens used an intuitive and expressionistic approach in his work at USC. His instincts were correct, and they enabled him to break new ground with ease. He encouraged his students to work in the same fashion and to trust expressions based upon their feelings.

Lukens was not skilled at using the potter's wheel, preferring to shape his work with a press mold. He wanted each form to be "simplified to its essence,"[1] but he eschewed the oriental aesthetic then popular, choosing bright tones and less elegant forms. His clay was often a low-fire white body or buff-colored body with extra grog. Both offered a fine background for his brilliant colors.

Yellow Plate is made of buff clay with a bright yellow crackle glaze decorating only the bowl. The rim serves as a contrast in both hue and texture. By choosing to have the only ornamental aspects be the color and network of spiderlike cracks, Lukens revealed his respect for the primary elements of a fired vessel. Few potters have been willing to let their work rest on these straightforward and simple components.

1. Levin 1982, p. [15].

Yellow Plate
1930s
Earthenware, press-molded and glazed,
with added grog
2 x 13½ (diam.) in. (5.1 x 34.3 cm)
M.87.1.85

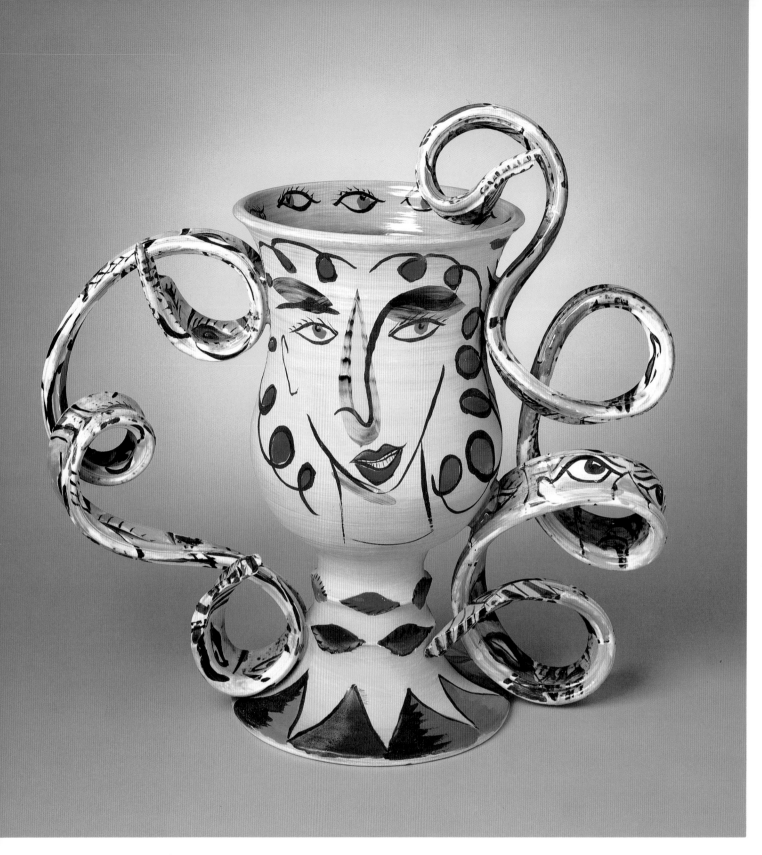

Untitled Vessel
1988
Earthenware, wheel-thrown, extruded, assembled,
and glazed
18¼ x 21 x 9½ (diam.) in. (46.4 x 53.3 x 24.1 cm)
TR.9282.4

PHILLIP MABERRY

United States, b. 1951

Active in Highland, New York

99

Born in Stamford, Texas, Phillip Maberry received his B.F.A. in 1974 from East Texas State University, Commerce. He did graduate work at Wesleyan University, Middletown, Connecticut, from 1975 to 1976 and later worked at the Brooklyn Museum of Art School and the Fabric Workshop in Philadelphia.

Maberry uses ceramics as well as fabric, paint, thrift-store finds, and assembled objects to create highly decorated interiors. Known for creating the total environment—ceilings, walls, floors, and furniture—he, according to a review of one of his designs, gives "free play to his highly personal mania for allover painting—redesigning the tiles for the kitchen and bathroom, covering the bedroom with murals and reinventing the motif for the fireplace and window."[1]

In his early ceramics work Maberry focused on slip-cast porcelain pieces with geometric or organic surface decorations. His present output quotes freely from the abstract forms used in the decorative arts of the 1950s.

In *Fish Platter* Maberry's enjoyment of and facility with color and pattern can be seen. His combination of form and tone is reflective of the stylistic freedom of the 1980s, freedom from the expected tonalities of the International Style. In *Untitled Vessel* the same liberty as well as the influence of Mexican pottery can be seen. All of this classifies him as a postmodern potter, one who combines the images and cultures of the past with a rejection of modernist restrictions to create a new, colorful, artistic synthesis. "There is inventiveness here about a way of seeing—and subversiveness about a way of designing."[2]

1. Alinovi 1982, p. 41.

2. Stephens 1981, p. 166.

Aesthetic Craze

1978

Porcelain, slab-built, with low-fire glazes,
underglaze pencils, china paint, overglaze decals,
and lusters

17 x 7 x 7 in. (43.2 x 17.8 x 17.8 cm)

M.87.1.188

L O U I S　　M A R A K

United States, b. 1942

Active in Eureka, California

Born in Shawnee, Oklahoma, Louis Marak received his associate degree in business administration from St. Gregory's Junior College, Shawnee, in 1962; his B.F.A. in ceramics from the University of Illinois, Champaign-Urbana, in 1965; and his M.F.A. in ceramics from the New York State College of Ceramics, Alfred University, in 1967. Upon graduation he took a teaching job at Keuka College, Keuka Park, New York, and continued to teach there until he moved to California in 1969 to teach at Humboldt State University, Arcata. In 1980 he was made chairman of the art department.

Marak is interested in the sculptural and painterly aspects expressed in ceramic forms. He likes to make his work "interpretation[s] of common, ordinary and mundane objects."[1] *Aesthetic Craze* is such a piece. Here he created a decorative, trompe l'oeil rendering of multicolored posts with butterflies fluttering in and out of the illusionistic space. Ribbons and bows seem to tie the poles together but cannot prevent their movement from two into three dimensions. The essentially rectangular vessel is at odds with the material, in that clay is difficult to form into crisp right angles. An interest in drawing is clearly evident.

Marak's subsequent work has become simpler in its tonal range and decoration, but he still employs trompe l'oeil effects. His technique has also changed; he now uses stoneware that is formed by press molding. To keep the clay plastic, he reinforces it with nylon fibers, a technique first used by Marilyn Levine. By forgoing the pleasant tonalities seen in *Aesthetic Craze*, he has moved from the pretty pot to the vessel as a sculptural canvas.

1. Marak 1988, p. 40.

JOHN MASON

United States, b. 1927

Active in Los Angeles

Born in Madrid, Nebraska, John Mason began his art school education at the Chouinard Art Institute, Los Angeles, in 1949. There he studied under potter and author Susan Peterson. He later attended the Otis Art Institute, also in Los Angeles, and worked with Peter Voulkos. During a brief period in 1957-58 Voulkos and Mason shared a studio in Berkeley, California.

Mason's aesthetic approach has always been his own, and his concerns have included interest in the physical properties of clay as well as in the underlying geometric structure inherent in any vessel form. His early work was vessel oriented. As part of that background he designed tableware for Franciscan China. During the late 1950s he shifted his focus and began to use clay sculpturally. Known for this work more than his vessel work, Mason has "always maintained a respect and commitment to the history of pottery and to the discipline of clay."[1] Even in his well-known sculptural/installation art piece, the *Hudson River Series* of 1977–78, Mason created large container forms out of fire brick that he placed in an architectural way.

During the 1960s he explored geometric forms through a series of monolithic X's and crosses. In addition to the structural interest he found in these forms, there was also the challenge of the technique. Firing such large pieces is difficult because of the different rates of curing and cooling.

Untitled is a smaller version of the monumental modules Mason has worked on recently. He took a slab-built vase form and placed it on an integrated base. In the process the form was twisted from its implied orientation, adding a sense of movement. The surface was decorated with geometric patterns that articulate the piece and provide a contrast with the base. This type of "pointless ornament" has led to the suggestion that he has "caved in to Post-Mod stylishness."[2] In reality, as with any good artist, he has continued to develop in ways that are both of himself and of the period.

1. McCloud 1988, p. 46.

2. Wilson 1986, p. 18.

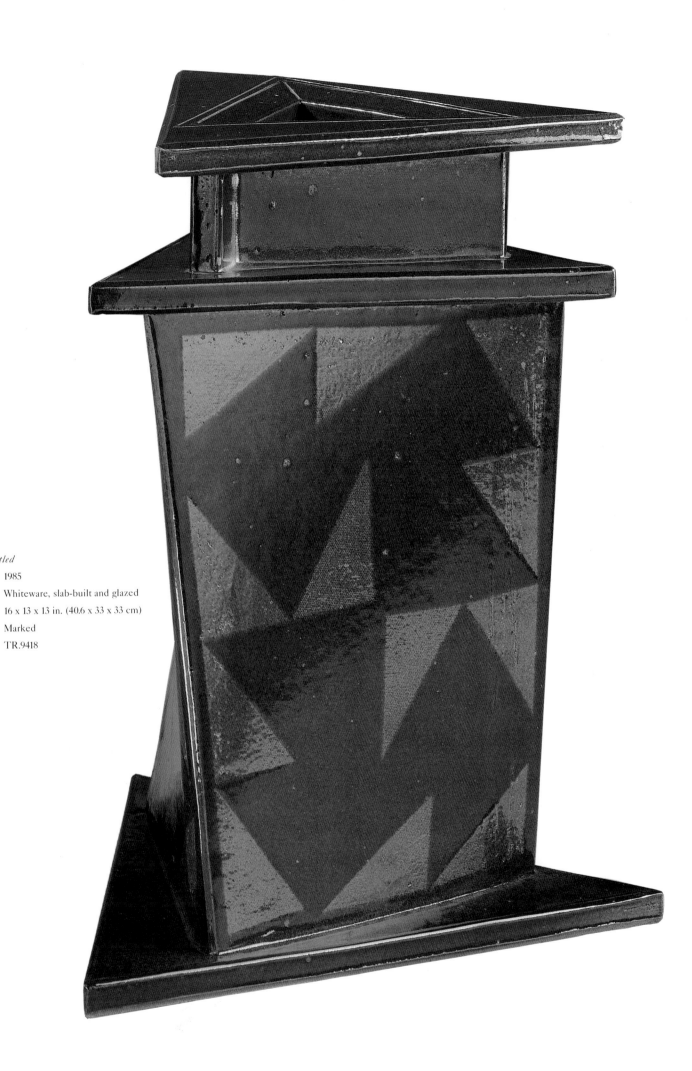

Untitled
1985
Whiteware, slab-built and glazed
16 x 13 x 13 in. (40.6 x 33 x 33 cm)
Marked
TR.9418

Le Souci de soi (The care for the self)

 1984

 Porcelain, wheel-thrown and glazed

 a. large plate: 1¼ x 13¼ (diam.) in. (3.2 x 33.7 cm)

 b. saucer: 1¼ x 8¾ (diam.) in. (3.2 x 22.2 cm)

 c. side bowl: 3 x 8 (diam.) in. (7.6 x 20.3 cm)

 d. bowl: 1¾ x 9½ (diam.) in. (4.4 x 24.1 cm)

 e. small plate: 1 x 9½ (diam.) in. (2.5 x 24.1 cm)

 f. cup: 2⅞ x 6½ x 5¼ (diam.) in.

 (7.3 x 16.5 x 13.3 cm)

 a-f combined: 7½ x 15¼ x 15 in.

 (19.1 x 38.7 x 38.1 cm)

 Marked

 TR.9282.3a-f

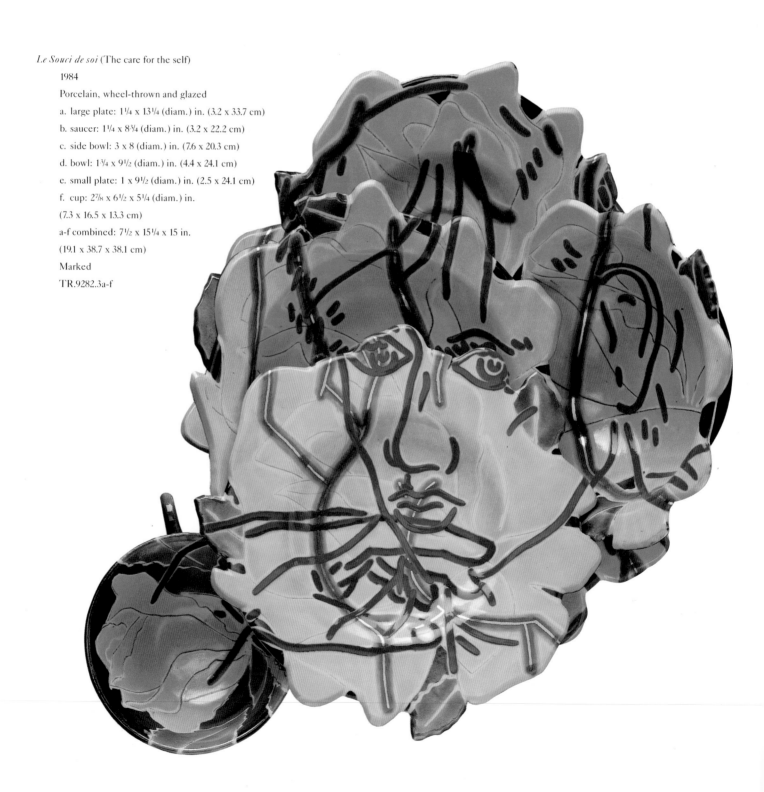

PAUL MATHIEU

Canada, b. 1954

Active in Montreal

Born in Bouchette, Quebec, Paul Mathieu started art school in 1972 at CEGEP du Vieux-Montreal, later attending the Alberta College of Art in Calgary. In 1979 he studied at North Staffordshire Polytechnic in Stoke-on-Trent, England, where he learned firsthand the English tradition of production ceramics as well as the use of color in tableware. After spending 1982 at the Banff Centre School of Fine Arts in Canada, Mathieu took his M.A. at California State University, San Francisco, under David Keroka. In 1987 he finished his M.F.A. at the University of California, Los Angeles, under Adrian Saxe. This was interspersed with teaching at CEGEP du Vieux-Montreal and the Visual Arts Centre of Montreal.

In *Le Souci de soi* (The care for the self; a chapter heading in volume 3 of Michel Foucault's *Histoire de la sexualité*[1]) Mathieu brought all of his ceramics experience to bear. The dishes, colorful and functional, could easily be production ware. These standard forms are decorated in such a way, however, that when juxtaposed in a specific arrangement an integrated image takes shape. This assembling of parts creates the content of the piece. When it is disassembled, the parts revert to familiar vessels but take on a new identity as shards.

By coupling these everyday forms with a set of personally meaningful images, Mathieu raises questions about philosophy, sexuality, and religion. The shapes perceived through this multipart yet whole stack of porcelain pieces are a face (the artist, here looking young and vulnerable), a torso (male sexuality), and a hand (that of God).[2] These drawings are rendered in yellow base color and red and black descriptive line. Through the manipulation of color Mathieu focuses the eye first on the artist and torso, letting the hand be secondary.

This combination of color, line, and form is presently the signature of Mathieu's work. He is postmodern in his layered, multifaceted sensibility and philosophical musings.

1. Falk 1985, p. 7.
2. Ibid., p. 11.

Covered Bowl

c. 1970

Stoneware, wheel-thrown and glazed

8 x 6 (diam.) in. (20.3 x 15.2 cm)

Marked

M.87.1.91a-b

HARRISON MCINTOSH

United States, b. 1914
Active in Claremont, California

Born in Vallejo, California, Harrison McIntosh attended the Art Center School in Pasadena in 1938. Two years later he enrolled at the University of Southern California, Los Angeles, where he studied under Glen Lukens. After World War II he worked in the porcelain studio of Albert King in Los Angeles and then entered the Claremont Graduate School, studying with Richard Petterson. Here he centered his attention on working with stoneware fired with cone 5 glazes.[1] For a time in 1953 McIntosh worked at the Pond Farm, Guerneville, California, with Marguerite Wildenhain, where he was exposed to the Bauhaus aesthetic. He taught the following year with Peter Voulkos at the Otis Art Institute in Los Angeles before establishing his own studio. Today he augments his studio ceramics work by designing production pieces for the Japanese firm Mikasa in both glass and ceramics.

A number of influences can be seen in McIntosh's work, among them the styles and philosophies of Wildenhain and Bernard Leach as well as the Scandinavian aesthetic as embodied in the work of Maija Grotell. These ceramists believed that success was gauged by the seamless melding of the studio potter's life-style and work. McIntosh was also encouraged in his elegant decorative style by exposure to Chinese Song porcelains and the output of the Gustavsburg Pottery.[2]

Since 1986 McIntosh has worked with a white clay body to create sculptural pieces. He often mounts these shapes on metal armatures, giving the clay and metal equal attention. These "floating" or "flying saucer" ceramics are removed in concept from his functional work but related in general form and decoration.[3] He has also developed a series of plates since the mid-1980s that make use of Japanese woodblock prints as sources for their imagery. Here the plate form becomes a canvas, uniting function and decoration.

Throughout his oeuvre there is an underlying quest for the wholeness of man, pot, and nature. As explained by Garth Clark: "The process we see evolving in McIntosh's work is the result of a monistical continuum in which the artist seeks, not so much to constantly improve, because that is a somewhat moralistic motivation, but simply to create the forms, surfaces and colours that are *appropriate* at a moment in time."[4]

McIntosh works with a small kiln in a quiet studio, wheel throwing stoneware forms that reflect the peacefulness of the surroundings. Glazes are applied by spraying in a small booth; the objects are then fired to cone 5. Decoration is either painted on or carved into the pieces when they are leather hard. All of his works in the Smits Collection are functional, related to the potter/artisan and brown pot concepts that Leach espoused. McIntosh is the clear embodiment of the clay craftsman ideal.

1. McCloud 1985, p. 24.
2. Founded in 1827 near Stockholm, the Gustavsburg Pottery was known for its factory production of utilitarian ware.
3. McCloud 1985, p. 25.
4. Clark 1979, p. 4.

Plate

1985

White earthenware, wheel-thrown and glazed

3 x 23 (diam.) in. (7.6 x 58.4 cm)

Marked

M.87.1.101

MINEO MIZUNO

Japan, b. 1944

Active in Los Angeles

Born in Gifu Prefecture, Mineo Mizuno studied ceramics at the Chouinard Art Institute, Los Angeles, from 1966 to 1968. Upon graduation he became a ceramics designer for Interpace China Corporation, Glendale, California. He stayed with them for the next ten years, establishing his own studio in 1978. In 1981 he received a National Endowment for the Arts award for his work in studio ceramics.

Much of Mizuno's output reflects his schooling at Chouinard and his years of designing at Interpace. At Chouinard he was exposed to the "fetish finish" style of the West Coast potters under Ralph Bacerra. Unlike the Northern California funk sensibility, with its disregard for craftsmanship and finished surfaces, the fetish finish ceramics artists were able to produce almost machine-perfect surfaces in handcrafted works. At Interpace, Mizuno learned about commercial glazes and efficient production. He subsequently applied this knowledge to his studio work.

Mizuno was profoundly influenced by the work of Josef Albers, painter and creator of the primary course of study for all Bauhaus students. Albers explored the illusionistic powers of color and related optical phenomena. For him the potential was within the material and to be exploited with economy; this led to the notion that each material had its own significant value and contribution to make. His guiding rules were "economy and efficiency, order and simplicity."[1] Mizuno has incorporated these concepts into his work.

In *Plate* the large, wheel-thrown form is covered in a simple, glossy, black glaze that has been sparingly painted with gestural brush strokes of complimentary pastel colors. With decoration pared to a minimum, the plate explores the notions of surface and tonal contrasts. Often Mizuno will combine a series of similar plates and install them as a wall group. In these works the individual pieces are complete within themselves and yet part of a greater whole. He also makes limited editions of functional forms for commercial use.

1. Naylor 1985, p. 156.

GERTRUD NATZLER

Austria, 1908–71

OTTO NATZLER

Austria, b. 1908
Active in Los Angeles

Born in 1908 in Vienna, Gertrud Amon studied at the Handelsakademie in 1927 and then took a job as a secretary. The same year Otto Natzler, also Viennese, graduated from the Lehranstalt für Textilindustrie and began working as a textile designer. In 1933 they met and began their lifelong collaboration. Although they studied for a brief time in 1934 with Franz Iskra, both potters were for the most part self-taught.

During the 1920s and 1930s the Vienna Werkstätte decorative style as seen in the ceramics of Dagobert Peche (1886–1923) was popular. This sentimental figurine tradition was the antithesis of the hallmark Natzler aesthetic of clear and classical forms. In fact, their work was more reminiscent of pieces by Viennese potter Robert Obseiger, who made monochromatic vessels with simple profiles.[1]

The Natzler team was a successful one, and after just three years of working together, Gertrud and Otto received a silver medal at the Paris Exposition of 1937. In 1938 the political situation in Austria forced them to immigrate to the United States, where they settled finally in Los Angeles in 1939. That year they entered and won first place in the Ceramic National in Syracuse, New York. Even with this fame they had to teach ceramics for their first few years in California until a following developed for their output.

From the beginning of their collaboration Gertrud threw while Otto glazed. This division of labor highlighted her fine throwing ability and his careful and imaginative use of glaze chemistry. Over a period of a month she produced about two hundred pots for him to glaze.[2] One of his signature coverings was the volcanic crater glaze, whose rough, pitted texture provided a visual counterpoint to the smooth forms created by Gertrud. Throughout his working life Otto has conducted more than twenty-five hundred glaze experiments, keeping copious records on each one.[3] To both artists the glaze was not just a coloring, but an integral part of the overall form and an expression of the unity of disparate elements.

The Natzlers saw their work as an expression of their philosophy of life. When asked what they were after in creating a pot, Otto would speak of their interest in the interactive effects of earth, fire, and water.[4] This became a metaphor for finding congruity in their own lives. This type of philosophizing was typical of the time when potting was seen as an activity that conferred on its practitioners a mantle of higher authenticity.

Gertrud died in 1971, and Otto stopped working except to glaze her unfinished pots. In 1974 he began to make his own vessels but, as he did not feel that he was a good thrower, made them using slab-construction methods. He continues to work in this way while also exploring new glazes.

Within the Smits Collection there are two outstanding examples of the Natzlers' work. The first is the *Pilgrim Bottle*. Based on the medieval water vessel used by pilgrims on journeys to religious shrines, this form was popularized as a purely decorative object in the nineteenth century. Typically the form is flat sided, with a short neck and

1. For a discussion of the differing Werkstätte styles see Bennett 1980, p. 12.

2. Otto Natzler, interview with author, 16 July 1987.

3. Natzler 1968, pp. 43–51, and Otto Natzler, conversation with author, 26 February 1989.

4. Natzler 1968, pp. 38–40.

swelling body (originally designed for convenient carrying against a flank or back). The Natzler version is deliberately oversized and covered with an equally large-scale crater glaze in dirty yellow brown.

The second piece is the *Red Bottle*. Thrown to perfection by Gertrud, it stands twenty-two inches high and is covered by a copper red glaze. Larger than their other, more conventionally sized pieces, it shows the Natzlers' mastery of the monumental scale.

Pilgrim Bottle
1956
Earthenware, wheel-thrown, altered, and glazed
17 x 13 x 5 in. (43.2 x 33 x 12.7 cm)
Marked
M.87.1.102

Vain Imaginings
c. 1978
White earthenware, glazed and molded, with wood
and silver-plated brass
16 x 16½ x 13½ in. (40.6 x 41.9 x 34.3 cm)
M.87.1.117a-e

RICHARD NOTKIN

United States, b. 1948

Active in Myrtle Creek, Oregon

Born in Chicago, Richard Notkin received his B.F.A. from the Kansas City Art Institute, where he studied with Ken Ferguson and Victor Babu, and his M.F.A. from the University of California, Davis, under Robert Arneson.

While at the Kansas City Art Institute, Notkin displayed a penchant for making small-scale, meticulously crafted ceramics dealing with social and political issues. After arriving in California, he joined the funk group of ceramists led by Arneson. Although the "any subject is OK for clay" attitude of this set was compatible with Notkin's ideas, the disdain with which it viewed craftsmanship in clay was not. He quickly turned from funk's casually crafted approach to his own "fetish finish" style. Often using molded and found forms to create his sculptural montages, he also avoided the more shocking funk imagery. His trompe l'oeil works asked the audience to examine its values.[1]

Skeleton Teapot and *Four Skeleton Cups* are multiples made from molds. In these pieces Notkin took his metaphor for the human mind (a skull) and depicted it as devoid of reason. In *Double-Crate Cup* the form is slip cast and features two stacked packing crates. But it is, after all, just a coffee cup. Through references to everyday objects and common ceramic forms Notkin made the most of the incongruity of content and implied function. In *Cooling Tower Teapot* he combined his historical interest in late sixteenth-century Yixing ware with social comment. The vessel is shaped like nuclear cooling towers; its lids are decorated with finials that resemble mushroom clouds. An evocative opposite—nuclear power as a source of both energy and death—is presented in the format of a traditional Chinese teapot.

Vain Imaginings is a tour de force both as a technical work and as a contemporary statement. A miniature television set rests on a "wooden" table along with a pop bottle, potted cactus, chess set, skull, and pile of books. Using the perfectly crafted surfaces and miniatures to lure the viewer, Notkin communicates his message through the symbolism of the table (representative of the world), the chess set (expressive of the risks of the world), the television and skull (mindless entertainment presented to a mindless audience), and the book titles (*The Shallow Life, Moth and Rust, Vain Imaginings,* and *By Bread Alone*). It is like a seventeenth-century Dutch still life, with layers of culturally shared images being used to communicate content.

1. Dunas 1987, p. 20.

MAGDALENE ODUNDO

Kenya, b. 1953
Active in Surrey, England

Born in Nairobi, Magdalene Odundo attended school in her homeland and in New Delhi, India. Using her early training as a commercial advertising artist, she worked in that field from 1969 to 1971 in Kenya. She then traveled to England and began studying at the Cambridge Art College, doing her course work in foundations and graphics. The next three years were spent at the West Surrey College of Art and Design. From 1976 to 1979 she taught at the Commonwealth Institute in London. In 1982 she received her M.A. at London's Royal College of Art.[1]

Charcoal Burnished Pot is typical of Odundo's work. She hand built it on a raffia-padded ring with successive coils building up the height of the vessel. Because the piece was created by this age-old method instead of being wheel thrown, a sense of the human hand was maintained (the slight modulations of the surface are the result). While hand coiling is the traditional way of pot building in Kenya, Odundo did not learn this way of making containers until she returned there for a visit during her ceramics studies.

To create a smooth surface, Odundo used the ancient technique of burnishing with small stones. Historically, this method made pots shiny and watertight. In this case it was used to give a deep sheen to the luster of the pot. The vessel, made of indigenous Surrey clay, was then fired in a reduction atmosphere until it turned rich pewter in color.

Odundo's output is both plain and elegant, with a sophisticated modulation of form made possible only through labor-intensive methods. The "innate, straightforward simplicity of form and shape . . . refers to natural containers such as gourds, nests, pitcher plants and to people and movement."[2] Her pots are ancient yet modern, refined yet natural.

1. Cooper 1986, p. 100.
2. Odundo 1984, p. 24.

Charcoal Burnished Pot

1983

Red earthenware, hand-built, burnished, and

reduction-fired

13 x 10 (diam.) in. (33 x 25.4 cm)

Marked

M.87.1.119

HENRY PIM

United Kingdom, b. 1947
Active in London

Born in Heathfield, Sussex, England, Henry Pim began his adult schooling at the Brighton College of Education, where he studied to become a teacher. After completing his courses, he spent 1969 traveling on the Continent before taking up teaching in a London primary school. While working, he took courses at Morley College and at Goldsmiths' College. In 1974 he left his job and attended the Camberwell School of Art and Crafts, receiving his B.A. in 1979. He was influenced there by the risk taking he saw in the work of Ewen Henderson and Gillian Lowndes. He presently teaches ceramics at the Sydenham Comprehensive School.

Pim has a unique technique for working with clay. When an idea for a vessel comes to him, he draws a rough sketch of it. He then proceeds to make a maquette out of paper or linoleum held together with masking tape. This allows him to adjust the form in whatever manner is needed. It is here that he works out the structural problems inherent in the piece. Slabs of clay are then rolled out and impressed with a design. The pattern is made either with a carved rolling pin or a plaster of Paris mold. The maquette is then disassembled and used as a template to cut out the parts. Dressmaking principles of connecting components are used in the final assembly. He then glazes the piece, using both commercially available glazes and a few of his own devising. Layers are built up with multiple firings, adding depth of color and subtlety.

In *Vessel* Pim has created a form grounded in the eclecticism of the postmodern aesthetic. The surface appears to be aged bronze, resembling that of an object buried in the ground for a millennium or two. The form is based on that of a Hittite vessel, and the casual swirls seem right out of early Aegean culture. The crust of layered glaze looks so much like dirt and decomposing metal that it is difficult to believe the work is not an ancient artifact. Pim's fascination with this kind of surface treatment is an embodiment of the late twentieth-century penchant for looking to the past as a way of forestalling the future.

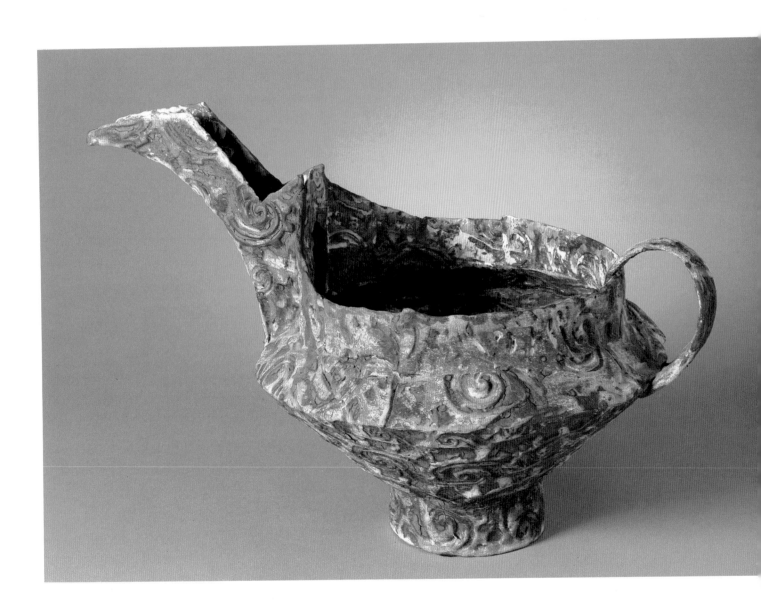

Vessel

1985

Stoneware, slab-constructed, assembled, and glazed

10 x 16 x 7 in. (25.4 x 40.6 x 17.8 cm)

Marked

M.87.1.122

ELSA RADY

United States, b. 1943
Active in Venice, California

Born in New York City, Elsa Rady studied
with Ralph Bacerra and Otto and Vivika Heino at the Chouinard Art Institute in Los
Angeles from 1962 to 1968. She developed a respect for the craft of working clay and
came to value a perfect surface finish for her pieces.

Rady's first job upon graduation was with the Interpace China Corporation of Glendale, California. The company had an arrangement with local art schools and often
offered employment to the schools' ceramics graduates. Here Rady augmented her
repertoire of glaze colors and was exposed to production finish standards. As a member
of the design team she worked on tiles and border decorations for dinnerware. An eight-
month contract stretched into a two-year job.

During these early years Rady also worked with Ron Cooper, Guy and Laddie John
Dill, and Tom Wudl. Philosophically, she found Bernard Leach to be a potent influence.
Her vessel work of the mid-1970s also showed the influence of Chinese porcelains of the
ninth-century Song period.

Rady works exclusively in porcelain. To her "porcelain is the most beautiful clay,
the most demanding, the most difficult, and the most rewarding" to work with.[1] Her
vessel forms are either open bowls or closed bottles. She enjoys pushing the functionally
linked elements of rim and foot beyond their practical limits. A final, formal element is
the glaze color. In her output she explores the interrelationship of color, shape, surface,
proportion, geometry, and movement.

In *Winged Victory* Rady went to great lengths to erase all traces of her hands. The
rim was cut in order to provide a sharp contrast with the profile and foot. A glaze color
was decided upon only after firing, then the piece was glaze fired. The same process
was followed in producing *Red Porcelain Bowl*.

While Rady has concentrated on the vessel form, she has also carried out mural commissions for Disneyland and the Jules Stein Eye Institute at the University of California,
Los Angeles. Currently she is working with her familiar vessel shapes but is presenting
them within a context established by the introduction of a base on which one or more
pieces are mounted. In this sense she is moving toward three-dimensional vessel compositions, ceramic still lifes.

1. Herman 1981, p. 101.

Winged Victory

1983

Porcelain, wheel-thrown, trimmed, and glazed

5 x 14½ x 15¼ in. (12.7 x 36.8 x 38.7 cm)

Marked

M.87.1.129

Vase

1979

Porcelain, wheel-thrown and glazed, with white

sgraffito and inlaid decoration

7¼ x 4 (diam.) in. (18.4 x 10.2 cm)

Marked

M.87.1.132

L U C I E R I E

Austria, b. 1902

Active in London

Born in Vienna, Lucie Rie, the daughter of a doctor, was raised in an environment expressive of the basic ideas of the modern movement in decorative arts and architecture. In fact, the furniture in her father's reception and surgery rooms had been designed by Eduard Wimmer, an active participant in Josef Hoffmann's secessionist circle.

From 1922 to 1926 Rie studied pottery at the Kunstgewerbeschule in Vienna under the leading ceramics artist of the Wiener Werkstätte, Michael Powolny. There she was exposed to the traditional techniques and eclectic styles of the vessel and figurative ceramics then popular. But these stylistic conventions ran counter to her aesthetic, which was drawn to the simpler forms found in the ancient and classical worlds. This may have been because of her early exposure to modern, clean-line, functional objects.

During these formative years Rie was influenced by the work of Viennese artists Leopold Bauer, Bruno Emmel, Jutta Sika, and her principal teacher, Robert Obseiger. It was perhaps through these potters, who worked both with and without decoration, that she was introduced to simple forms with monochromatic glazes.[1]

In 1937 Rie traveled to London. She found that English galleries were little interested in her elegant, thin-walled pots. Nevertheless, when political turmoil forced her to immigrate in 1938, she returned to England, remembering the gentility she had found there.[2] Unfortunately, she failed to gain the appreciation of either the studio ceramics world dominated by Bernard Leach or the art pottery movement of William Staite Murray. When showing her work to Murray, then head of the Royal College of Art, he even asked her when she was going to begin making pots.[3] Subsequently, she did win over Leach and others. During her initial period in London, however, in an effort to fit in, she abandoned her sophisticated, thin-walled style and attempted to throw "heavier" pieces. This made her work awkward, and it lost its fine nuances.

During World War II Rie was hired by Fritz Lampl, a Viennese friend, to press glass buttons for his Bimini Workshop. In 1945 she turned to designing and making ceramic buttons on her own. A year later Hans Coper, a fellow émigré, came to work with her as a studio assistant. With his help she returned to her unique style of functional pottery. By this time she was able to find an audience that appreciated her output. Sharing a studio and working together until 1958, Coper and Rie remained close friends until his death in 1981.

As her work developed, Rie looked to the ancient antecedents of Cretan, Cycladic, and Mycenaen pottery for inspiration.[4] Not a theoretician and never the propagandist and publicist Leach was, she developed her own style and kept a low profile. She worked with wheel-thrown, elegantly proportioned, classical forms that she articulated in a graphic and sometimes painterly manner. She also designed for industry, offering her simple yet satisfying forms for mass production needs. Rie stayed within the confines of the vessel tradition, working principally with stoneware and porcelain. Most of her work was limited in color (only recently has bright color entered her oeuvre), glazed raw, and fired once in an electric kiln.

Speckled White Footed Bowl is reminiscent of Chinese Ding ware of the eighth to the thirteenth centuries. The brown rim mimics the metal band Chinese potters of the period used to add decoration and structural strength and to aid in firing. Note that the whiteness of the porcelain is achieved through glaze and not the body itself. In *Tall Vase* Rie uses an unusual technique of throwing two clay colors together, resulting in a chocolate, swirl-like pattern. In *Footed Bowl* (1970s), *Vase*, and *Bowl* she employs her signature sgraffito decoration, which imparts to her work a decorative pattern not unlike the texture of fabric. The form of the vase is classical in feeling, and its blue collar shows Rie's interest in color. The concern with textural glazes is seen in the *Crater Bowl*, where the glaze is Natzler-like. The Natzlers used glazes to contrast with forms, however; Rie intended the glaze to harmonize with the form.

Throughout her career Rie has succeeded in transforming the simple, monochromatic pot into a refined container that brings together the best of modern and traditional pot aesthetics.

1. Bennett 1980, p. 12.
2. Houston 1981, p. 16.
3. Ibid., p. 17.
4. Ibid., p. 19.

Lucie Rie

Speckled White Footed Bowl

c. 1979

MARY ROGERS

United Kingdom, b. 1929

Active in Leicestershire, England

Born in Derbyshire, England, Mary Rogers first trained as a lettering artist and illustrator. In 1960 she set up her own ceramics studio and concentrated on making hand-built vessels. Hand building with clay is one of the oldest ways of producing vessels, predating the invention of the potter's wheel. Rogers learned all the traditional techniques involved with this method, including pinching, coiling, and modeling. After eight years of hand building earthenware and stoneware objects, she added porcelain to her repertoire, lured by its translucency.

Rogers's vessels are colored with mat or semimat glazes, then fired in an oxidizing atmosphere. She unites a direct hand/clay relationship with interest in the garden and the natural world. By making drawings of vegetation, she establishes a vocabulary of forms that later show up in her vessels. Expressive of the plain pot sensibility, her works have the simplicity, integrity, and dignity espoused by Bernard Leach.

Rogers employed natural shapes and a pinch-forming technique in *Footed Bowl* and *Kiwi Bowl*. To pinch build each, she started with a lump of clay placed in her hand; with her thumb she worked the clay out and up to create the vessel. Oxides, incorporated into the clay body before shaping, provide decoration. *Moulded Petal Bowl* is based on a dried marrow form. A sheet of porcelain folded up onto itself composes the container. Tools were used only at the end of the process for trimming the foot. The irregularities seen in the rims and curves of these three pieces are the result of natural imperfections inherent in the hand-building method. It is from this intimate record of the personal contact with clay that the pieces derive their charm.

In *Double-Form Vase* Rogers used stoneware to make a pinch- and coil-formed piece. The rim was articulated and glazed for added emphasis. The impurities within the clay body came to the surface during firing and enliven the overall object. It is interesting to note that even though none of her works were made on the wheel, they still retain the centered orientation that this method implies.

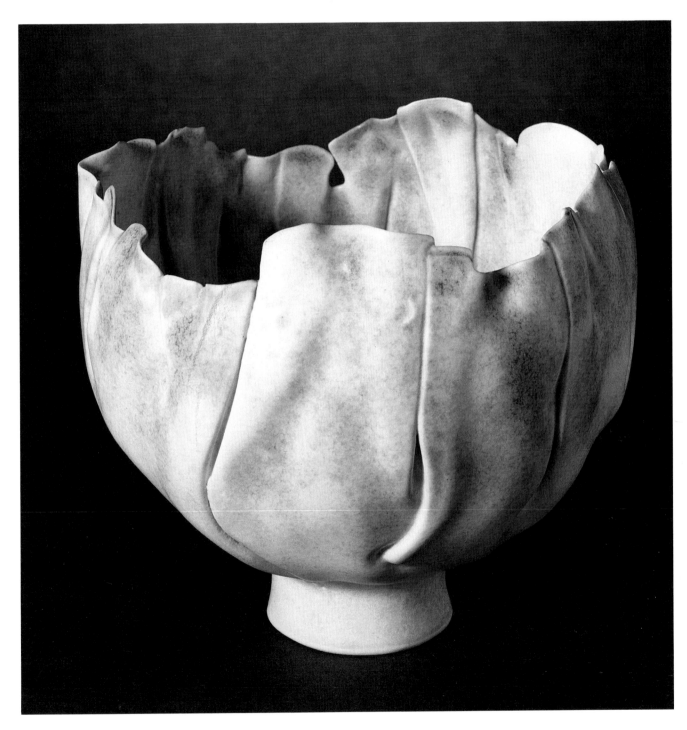

Moulded Petal Bowl
1984
Porcelain, pinch-built, oxidized-fired, and glazed
4 x 5 (diam.) in. (10.2 x 12.7 cm)
Marked
M.87.1.139

JERRY ROTHMAN

United States, b. 1933

Active in Laguna Beach, California

Born in Brooklyn, Jerry Rothman studied at Los Angeles City College from 1953 to 1955, intending to become a cabinetmaker. Instead, he found himself drawn to art and transferred to the Art Center School, receiving his B.A. in 1956. The following year he had his first show, at the Ferus Gallery in Los Angeles. There he presented his constructivist sculptures alongside the work of fellow students John Mason and Paul Soldner. He next attended the Otis Art Institute in Los Angeles, under Peter Voulkos, and, after a year working in Japan, received his M.F.A. in 1961.

Throughout his career Rothman has worked intermittently with both vessel and sculptural forms. He has been characterized as a maverick in both arenas, not dependent upon trends to inform his art. To him there is no limitation to what can be accomplished in any given material; the limits come only from the artist's imagination.[1]

Parallel to his artistic activities, Rothman has maintained the practice of working with ceramics for industry. He has invented several new clay bodies and developed a technique to cantilever ceramic forms on high-fire metal armatures. He uses this technique in his sculptures. He has also invented a nonshrinking clay that facilitates the making of large-scale works. His interactive range of clay expertise demonstrates the value of empirical knowledge in ceramics.

Rothman's vessel oeuvre has seen two distinct periods. The first was in the late 1950s, when he was involved with the Otis group under Peter Voulkos. This was the time of his Sky Pot series. Through expressive renting of the clay and the addition of biomorphic shapes executed in subtle tones, he successfully made the vessel into a sculptural vehicle.

In the late 1970s Rothman made another foray into the vessel field with the showing of his Bauhaus-Baroque soup tureens at the Vanguard Gallery in Los Angeles. Here he explored the tension inherent in combining the classical, cool Bauhaus style, long touted as the only true "good taste" design, with the sensual, excessive postmodern style. This penchant for debunking accepted attitudes is typical of his work and makes him the embodiment of the artist as commentator. He symbolizes the transition from the expressive pot era to that of the content pot. Currently, he has suspended his work in clay although it seems likely that he will, as before, return to the medium.

Sky Pot has an upright form and clearly defined back and front. The piece was casually crafted, reflecting the period in which it was made. The surface decoration is also suggestive rather than specific in its content. Rothman used a technique in which pigments surface after firing through the top layer of clay to create shapes of muted color. Here, while contained in a functionally related format, is a piece that blurs the distinction between vessel and sculpture.

1. Jerry Rothman, interview with author, 21 August 1987.

Sky Pot
1961
Stoneware, hand-built and glazed
20 x 13 x 6 in. (50.8 x 33 x 15.2 cm)
M.87.1.142

JUDITH SALOMON

United States, b. 1952
Active in Cleveland

Born in Providence, Judith Salomon studied
at the Penland School of Crafts, North Carolina, from 1974 to 1975. She earned her B.F.A.
from the School for American Craftsmen, Rochester Institute of Technology, New York,
in 1975. In 1977 she received her M.F.A. from the New York State College of Ceramics
at Alfred University. She is presently an associate professor of ceramics at the Cleveland
Institute of Art.

Salomon works in a constructivist manner. While all pots on a basic level deal with
construction, not all take that as their subject matter. In her output large forms are put
together in a geometric and colorful manner. She is articulate about her work and says
about her pot making: "I enjoy the process, the construction, the connection to clay,
the material and the idea of presentation—setting tables and eating food. The larger
constructions that I make now are more complex—all about inside and outside and the
sense of volume—but they still go back to the original intent—pottery and the vessel. I
think the visual influences are Russian Constructivism, Art Deco, all sorts of architec-
ture, folk art and how objects sit next to each other, i.e., an apple next to an orange—
that's where the ideas come from."[1]

In *Mat Green Vessel Box* many of these aspects can be seen. The use of color as a
structural element is constructivist and architectonic. Her tones are muted and involve
sophisticated harmonies and dissonances, adding liveliness to the cerebral style of the
piece. Salomon's current work continues in this vein, with increased interest in the role
of color in both melding and breaking up planes.

1. Judith Salomon, letter to author,
21 November 1987.

Mat Green Vessel Box

1986

Low-fire whiteware, slab-constructed and glazed

11¼ x 22 x 10¾ in. (28.6 x 55.9 x 27.3 cm)

M.87.1.143

ADRIAN SAXE

United States, b. 1943
Active in Los Angeles

Born in Glendale, California, Adrian Saxe attended the Chouinard Art Institute from 1965 to 1969. There he studied under Ralph Bacerra and learned the craft of pot making. In 1974 he completed his B.F.A. at the California Institute of the Arts, Valencia. Since 1973 he has taught at the University of California, Los Angeles, where he is now an associate professor of design.

Although drawn at first to the sculptural potential of clay, Saxe became intrigued with the possibilities found within the vessel form. He chose porcelain as his main medium early in his career. It is notoriously difficult to work, with its unforgiving whiteness and limited plasticity, but the challenge is balanced by the inherent beauty of the material. For Saxe porcelain had the added attraction of being a culturally loaded medium. Made in China since the seventh century, it was not produced in Europe until the early eighteenth century. Whether imported from the East or made in Europe, porcelain objects in the West were used as gold and silver vessels had been, for display. Although the pieces were based on functional forms, their use was primarily as status symbols.

In 1983 Saxe was the first artist selected by the French government to work at the Manufacture de Sèvres in Paris. This opportunity was a great boon for him due to his interest, both historical and philosophical, in the French porcelains of the mid-eighteenth century. Intrigued by their technical wizardry, the nascent interrelationships of production and craft concerns of the period, and the issues of patronage and status as conferred by objects, he was in his element. As part of this experience he was allowed to use and copy original Sèvres factory molds for his own work.

In the 1980s his pieces have become increasingly intellectual, a trait not admired by all.[1] Content is communicated through seductive surfaces and the witty juxtaposition of elements. By widening the range of topics addressed by clay, Saxe is expanding upon what Robert Arneson began.

Small Globular Vase is an early piece that illustrates his ongoing investigation into glaze chemistry. The pot's decoration is poured on in a random way and played off against the highly unusual mat copper glaze (which normally is fired to red, not pink). *Squash Teapot* illustrates the additive, assembled technique often used by Saxe. A mold was made of a real squash, to which was added an oriental vase stand. The entire form was then slip cast and the lid cut out. Next, the handle and finial were press molded and attached. Finally, Saxe selected a spout from his stock of cast pieces and attached it. The whole form was then glazed. This use of both nature-related and previously designed forms is typical of his current work.

The *Cup and Raku Base* is a study in contrast. The golden cup appears usable but is rendered useless by its serrated rim.[2] This "cup and saucer," with its opposite mediums and implied/denied functionality, is suitable only for display. In *Antelope Jar* Saxe again juxtaposed mediums. A raku base supports a form inspired by a Buddhist temple bell—a form that wears a delicate antelope finial on its lid. This pot, trophy, or funerary urn is typical of his "sincerely insincere" works.[3] Both objects "are and are not what they seem . . . are period pieces from a period—ours—of multiple fractures."[4]

1. Forde 1983, p. 65.
2. Perrone 1987, pp. 5–7.
3. Schjeldahl 1987, p. 15.
4. Ibid., p. 13.

Antelope Jar

1985

Porcelain, wheel-thrown, glazed, gilded,

and press-molded, with raku base

23 x 11¾ x 10 in. (58.4 x 29.8 x 25.4 cm)

Marked

TR.9301a-c

Bowl with Cross Opening
 1980s
 Stoneware, hand-built and glazed
 5$\frac{1}{2}$ x 10 x 10 in. (14 x 25.4 x 25.4 cm)
 Marked
 M.87.1.146

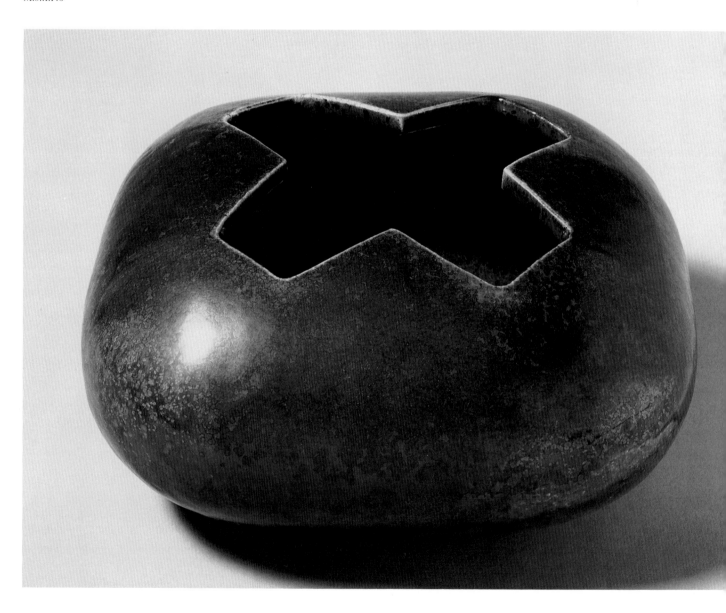

DAVID SHANER

United States, b. 1934
Active in Bigfork, Montana

Born in Pottstown, Pennsylvania, David Shaner earned a B.A. in art education from Pennsylvania State University. In 1959 he received his M.F.A. from the New York State College of Ceramics, Alfred University. While there he worked with fellow students Ken Ferguson, Daniel Rhodes, and Robert Turner. Their output as well as Native American pottery and the sculptures of Isamu Noguchi and Constantin Brancusi were influential during his formative years.

From 1959 to 1963 Shaner was assistant professor of art at the University of Illinois, Champaign-Urbana. He then became resident potter and director of the Archie Bray Foundation, Helena, Montana, in 1963, remaining there until 1970.[1] Since that time he has maintained a studio at Bigfork, Montana, where he makes functional and semifunctional pots.

Bowl with Cross Opening is an example of Shaner's skill in making "sturdy reductivist forms."[2] The work is grounded in function but has moved beyond this to become almost sculptural. He used a neutral, mat-blue glaze to accentuate the contrast between the swelling outline and the angular, cross-cut opening. The exploration of interior versus exterior space is clear.

Shaner's work is expressive of the functionally based brown pot aesthetic that characterized ceramics at midcentury. Like many others who began in that tradition, however, he has expanded his technique and changed his style and now, through his pieces, conducts philosophical discussions about the essence of pots.

1. See introduction and Rudy Autio entry, note 1, for more information on the Archie Bray Foundation.
2. Clark 1987, p. 298.

A L E V S I E S B Y E

Turkey, b. 1938
Active in Copenhagen and Paris

Born in 1938 in Istanbul, Alev Siesbye began her art education by studying sculpture at the Academy of Fine Arts in Istanbul from 1956 to 1958. After working as a production potter for Höhr-Grenzhausen, Westerwald, West Germany, she served as an artist for Royal Copenhagen from 1963 to 1968. In 1975 she joined Rosenthal in Selb, West Germany, as a free-lance designer, staying there until 1984. Since then she has done her own studio work as well as free-lance projects for Royal Copenhagen.

Often employing the oldest technique used by vessel potters, the hand-coiling method, Siesbye creates pieces that explore the idea of enclosed space, with a "refined, tense form and dramatic organisation of surface color and decoration."[1] Working within the vessel tradition (and within that sector that prizes simple, clean forms), she combines the elegance of Danish design with the bright colors of Turkey.

Large Platter and *Turquoise Bowl* represent Siesbye's studio production work. In both pieces she uses one of her favorite decorative techniques: allowing a band of unglazed clay to define and articulate the rim. This functions like a piece of string on a package, here visually, if not actually, holding everything together. This also conveys a sense of fragility, for it seems that if the "string" were to come off, the form would swell and break apart. Her successful creation of tension between form and surface is often compared to effects achieved by Lucie Rie.[2]

In *Black-and-White Bowl* an equally restrained form is presented, but the surface is embellished with stylized cloud motifs that blend Moorish carpet design with contemporary graphics. Through careful modulation of the intensity of the black-and-white glaze, a distinct, but not sharp, contrast is created. This vessel contains subtlety and sophistication, all within the framework of a classic ceramic vessel. These qualities are the hallmarks of the Siesbye style.

1. Clark 1984, p. [7].
2. Ibid.

Large Platter

1983

Stoneware, hand-coiled and oxidized-fired

5³⁄₄ x 21 (diam.) in. (14.6 x 53.3 cm)

Marked

M.87.1.152

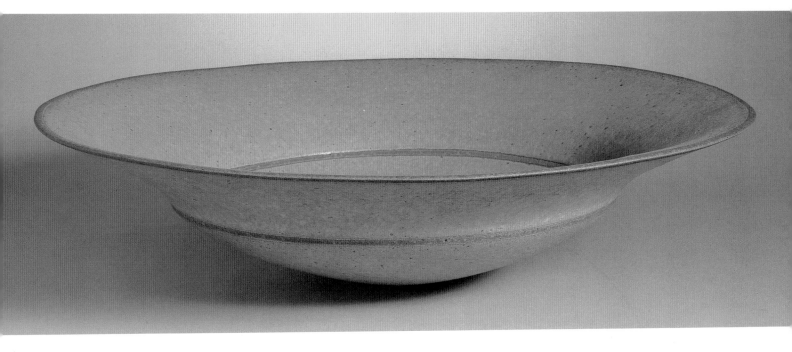

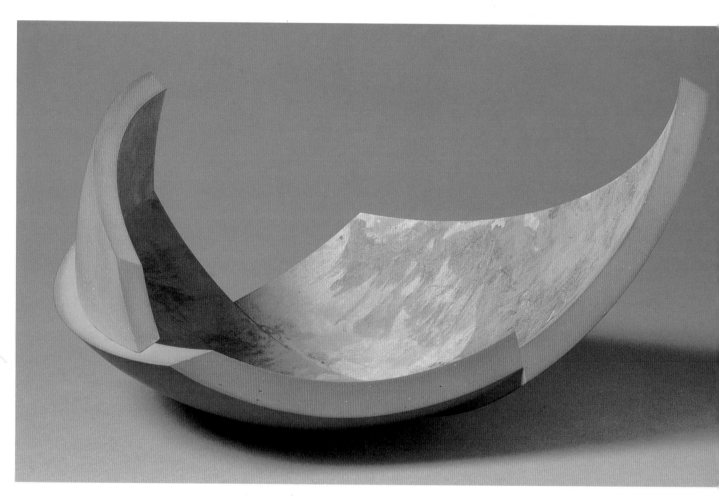

Bowl

c. 1979

Red earthenware, glazed, with epoxy

6⅛ x 13 x 9⅛ in. (15.6 x 33 x 23.2 cm)

M.87.1.157

MARTIN SMITH

United Kingdom, b. 1950

Active in London

Born in England, Martin Smith attended the Ipswich School of Art from 1970 to 1971 before starting at Bristol Polytechnic, where he studied until 1974. The following year he entered the Royal College of Art (RCA), London, receiving his M.A. in 1977. Like Alison Britton and Jacqueline Poncelet, fellow potters at the RCA, Smith put aside the still popular brown pot idea of Bernard Leach and began examining the sculptural qualities of clay vessels.

After a number of years spent working with both wheel- and slab-construction methods, Smith adopted a new technique. Employing styrofoam maquettes, he created plaster molds of vessel parts that he then cast and assembled. Switching from raku to red earthenware because of its lack of "preciousness" as a medium,[1] he approached the forming of vessels in an architectural manner. This was accentuated by his use of a diamond saw, which allowed him to carve the ceramic components with an antiseptic cut, creating both a graphic and dimensional edge.

Smith's "slice-and-reassemble" technique[2] recalls the experience of moving rapidly along a picket fence, with the eye seeing fragmented images that the brain orders into a comprehensible whole. He gives viewers abstracted geometric fragments from which they can visually complete a vessel.

In *Bowl* the essence of the shape is presented in slices, really "forms around a vessel."[3] In this case the piece has a feeling of both form and implied form; that which surrounds and that which is surrounded. In *Two Angular Forms* the pieces are juxtaposed to create a whole object. The work seems like a maquette for a larger sculptural form, with its powerful geometric interplay. Once again parts represent the whole.

Smith is an intellectual's ceramist, less interested in the tactile and intimate qualities often glorified by potters and far more comfortable with using the medium to ask questions about the perception of forms. His aesthetic of assembled constructs is actively postmodern.

1. Smith 1987, p. 16.

2. Harrod 1987b, p. 53.

3. *Forms Around a Vessel* was the title of a 1981 exhibition of Smith's works organized by the Leeds Art Galleries, Leeds, England.

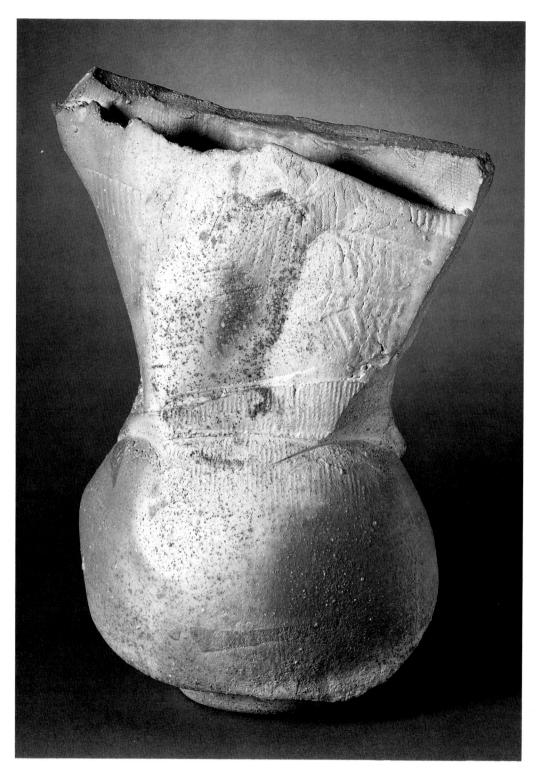

Wasp-Waist Form

1982

Earthenware, wheel-thrown, hand-built, impressed,

and raku-fired

15½ x 12 x 8 in. (39.4 x 30.5 x 20.3 cm)

Marked

M.87.1.158

PAUL SOLDNER

United States, b. 1921

Active in Claremont, California, and Aspen, Colorado

Born in Summerfield, Illinois, Paul Soldner attended Ohio's Bluffton College, receiving his B.A. in 1946. He then took his M.A. from the University of Colorado, Boulder, where he was introduced to clay by Katie Horseman, head of the ceramics department at the Edinburgh College of Art, Scotland. This experience more than piqued his interest: he ended up graduating with an M.F.A. in ceramics from the Otis Art Institute in Los Angeles in 1956. Since 1968 he has been professor of art and head of the ceramics department at Scripps College, Claremont, California, where he has influenced several generations of students. He spends half the year in Aspen, Colorado, running his studio and ceramics supply house.

At Otis, Soldner was the first graduate student to work with the newly hired Peter Voulkos. As the school year started, they furnished the studio by designing and building the kiln and other necessities. That year Soldner was joined by fellow students Billy Al Bengston, Michael Frimkess, John Mason, Kenneth Price, and Jerry Rothman. Soldner, like Voulkos and other potters of the period, knew all the skills necessary for making utilitarian ceramics but chose to explore process as captured in clay. Soon functionality became secondary.

Soldner became intrigued by both the process and results of the Japanese technique called raku. This working method and philosophy, first used by the Raku family of sixteenth-century Japan, valued chance occurrence in low-fired, rapidly cooled clay and was informed by the Zen interest in the spiritual expressed in daily actions. After reading Bernard Leach's *A Potter's Book*, Soldner decided to try building and firing his own kiln in the raku style. Through trial and error he learned how to work with this approach.

Over time Soldner developed his own techniques, tools, and rituals, thereby creating American raku. Largely as the result of his interest in the technique, American raku (a quick firing at a low temperature followed by a fast reduction in an enclosed container or in a combustible material such as sawdust or newspaper) became a popular method for making ceramics. Although he thought he was using the authentic Japanese raku method, it was revealed to him on a trip to Japan in the 1970s that he had been working in a technique wholly of his own devising.[1]

In addition to raku Soldner has also worked with low-fire salt glaze. He is currently making larger, black forms that emphasize his understanding of clay's sculptural potential.

Wasp-Waist Form is from a period when Soldner was working with sandy, pink, salt-glazed clay. The piece was formed by wheel throwing a base on which the rest was hand built. The surface was then randomly impressed with various objects. The resulting texture, coupled with the mottled effect achieved through the firing, gives the surface a feeling of timelessness.

Soldner emerged in the 1960s as one of the innovators of the sculptural expressive pot and has maintained his position as a creative artist and teacher.

1. Dunham 1982, p. 24.

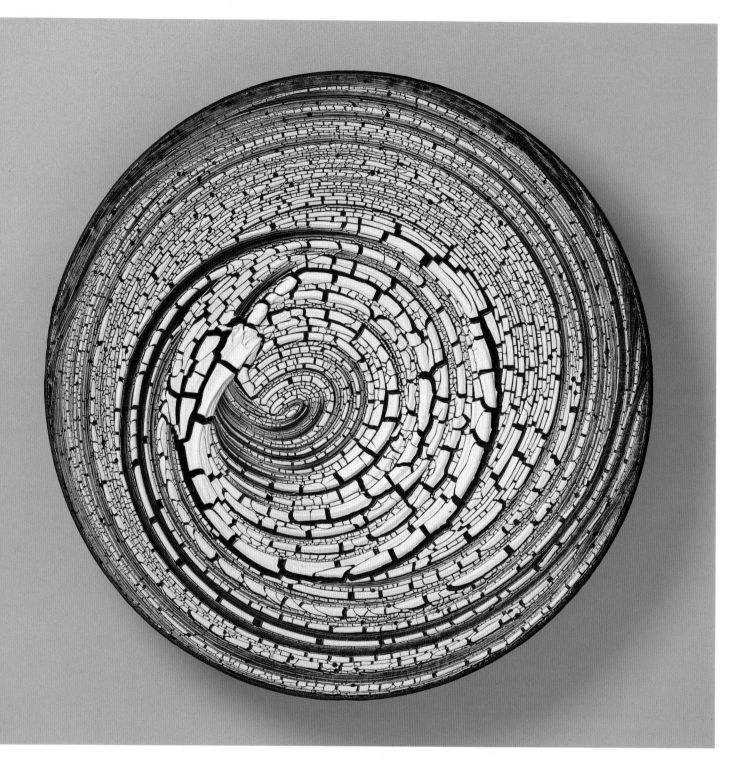

Plate

1986

Stoneware, wheel-thrown, with white slip

3¾ x 27½ (diam.) in. (9.5 x 69.9 cm)

Marked

TR.9282.7

ROBERT SPERRY

United States, b. 1927
Active in Seattle

Born in Bushnell, Illinois, Robert Sperry grew up in Druid, Saskatchewan. In 1945 he had his first art lesson, while in the U.S. Army in Germany, and although he then started painting, he soon was drawn to clay. In 1950 he received a B.A. from the University of Saskatchewan and in 1953, a B.F.A. from the Art Institute of Chicago, where he studied under Briggs Dyer. The year 1954 was a seminal one for him, for he met Peter Voulkos and Rudy Autio at the Archie Bray Foundation in Helena, Montana, and was greatly influenced by their work. Moving to Seattle later that year, he completed an M.F.A. at the University of Washington. Upon graduation in 1955 he was hired by the university to teach ceramics.

As part of the abstract expressionist generation affected by the powerful mix of clay, process, and Asian traditions, Sperry has always focused on "the pot."[1] Attracted by the performance and risks of the creation of clay works, his mature pieces combine a startling number of interests and influences.

During his early period Sperry was affected by the Scandinavian aesthetic. Vessels were wheel thrown and elegantly decorated. In the 1950s his work was abstract expressionist in content and execution. After receiving a Louis Comfort Tiffany Foundation grant in 1957, he began to explore salt glazes. In the 1960s he turned from clay work and began to explore film, traveling to Japan and combining his two interests by making a movie about ceramics. By the end of the decade he began to make functional pottery to supplement his income.

The year 1970 marked the end of his first phase. After a brief flirtation with funk he began to explore the effects of crackle and crawl glazes. Beginning with forms that were covered with a thick glaze, this interest progressed into a technique of applying slip over glaze to create monumental cracks and fissures. Moving away from the metallic lusters that had occupied him during the early 1970s, he came to work with black and white as his palette. While on a trip to Italy in 1984 he saw an exhibition by the Italian painter Alberto Burri. Burri's gutsy use of paint and burlap paralleled Sperry's interest in textured surfaces. Sperry was also impressed by the scale of Burri's work and incorporated this into his output.

Plate is an example of Sperry's latest style. Here the surface is worked like a canvas, with wide bands of slip overglaze that crack and allow the contrasting black underglaze to appear. The slip trail makes a pattern that records the process. By accentuating the scale of glaze versus the flat form, a pleasing crudity is achieved. The plate both denies and affirms the surface as canvas and is a statement of abstract expressionism in clay.

1. Harrington 1985, p. 4.

Bowl

1951

Stoneware, wheel-thrown, altered, glazed, and fired

5 x 9½ x 8½ in. (12.7 x 24.1 x 21.6 cm)

Marked

M.87.1.161

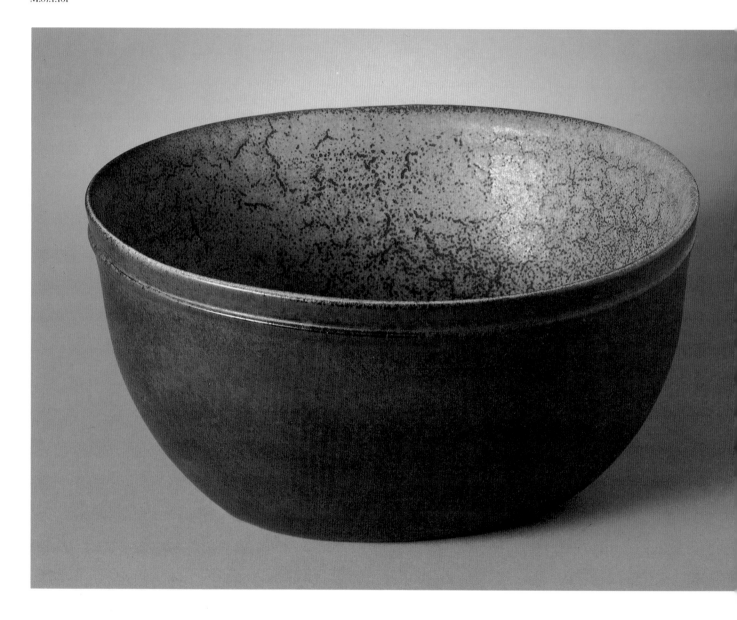

R U D O L F S T A F F E L

United States, b. 1911
Active in Philadelphia

Born in San Antonio, Rudolf Staffel was first drawn to painting, studying with Hans Hofmann and José Arpa in New York and Louis Ripman and Laura Van Papelladam in Illinois (at the Art Institute of Chicago from 1932 to 1936). Inspired by the passage of light through such materials as wax and watercolors, he turned to glass and eventually ceramics, figuring he "could be a painter and a potter or rather be a painter who was a potter or eventually be a potter who was a painter and then eventually be a potter."[1] During this early period one of his most important influences was Paul Cox, who ran a production pottery in New Orleans. It was from Cox that Staffel received his knowledge of and appreciation for ceramics history. In 1940 Staffel joined the Tyler School of Art at Temple University in Philadelphia, teaching there until his retirement in 1978.

Developing a background in painting and both one-off and production ceramics, Staffel did not enter his most innovative period until the 1950s. It was then that he began exploring the inherent light-transmitting qualities of porcelain. While using this type of clay body, he made a radical turn from generally symmetrical wheel-thrown forms to asymmetrical forms with intricate rhythms and a dynamic interplay of surface and volume. Referred to as "light-gatherers,"[2] these vessel shapes explored the painting notion of chiaroscuro and the ceramics concern for contained space while testing the technical possibilities of the medium.

Bowl predates Staffel's light-gatherer phase, falling into his stoneware period. The nuances seen in this piece, however, perhaps hint at his future interest. The pot is mat gray black on the outside and gray blue on the inside. The glaze on the interior has crawled, creating a slightly mottled, skinlike texture. The rim has been articulated, and the form altered from its wheel-thrown beginnings into an ovoid. Overall, form and surface are combined in a sophisticated relationship that quietly takes the object beyond the simple vessel level.

1. Staffel 1977, p. 26.
2. Sozanski 1985, p. 5D.

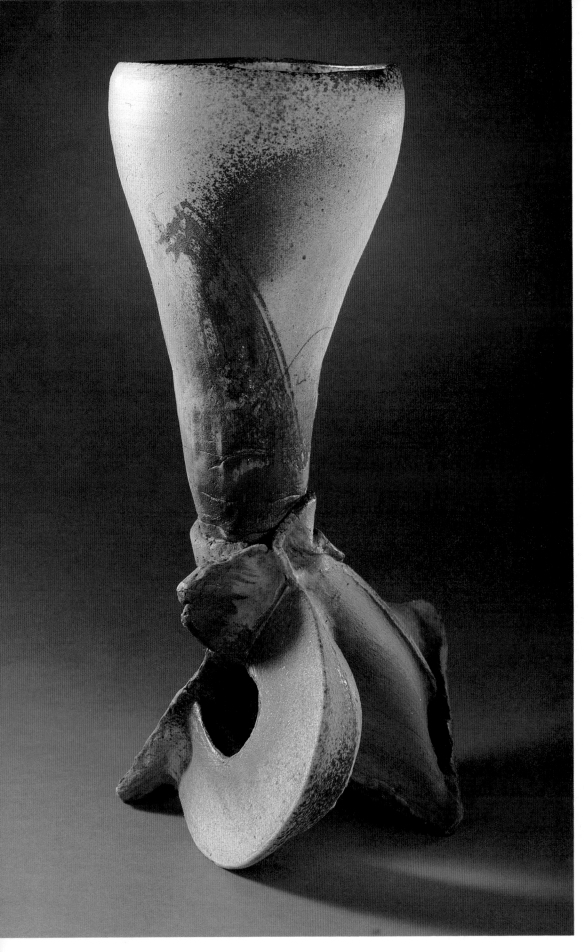

Extruded Foot Vessel

1982

Terra-cotta, wheel-thrown, altered, and glazed,

with extruded clay

17³/₄ x 13¹/₂ x 10¹/₂ in. (45.1 x 34.3 x 26.7 cm)

M.87.1.162

SUSANNE STEPHENSON

United States, b. 1935
Active in Ann Arbor, Michigan

Born in Canton, Ohio, Susanne Stephenson studied painting and ceramics at Carnegie-Mellon University in Pittsburgh, receiving her B.F.A. in 1957. During her years there she was influenced by Wesley Mills and Ken Ferguson, the latter helping her master the potter's wheel. After taking a year off to teach junior high school, she resumed her study of ceramics, this time at the Cranbrook Academy in Bloomfield Hills, Michigan. There Maija Grotell became her mentor. For her thesis Stephenson explored the possibilities of inlaid and colored clay. Upon graduation in 1959 she took a teaching job at the University of Michigan, Ann Arbor, met and married fellow ceramist John Stephenson, and spent the next year in Japan with him studying glazes and the Japanese approach to working clay.

After returning to the United States, Stephenson began teaching at East Michigan State, Ypsilanti. In 1973 she spent her sabbatical in Spain investigating Hispano-Moresque lusters. During this trip she was impressed with the colors used by Antoni Gaudí in his Güell Park walls.[1] In 1977 she and her husband purchased a clay extruder. This moved her toward unifying vessel and sculptural ideas, and she began combining wheel-thrown and extruded forms. The result was a dynamic play of contrasts. Her next breakthrough was the shift from porcelain to low-fire terra-cotta. This allowed her to work on a larger scale. Her palette also changed. She began using clay slips in "stronger colors . . . [that] could practically be sculpted onto her thrown bottles, vases or platters."[2]

In *Extruded Foot Vessel* a successful integration of these elements can be seen. Both sections, the wheel-thrown vessel and the extruded foot, were "made in groups of parts—bases first—and combined after study."[3] Glaze was applied in several layers, enhancing the joined forms rather than defining them. The concept of presenting vessel and base as equal components marks a progression within Stephenson's career of vessel making. Her choice of muted and nature-based colors deepens the sense of organic rightness in these combined objects.

1. Slowinski 1988, p. 5.
2. Ibid., p. 7.
3. Koplos 1982, p. 16.

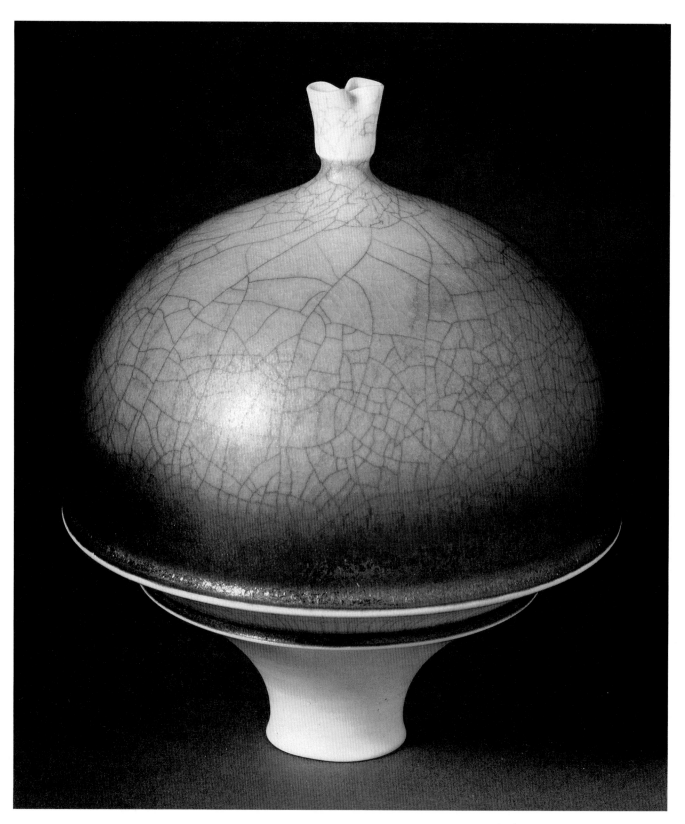

Porcelain Form

1982

Porcelain, wheel-thrown and glazed,

with enamel and luster

4½ x 4 (diam.) in. (11.4 x 10.2 cm)

Marked

M.87.1.163

GEOFFREY SWINDELL

United Kingdom, b. 1945

Active in Cardiff, Wales

Born in 1945 in Stoke-on-Trent, England, Geoffrey Swindell came from a family long connected with the pottery business. His initial education, however, was in painting, at Stoke-on-Trent College from 1960 to 1967. He then took up ceramics and studied under Hans Coper at the Royal College of Art in London from 1967 to 1970.

During his school years Swindell experimented with making "a lot of totally unsuccessful big pots."[1] In his pieces from 1970 to 1976 he turned to smaller press-molded and assembled forms. Subsequently, his work became exclusively wheel thrown. He has always taken his inspiration from organic sources, from "soft forms akin to the weathered shells and other objects picked up on the beach."[2] His main interest is in the relationship of form and surface. Working just in porcelain, as it is perfect for his meticulously thrown, trimmed, and detailed pieces, he creates sculptural shapes that have only passing references to utility. Not feeling the need to create his own glazes, as some potters do, he finds enough expressive qualities in commercially available products. He strives to unify the glaze with the dynamics of form.

The four Swindell objects in the Smits Collection are typical of his output from the early 1980s. The pieces, with their mushroomlike profiles and moonlike surfaces, would be menacing were it not for their small scale and resultant whimsical appearance. When placed together, they tweak the viewer into thinking that a nest of little, friendly, interplanetary beings of unknown proclivities has been discovered.

1. Elliott 1981, p. 72.
2. Ibid., p. 76.

AKIO TAKAMORI

Japan, b. 1950

Active in Helena, Montana

Born in Nobeoka, Miyazaki, Japan, Akio Takamori attended Tokyo's Musashino Art College from 1969 to 1971. He then was apprenticed to the master folk potter at the production workshop in Fukuoka. To continue his education, he came to the United States and studied under Ken Ferguson at the Kansas City Art Institute, receiving his B.F.A. in 1976. He proceeded to the New York State College of Ceramics at Alfred University, completing an M.F.A. in 1978. While attending Kansas and Alfred, he worked with nonfunctional, sculptural shapes, only later returning to the combination of vessel and human body forms that are his hallmark.

While growing up in Japan, Takamori was influenced by Ukiyo-e woodblocks as well as the paintings of Picasso and Brueghel, reproductions of which he found by chance in books in his father's library. His father was a doctor who ran a venereal disease clinic, and Takamori became aware of human sexuality at an early age.[1] This led him to express in his work the duality of dark (pain) and light (pleasure) within one phenomenon (sexuality). He also used this as a metaphor for other of life's dualities.

Another influence was *mukōzuke* ware, exported from China to Japan for use in the tea ceremony. These dishes incorporated silhouettes of animals, with spontaneous drawings in cobalt blue.[2] Also important were the ancient cave paintings found in Spain and France, where myth and ritual, ancient and contemporary man, were linked. To these traditions he added twentieth-century techniques of commercial glazes and graphic arts.

In the both tender and menacing *Man with Chicken*, as in most of Takamori's works, the human form is the main subject. The man and bird exchange wary glances that make clear the mutual knowledge that the chicken will soon be dinner. The forms, both three-dimensional and graphic, are rounded invitingly, with the embrace of the chicken felt sculpturally.

Takamori works from numerous drawings, using the final one as a pattern with which to cut out clay slabs. These are then incised with basic pictorial elements and shaped. The pieces are permitted to dry enough to be handled and are then slip joined, with the bottom added last. For Takamori, a "vase does more than hold something like flowers; it can hold mental images, concepts."[3] This makes him an important proponent of the notion of a vessel being both real and metaphorical in its content. He combines the pretty pot and the message pot.

1. Clark 1987, p. 302.

2. Ibid.

3. Takamori 1988, p. 30.

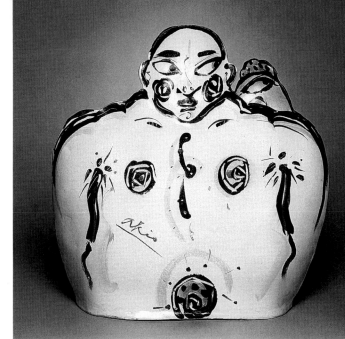

Man with Chicken

1985

Stoneware, slab-constructed and salt-glazed,
with overglaze and underglaze paints

17½ x 18 x 7 in. (44.5 x 45.7 x 17.8 cm)

Marked

M.87.1.167

SUTTON TAYLOR

United Kingdom, b. 1943

Active in Leeds, England

Born in Keighley, Yorkshire, England, Sutton Taylor, a self-taught potter, took his inspiration from the luster glazes of ninth-century Persian pots. He spent the period from 1966 to 1970 in Kingston, Jamaica, learning about, working with, and teaching ceramics. Upon returning to England, he began teaching at a comprehensive school to support himself in his pottery work. He was attracted to the lusterware process because of its potential for subtle blendings of color within a metallic surface glaze, a type of nuance that could be achieved only with this ancient technique. Little is known of the history of Persian lusterware, but through experimentation, Taylor was able to reinvent adequate technology to achieve his aesthetic ends. His earliest work was in stoneware and porcelain, but he switched to earthenware when he found it to be a better body for the elusive glaze.

Taylor's lusterware technique requires a number of steps. Starting with a straightforward wheel-thrown form, the vessel is glazed using a brush and then fired. Luster pigments are painted on, generally in an ocher vehicle in which copper, silver, or other metallic dusts are suspended. After being fired, the ocher residue is cleaned off, revealing muted layers of color. Due to the multiple firings and unreliability of the metallic pigments, this process involves chance and a high rate of kiln losses. For Taylor this risk element makes the technique challenging and rewarding.

In *Plate* his fascination with overlapping veils of color can be seen. What otherwise would be an ordinary form covered with muted glaze layers is transformed into something more impressive by the magic twinkle of metallic glints.

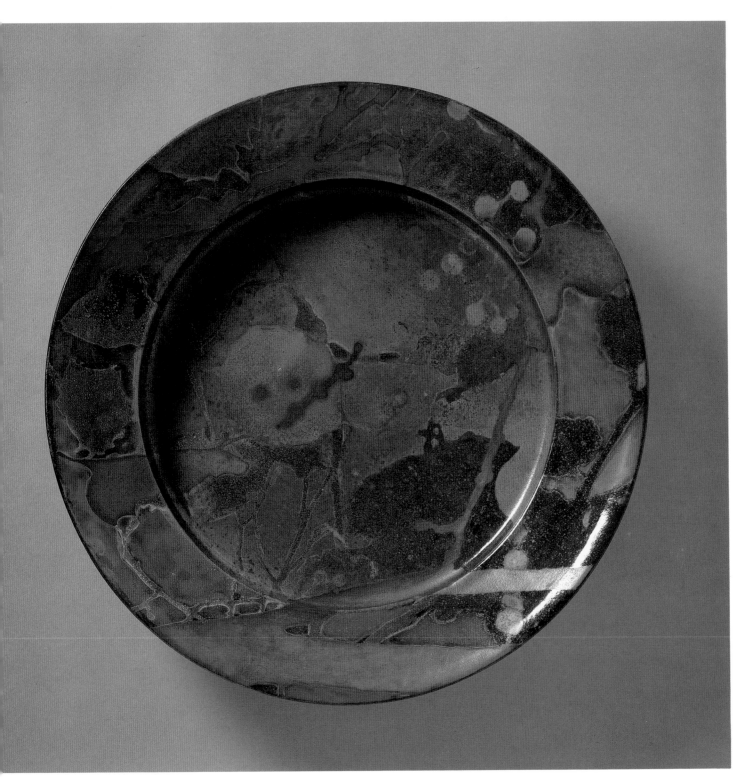

Plate

c. 1985

Earthenware, wheel-thrown, wood-fired, painted,

and reduction-fired

3 x 16 (diam.) in. (7.6 x 40.6 cm)

Marked

M.87.1.169

ROBERT TURNER

United States, b. 1913
Active in Alfred, New York, and Santa Fe

Born in Port Washington, New York, Robert Turner was the son of Quaker parents. He received his B.A. in 1936 from Swarthmore College, Pennsylvania, where he majored in economics. He then studied painting and met influential artists Stuart Davis and Franz Kline. To fulfill service requirements as a conscientious objector during World War II, he worked with developmentally disabled students. In 1946 he turned from painting to ceramics and started school at the New York State College of Ceramics at Alfred University. From 1949 to 1951 he taught at Black Mountain College, North Carolina, where he started a ceramics program and opened his own pottery. In 1958 he joined the faculty at Alfred University, teaching there until 1979.

Eclectic in his interests and open to a range of aesthetics, Turner has drawn from a number of sources. He has traveled widely, with trips to West Africa and Arizona having a lasting effect on his work. Other influences have been Chinese stoneware, the work of Peter Voulkos, and a deep affinity for nature.

Turner uses a limited number of forms for his current output. Each one has a name that has come to be associated with his oeuvre. They are dome, red bowl, Ashanti (a kingdom in Africa), circle/square, and four variations on a cylinder: Akan (people of Ashanti), Ife (town in Nigeria), Oshogbo (town northwest of Ife), and de Chelly (Arizona canyon).[1] As his work has developed, functional references have been rendered vestigial.

Turner works in three basic colors: black, white, and a reddish-brown. Each piece is glazed and sandblasted to make the surface nonreflective. All his work deals with the inherent contrast between the inside and outside and with the sense of contained space.

In *de Chelly* Turner's impressions of Canyon de Chelly are captured. The shape recalls the geological buttes found in the southwestern part of the United States. Created as part of an ongoing group of objects, this particular piece has no structural appendages added to the top as is the case with others. It was wheel thrown and then altered to soften the sense of center. Each incised line, gouge, and inclusion, while appearing as natural as the marks of time on the walls of the canyon, is planned to enrich the form. As with many mid-century-trained potters and Alfred graduates Turner achieves an almost casual craftsmanship only because of his thorough grounding in the craft of working clay.

1. Westphal 1985, pp. 4–10.

de Chelly

1983

Stoneware, wheel-thrown, altered, glazed, and

sandblasted

10 x 9 (diam.) in. (25.4 x 22.9 cm)

Marked

M.87.1.173

Standing Jar
1958
Stoneware, wheel-thrown, with applied slabs,
glazed with cobalt and red iron oxides
22½ x 16 x 17 in. (57.2 x 40.6 x 43.2 cm)
TR.9282.2

PETER VOULKOS

United States, b. 1924

Active in Oakland

Born in 1924 in Bozeman, Montana, Peter Voulkos was the third child of Greek immigrants. In 1941, as part of the war effort, he became a molder, making parts for Liberty Ships. From 1943 to 1945 he served as a U.S. Navy Air Force nose gunner in the Pacific theater. After military service he took advantage of the GI Bill and studied painting under Robert De Weese and Jessie Wilber at Montana State University, Bozeman. During his last year there he worked in clay under Frances Senska.

Voulkos found clay a compatible medium and soon gained recognition for his work, winning the Potters Association Prize in 1949 at the Ceramic National in Syracuse, New York. Like other potters of his generation he worked exclusively with the vessel form and concentrated on acquiring the traditional skills of throwing and decorating pots to conform to the Scandinavian and Asian aesthetics then popular. In fact, when he received his M.F.A. from the California College of Arts and Crafts, Oakland, in 1952, his graduate thesis was on the functional lidded jar.[1]

In 1952 Voulkos returned to Montana and, with Rudy Autio, established the ceramics workshop at the Archie Bray Foundation. At this time he met Shōji Hamada, Bernard Leach, and Sōetsu Yanagi, who were traveling in the United States. The next year he went to Black Mountain College in Asheville, North Carolina, and New York City, and was exposed to new trends in American art, including abstract expressionism.[2]

In 1954, at the invitation of director Millard Sheets, Voulkos started teaching at the Otis Art Institute in Los Angeles, with Paul Soldner as his first student. They set up the studio from scratch, building the working spaces and kilns with ceramics engineer Mike Kalan.[3] Soon Voulkos gathered around him a number of students, including Billy Al Bengston, Michael Frimkess, John Mason, Malcolm McClain, Kenneth Price, Jerry Rothman, and Henry Takemoto. All of these later came to make their own contributions to the arts in Los Angeles, but first they served as participants in Voulkos's revolutionary transformation of the functional brown pot into the sculptural expressive pot.

Perhaps because of his painting education Voulkos did not see himself as limited by the restraints placed on the clay medium by others. Since he was equally skilled at both functional and expressive work, he was an appropriate person to take on entrenched notions about the proper way to use clay. In his teachings he argued that students should use themselves as source material, expressing their ideas in the forms they created. Recording the process of artist/clay interaction was the goal, not producing useful pieces. Functionality was deemed confining and made only referential. These, of course, were radical ideas, and they caused a stir in the ceramics community. But his breakthrough made the expressive approach the standard approach for clay artists.

Voulkos moved to Berkeley in 1959 to teach at the University of California. Again he attracted a high-powered group of students, among them Robert Arneson, Clayton Bailey, Robert Hudson, Marilyn Levine, James Melchert, Ron Nagle, and Richard Shaw. He turned to sculpture during the 1960s and early 1970s, moving away from clay as his primary medium. Much of this metal work was "playful and intelligent, if largely deriva-

tive."[4] He continued to conduct workshops in clay and to display his prodigious energy for work and creativity.

In 1967 Voulkos traveled to Italy and met Lucio Fontana, an abstract expressionist painter and potter. Fontana tore and punched his canvases and rended his clay forms. This approach intrigued Voulkos, and he explored these notions in a series of plates and bottles that displayed what became his signature, sliced and slashed surfaces.[5]

In 1973 Voulkos "decorated" (with holes and scratches) a limited edition of two hundred large plates that had been thrown by an assistant. He then produced another series of plates based on the same aesthetic, but this time he threw the objects, thereby imparting a stronger, more irregular power to them.[6] These pieces were fired in a gas kiln with a glaze made to imitate that achieved in wood firings. In both series he combined his clay vessel interest with that of painting.

Tea Bowl is from Voulkos's brown pot period. It is a simple piece based on a classic Japanese form. In *Coffee Pot*, Voulkos's fine throwing ability, painting talent, and skill in melding Scandinavian elegance with Asian decoration is displayed. In *Large Plate* the influence of Fontana can be seen.

Standing Jar is an example of the powerful, expressive pots Voulkos made during the 1950s. Vessel in form, its heavy and oversized shape consciously obviates the implied storage function. The surface, enlivened by the application of clay strips in a casual vertical pattern, is glazed overall with cobalt and red iron oxides that create a mottled, misty-blue and brown color.

It was with vessels such as *Standing Jar* that Voulkos moved ceramics beyond function and into a sculptural presence. Although creating functionally related forms, he transcended his medium and transformed clay from being useful to being meaningful.

1. Clark 1987, p. 305.
2. See introduction for more information.
3. Slivka 1978, p. xiv.
4. Goldberg 1979, p. 36.
5. Slivka 1978, p. 72.
6. Clark 1981a, p. 53.

Peter Voulkos
Coffee Pot
1955

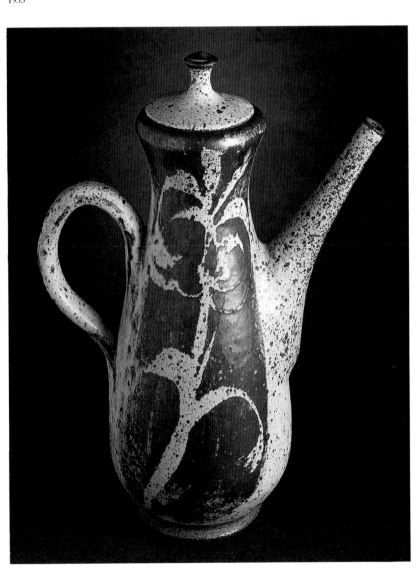

JOHN WARD

United Kingdom, b. 1943
Active in Dyfed, Wales

Born in London, John Ward was first exposed to ceramics as an artistic medium in 1965. Although working at the British Broadcasting Corporation as a cameraman, he took a studio pottery course at East Ham Technical College in East London and caught the ceramics bug. One year later he was accepted into the Camberwell School of Art and Crafts, London, where he received his Diploma in Art and Design in 1970. After graduation he established his own studio, supporting himself by part-time teaching until 1979, when he moved to Wales and began to make pots full time.

Ward has always been drawn to hand-building techniques. He makes his vessels by pinching the clay into thin-walled forms, often softly geometric in feeling. The surface is then burnished. Oxides are rubbed or painted on the surface to create blurred color variations, and the work is fired in an electric kiln.

The preoccupation with enclosed space is a traditional ceramics concern, and it intrigues Ward. His works start as vessel forms but grow out of their vessel genesis into a sculptural reality. The finished pieces are clear and elegant.

All of these qualities can be seen in *Striped Bowl*. The stripes and center dimple/fold contrast with the external curve of the form. The rim is subtly dipped to add a further sense of plasticity. Overall the object conjures up the feeling of a seashell, with its thin walls and conchlike bottom curve. Ward's current work continues to explore the same concerns, often involving formal design issues of molding square shapes into round ones.

Striped Bowl

c. 1983

Stoneware, hand-built, glazed, and fired,

with oxide decoration

7½ x 9½ x 5½ in. (19.1 x 24.1 x 14 cm)

Marked

M.87.1.177

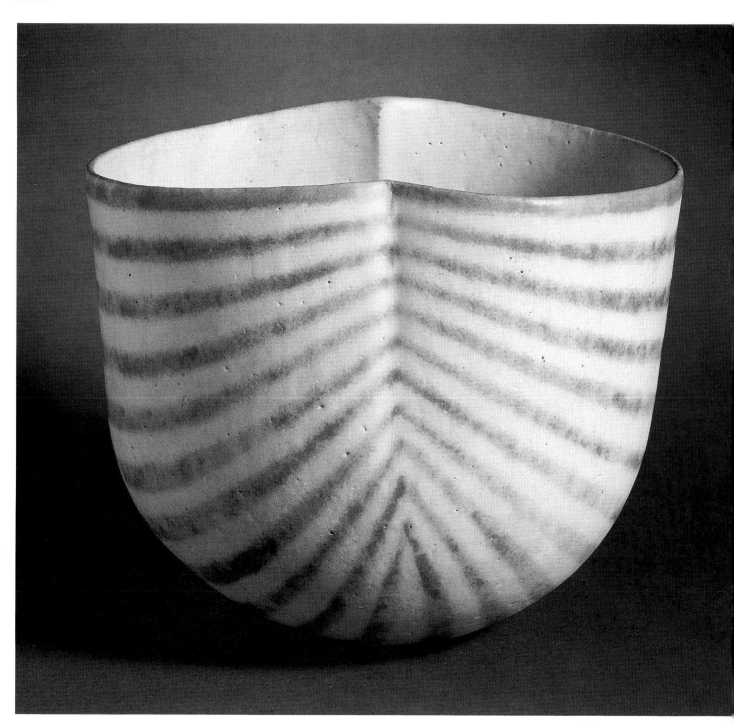

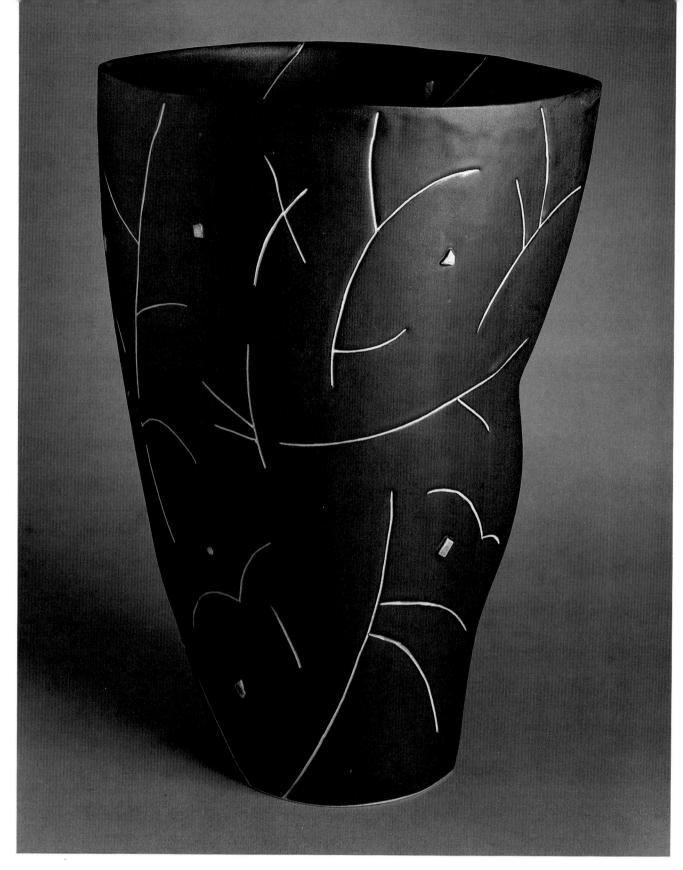

Tall Charcoal Vase

1982

Porcelain, slip-cast, incised, glazed, and fired,

with glaze chip inclusions

17½ x 13 x 9 in. (44.5 x 33 x 22.9 cm)

Marked

M.87.1.178

KURT WEISER

United States, b. 1950

Active in Helena, Montana

Born in Lansing, Michigan, Kurt Weiser earned his B.F.A. in 1972 from the Kansas City Art Institute and his M.F.A. in 1976 from the University of Michigan, Ann Arbor. In 1977 he was appointed resident director of the Archie Bray Foundation in Helena, Montana. There he runs the nondegree school for the advanced study of ceramic arts.

Weiser's work reflects his interest in natural forms and fascination with the open skies of Montana. His "line and chip designs follow directly from petroglyphs found in eastern Montana, and from Eskimo line drawings. In fact, some of the incised lines suggest the Inuit alphabet or some other lost language. Irregular bumps and edges give the forms an artificial handmade quality, which underscores their pseudo-archaeological character. Smooth, dense black, brown, and gray glazes make them look as though they were excavated by the Smithsonian."[1]

Technically, Weiser makes use of slip-cast methods that exploit the malleability of clay, but he fixes the material's flow in time by "freezing" it through firing. Such a process was followed in *Tall Charcoal Vase*. He slip cast a form that appears to stand uneasily, almost collapsing, caught and frozen in a moment of vulnerability. The surface is incised with sgraffito lines that articulate and enliven both the inside and outside of the vessel. Chips of glaze material vary the texture and are randomly scattered as if they were stars against the dark sky of the vase. These various decorations express his particular interest in marks, "prehistoric remnants."[2] This notion of marks or traces is also found in the work of other potters, such as Marilyn Levine, and reflects a late twentieth-century sensitivity to the archaeological ramifications of man's activities. In this case the linear decorations are ambiguous: are they simply lines, are they to imply shape, or do they have a semiotic meaning?

1. Kangas 1983a, p. 71.
2. Ibid.

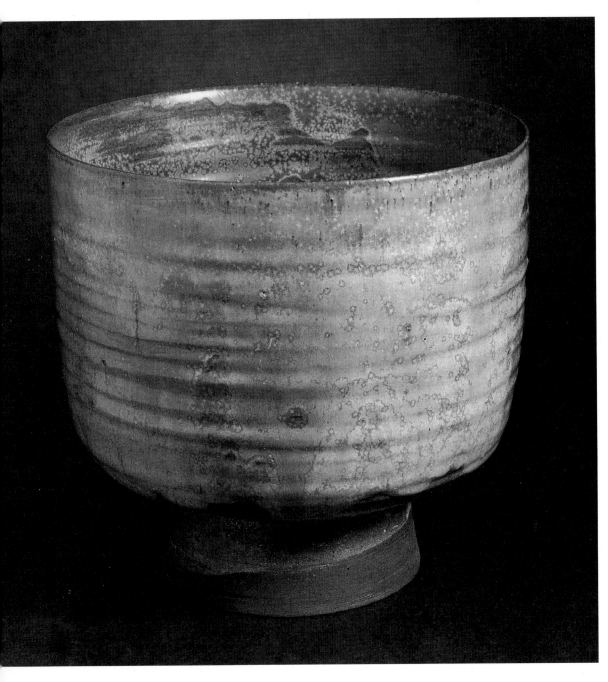

Luster Glaze Footed Vessel

c. 1955

Earthenware, wheel-thrown and glazed, with lusters

6¼ x 7 (diam.) in. (15.9 x 17.8 cm)

Marked

M.87.1.179

BEATRICE WOOD

United States, b. 1894

Active in Ojai, California

Born in San Francisco, Beatrice Wood has always been an interesting character. As a teenager she announced that she was going to study in Paris, and in 1910, after overcoming family resistance, she did. Following a brief time at the Académie Julian and a year back in the United States, she returned to Paris, this time to study theater at the Comédie Française. The outbreak of World War I forced her return to America in 1914. Two years later, while in New York, she had a chance meeting with Marcel Duchamp, which served as her entrée into the world of Dada and surrealism.

Wood's first artistic works were drawings, in which she displayed her often risqué sense of humor.[1] She turned to ceramics because of a purchase she made while traveling. The story goes that about 1928, after she had settled in California, Wood became interested in the teachings of the Indian philosopher Krishnamurti, adopting his philosophy and approach to life. While on a trip to Holland to hear him speak, she happened to buy a set of six luster plates. Upon returning home she decided that she wanted a teapot to go with them. Someone suggested that she simply make one, and to that end she enrolled in a pottery class at Hollywood High School. From this beginning she progressed to lessons with Glen Lukens and Gertrud Natzler. By her own admission an untalented craftswoman, she instead finessed her work by mining her personality and view of life for inspiration, lacing her pieces with theatrical touches, humor, and spirituality.

The decades of the 1970s and 1980s have been very productive for Wood. She works in three main modes: vessels, wheel-thrown and glazed in mercurial luster glazes; figurative pieces; and wall tiles. In the latter two she presents vignettes that often wryly capture the foibles of men and women. It is in these works that her sense of humor and perspective on life are given full sway. As a testament to her spirit and passion for work, at the age of ninety-four she traded her electric kiln for a state-of-the-art gas kiln.

Suspicious Wife Plate and *Luster Glaze Footed Vessel* date from the 1950s and are good examples of her art of that time. In *Suspicious Wife Plate* the image is drawn in a semi-cubist manner on a dry, textured surface. The title makes clear why the woman is looking out from the plate with such a penetrating gaze. In *Luster Glaze Footed Vessel* Wood created an apricot luster glaze that shimmers. The surface is intriguingly bumpy, the result of her loose throwing style.

Double Bottle and *Cup and Saucer* are examples of her later work and show its growing complexity. Many of Wood's pieces are meant to be used and enjoyed as handsome vessels for the table, and these two fall into that category.

1. Wood's entry in the 1917 New York Exhibition of the Society of Independent Artists was a painting of a nude woman emerging from a bath. With Duchamp's advice she strategically placed an actual bar of Vignola soap on the painting's surface. Intending to call the work "A little soap in some water," Wood accidentally entitled it *Un peu d'eau dans du savon* (A little water in some soap). Clark says the title caused a great controversy; Naumann writes that the positioning of the soap bar and the fact that a woman created the erotic work caused the excitement. See Clark 1987, p. 309; Naumann 1983, p. 13.

BETTY WOODMAN

United States, b. 1930

Active in New York City, Boulder, Colorado, and Antella, Italy

Born in Norwalk, Connecticut, Betty Woodman was introduced to the crafts world by her woodworking father. While initially drawn to wood, she took a ceramics class in high school and fell in love with the notion of pots and function.[1] Subsequently, she studied at the School for American Craftsmen at Alfred University from 1948 to 1950. At that time the Bernard Leach brown pot aesthetic was in favor, accompanied by a strong emphasis on the history of ceramics. Woodman eventually rejected the former and explored the latter.

Alfred University was oriented toward industrial ceramics, so Woodman's early exposure was to the technical side of clay. Upon graduation she began work as a production potter. This initial experience with utilitarian forms has served as the basis for her work.

In 1952 Woodman went to Italy. There she worked with painter Giorgio Ferrero and sculptor Leonello Fallacari, both of whom were supporting themselves by making pots. Through them and the exposure to seventeenth-century Italian maiolica, she was made aware of an aesthetic outside of that espoused by Alfred University. In the early 1970s she became enamored with the innate softness of earthenware and saw the potential of reworking that medium in a contemporary way.

What is seen now as a postmodern interest in multiple cultural quotations has always interested Woodman. She states: "In making reference to pots from other cultures, architectural details, fabrics, and fountains, these forms are not merely quoted, but are framed, placed in context, italicized, so to speak, so that some point is made from the tension existing between the original source and its contemporary expression."[2] This combination of decoration, function, and cultural references can be seen throughout her work. Indeed, Woodman, "a crafts-based artist," has now become "an historian of ceramic gesture."[3]

Waterbug Breakfast Tray with Pitchers is made of white earthenware concocted of equal parts of ball clay, kaolin, and fire clay. The form implies function but succeeds in transforming the presentation of food into a dramatic event. The colors are taken from several sources, including Persian, Greek, and Mexican wares.

In *Pillow Pitcher*, a shape used often by Woodman, the innate characteristics of clay are combined with a thorough knowledge of ceramics history. The form itself, inspired by traditional Etruscan pieces, was developed out of a wheel-thrown cylinder that was turned on its side and pinched closed at either end. A neck, spout, and handle were then added.

Woodman is currently making environmental installations. She continues to work inventively and progressively, as she has throughout her ceramics life, both leading and observing trends.

1. Wechsler 1981, p. 131.
2. Ibid., p. 135.
3. Lippard 1988, p. 15D.

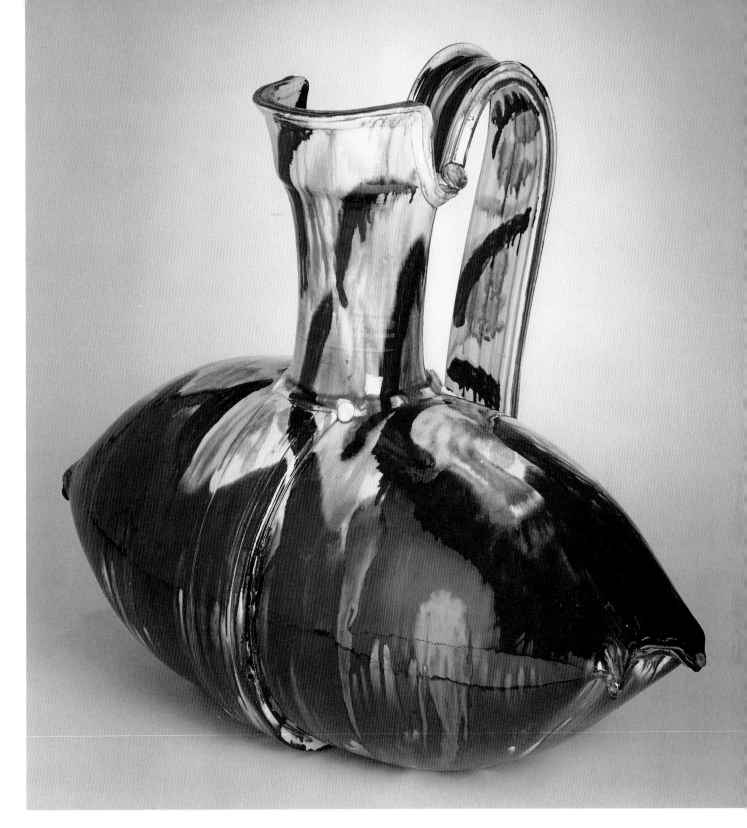

Pillow Pitcher

1982

Low-fire whiteware, wheel-thrown, altered,

assembled, and glazed

20 x 24 x 13 in. (50.8 x 61 x 33 cm)

Marked

M.87.1.184

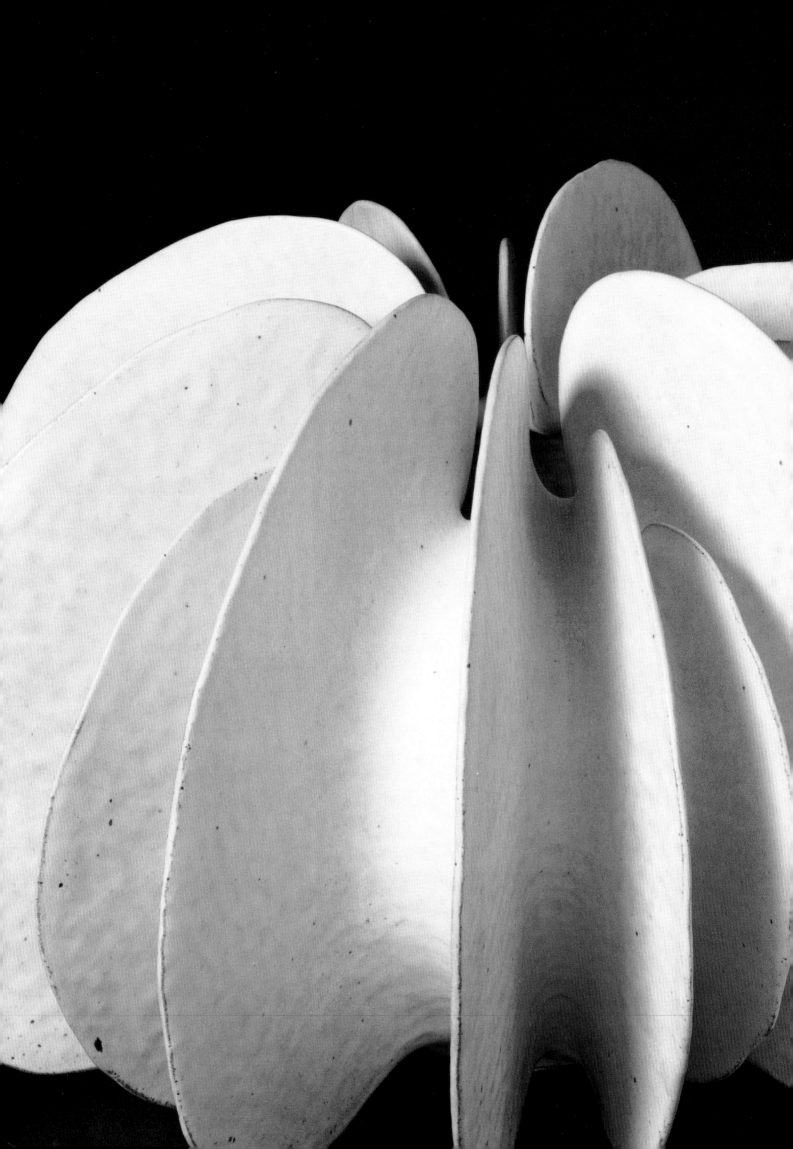

CATALOGUE

This catalogue lists all pieces donated or promised to the Los Angeles County Museum of Art by Howard and Gwen Laurie Smits. In addition to the information presented previously in the Selected Artists section (titles in **bold italics**), a provenance, including exhibition history, is provided here. (An * after the registrar's number indicates the piece was exhibited in *Contemporary Ceramics from the Smits Collection* at the Los Angeles County Museum of Art in 1987.) Photographs of all marks and pieces not pictured in the Selected Artists section are also supplied. (Please note that when an artist uses the same mark on two or more pieces, only one mark photo is provided.)

Warren Hullow

Sea Form 1 (detail)

c. 1980

167

Jane Aebersold

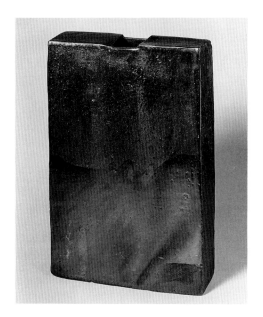

United States, b. 1941

Black Thunder Suite #3, 1980

Stoneware, slab-built, with lusters

16½ x 12 x 3¼ in. (41.9 x 30.5 x 8.3 cm)

M.87.1.1

Purchased from Meyer, Breir, Weiss Gallery,

San Francisco, September 1980

Laura Andreson

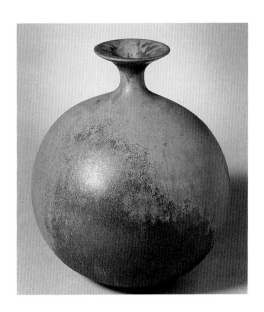

United States, b. 1902

Yellow Orange Bottle, c. 1980

Porcelain, wheel-thrown and glazed

8½ x 7½ (diam.) in. (21.6 x 19.1 cm)

Marked

M.87.1.2 *

Purchased from Marcia Rodell Gallery, Los Angeles,

June 1981

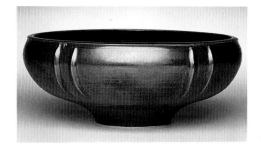

Bowl with Ridges, 1980

Stoneware, wheel-thrown and glazed

4 x 10 (diam.) in. (10.2 x 25.4 cm)

Marked

M.87.1.3

Purchased from Free Hand, Los Angeles,

October 1981

Exhibited at Baxter Art Gallery, California Institute

of Technology, Pasadena, *Contemporary Ceramic*

Vessels: Two Los Angeles Collections, 1984; and

Muckenthaler Cultural Center, Fullerton, California,

Ceramic Form: A Woman's Perspective, 1989

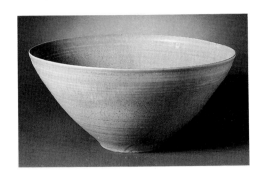

Blue-and-Green Bowl, c. 1980
Porcelain, wheel-thrown and glazed
5⅛ x 11 (diam.) in. (13 x 27.9 cm)
Marked
M.87.1.4
Purchased from Four Oaks Gallery, San Marino,
California, December 1980

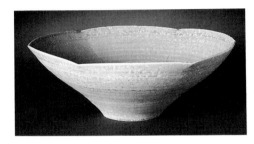

Turquoise Bowl, c. 1980
Porcelain, wheel-thrown, altered, and glazed
3¼ x 9 (diam.) in. (8.3 x 22.9 cm)
Marked
M.87.1.5
Purchased from Marcia Rodell Gallery, Los Angeles,
June 1981

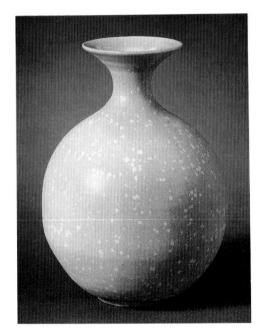

Small Yellow Bottle, c. 1980
Porcelain, wheel-thrown and glazed
4½ x 3¼ (diam.) in. (11.4 x 8.3 cm)
Marked
M.87.1.6 *
Purchased from Mandell Gallery, Los Angeles,
April 1980

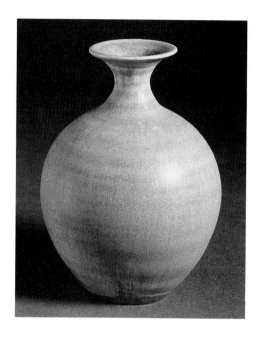

Bulbous Blue Bud Vase, 1980
Porcelain, wheel-thrown and glazed
3⅜ x 2¾ (diam.) in. (8.6 x 7 cm)
Marked
M.87.1.7
Purchased from Four Oaks Gallery, San Marino,
California, December 1980

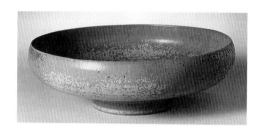

Blue Bowl, 1980
Porcelain, wheel-thrown and glazed
3½ x 10 (diam.) in. (8.9 x 25.4 cm)
Marked
M.87.1.8
Purchased from Craft and Folk Art Museum Shop,
Los Angeles, October 1982

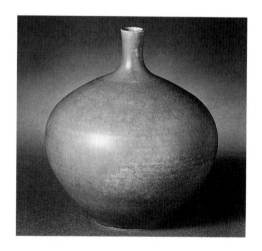

Small Orange Bottle, 1965
Porcelain, wheel-thrown and glazed
3½ x 2½ (diam.) in. (8.9 x 6.4 cm)
Marked
M.87.1.189
Purchased from Pasadena Guild of Childrens
Hospital, c. 1965

Robert Arneson

United States, b. 1930
Jackson Pollock, 1983
White earthenware, molded and glazed
15 x 11½ x 8 in. (38.1 x 29.2 x 20.3 cm)
Marked
M.87.1.9 *
Purchased from Fuller Goldeen Gallery,
San Francisco, June 1985
Exhibited at Art Center, Pasadena, *Pasadena Collects*, 1986

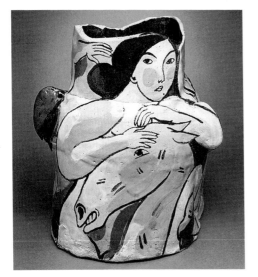

Rudy Autio

United States, b. 1926
Salt Creek Games, 1983
Stoneware, hand-built and glazed
14½ x 13 x 12 in. (36.8 x 33 x 30.5 cm)
Marked
M.87.1.10
Purchased from Garth Clark Gallery, New York City,
October 1984

Ralph Bacerra

United States, b. 1938
Fish Soup Tureen, 1976
Porcelain, wheel-thrown and assembled,
with underglaze painting
13 x 15 x 11 (diam.) in. (33 x 38.1 x 27.9 cm)
Marked
M.87.1.11a-b
Purchased from American Hand Gallery, April 1986

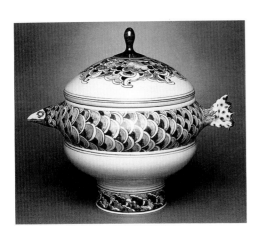

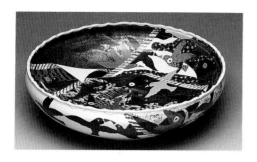

Large Bowl, 1981
Porcelain, wheel-thrown, with underglaze and
overglaze painting, lusters, and enamels
5 x 17½ (diam.) in. (12.7 x 44.5 cm)
Marked
M.87.1.12
Purchased from the artist, February 1981
Exhibited at Baxter Art Gallery, California Institute
of Technology, Pasadena, *Contemporary Ceramic
Vessels: Two Los Angeles Collections*, 1984

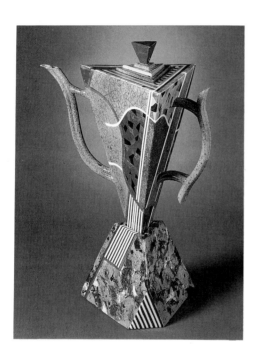

Teapot, 1984
Porcelain, slab-built, with painting, lusters, and
enamels
18 x 9 x 7½ in. (45.7 x 22.9 x 19.1 cm)
Marked
M.87.1.13a-c *
Purchased from Garth Clark Gallery, Los Angeles,
December 1984
Selected at the artist's studio

Gordon Baldwin

United Kingdom, b. 1932
Vessel on Base (Vessel for Max Ernst), 1984
Earthenware, coil-built, with glazes, engobe, oxides,
and stains
15 x 13 x 13½ in. (38.1 x 33 x 34.3 cm)
M.87.1.14
Purchased from the artist, Windsor, England,
July 1984

Quentin Bell

United Kingdom, b. 1910
Blue Oval Platter, 1980s
Terra-cotta, slab-constructed, with glaze
1½ x 20½ x 9 in. (3.8 x 52.1 x 22.9 cm)
Marked
M.87.1.15
Purchased in England, 1980s

Curtis Benzle (United States, b. 1949)
Susan Benzle (United States, b. 1950)

Sculptural Form, 1985
Porcelain, colored and layered
7 x 17½ x 3½ in. (17.8 x 44.5 x 8.9 cm)
Marked
M.87.1.16
Purchased from Sandra Ainsley Art Forms, Toronto,
October 1985

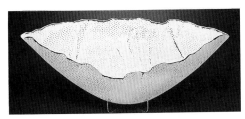

Luis Bermudez

United States, b. 1953
"Moksha," M-1, 1986
High-fire ceramic with low-fire glaze
17 x 19 x 7¾ in. (43.2 x 48.3 x 19.7 cm)
M.87.1.190a-b
Purchased from Garth Clark Gallery, Los Angeles,
December 1986

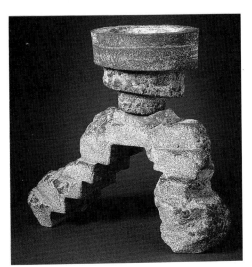

Christina Bertoni

United States, b. 1945
Double Yolk, 1981
White earthenware, slip-cast, with engobe
and india ink
4 x 9 (diam.) in. (10.2 x 22.9 cm)
M.87.1.17
Purchased from Hadler/Rodriguez Gallery,
New York City, June 1981
Exhibited at Muckenthaler Cultural Center,
Fullerton, California, *Ceramic Form: A Woman's
Perspective*, 1989

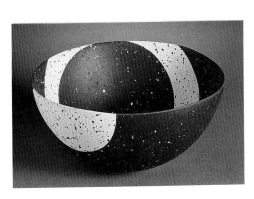

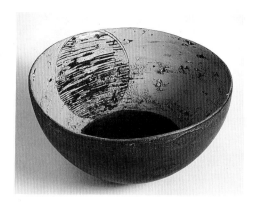

Black Yolk, 1981
White earthenware, slip-cast, with engobe
3½ x 7 (diam.) in. (8.9 x 17.8 cm)
M.87.1.18 *
Purchased from Hadler/Rodriguez Gallery,
New York City, June 1981
Exhibited at Muckenthaler Cultural Center,
Fullerton, California, *Ceramic Form: A Woman's
Perspective*, 1989

Alison Britton

United Kingdom, b. 1948
Two-Part Vessel, 1987
Earthenware, slab-constructed, with slip and oxides
a. 14 x 13½ x 11 in. (35.6 x 34.3 x 27.9 cm)
b. 12 x 8½ x 8 in. (30.5 x 21.6 x 20.3 cm)
Marked
TR.9282.6a-b
Purchased from Garth Clark Gallery, Los Angeles,
January 1988

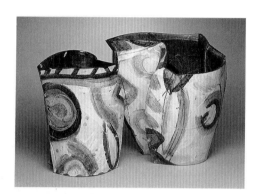

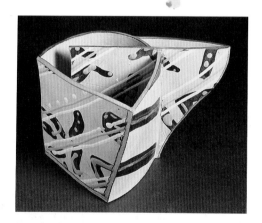

Asymmetrical Pot, 1982
Earthenware, slab-constructed, with slip and oxides
8¾ x 13 x 9½ in. (22.2 x 33 x 24.1 cm)
Marked
M.87.1.19
Purchased from Victoria and Albert Museum Craft
Shop, London, July 1982

Lidya Buzio

Uruguay, b. 1948, active United States
Roofscape, 1983
Earthenware, slab-constructed, glazed,
and burnished
11 x 14¼ x 6 in. (27.9 x 36.2 x 15.2 cm)
Marked
M.87.1.20
Purchased from Garth Clark Gallery, New York City,
1983

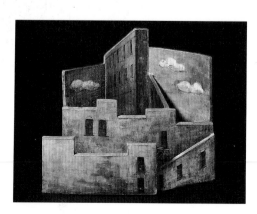

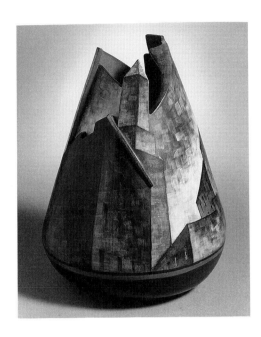

Untitled, 1983
Earthenware, slab-constructed, glazed,
and burnished
15½ x 11 (diam.) in. (39.4 x 27.9 cm)
Marked
M.87.1.21 *
Purchased from Garth Clark Gallery, New York City,
1984

Michael Cardew

United Kingdom, 1901–83
Large Plate, 1970
Stoneware, wheel-thrown, with sgraffito decoration
3 x 16 (diam.) in. (7.6 x 40.6 cm)
Marked
M.87.1.22 *
Purchased from Garth Clark Gallery, Los Angeles,
December 1982
Previously owned by Chris Johnson

Virginia Cartwright

United States, b. 1943
Teapot, 1983
Earthenware, hand-built
7½ x 10¼ x 7¾ in. (19.1 x 26 x 19.7 cm)
Marked
M.87.1.23a-b
Acquired from the artist in exchange for another
Cartwright vessel, December 1986

Carmen Collell

Spain, b. 1957

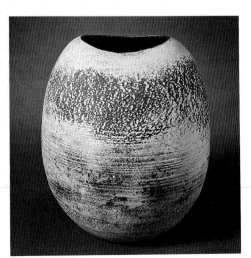

Teapot, 1985
Earthenware, slab-constructed, glazed,
and burnished
6 x 10 x 3⅝ in. (15.2 x 25.4 x 9.2 cm)
Marked
M.87.1.24a-b
Purchased from Garth Clark Gallery, Los Angeles,
December 1985

Teacups and Saucers, 1984
Earthenware, slab-constructed, glazed,
and burnished
a. teacup (each): 3 x 3¼ x 2½ in. (7.6 x 8.3 x 6.4 cm)
b. saucer (each): ¼ x 4⅛ x 2¾ in. (.6 x 10.5 x 7 cm)
Marked
M.87.1.25a-b; .26a-b
Gift from Garth Clark, December 1984

Hans Coper

Germany, 1920–81, active United Kingdom

Spade-Shaped Vase, c. 1969
Stoneware, wheel-thrown, altered, and assembled,
with engobe
11½ x 8¼ x 3½ in. (29.2 x 21 x 8.9 cm)
Marked
M.87.1.27 *
Purchased in Amsterdam, 1969
Exhibited at Baxter Art Gallery, California Institute
of Technology, Pasadena, *Contemporary Ceramic
Vessels: Two Los Angeles Collections*, 1984

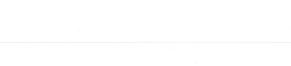

Candle Holder, 1969
Stoneware, wheel-thrown and altered, with engobe
5 x 4½ x 4 in. (12.7 x 11.4 x 10.2 cm)
Marked
M.87.1.28 *
Purchased from Oxford Gallery, Oxford, England,
June 1984

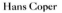

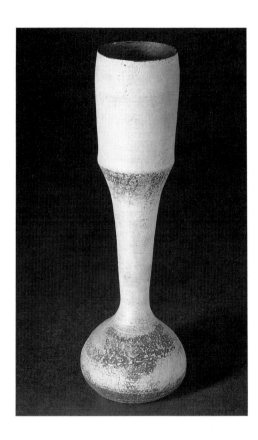

Dog Bone, 1965
Stoneware, wheel-thrown, altered, and assembled,
with engobe
8¾ x 2¾ (diam.) in. (22.2 x 7 cm)
Marked
M.87.1.29
Purchased from Beaux Arts Gallery, Bath, England,
July 1984

Annette Corcoran

United States, b. 1930
Teapot, c. 1983
Porcelain, wheel-thrown, altered, painted, and
glazed
4 x 7½ x 3¾ (diam.) in. (10.2 x 19.1 x 9.5 cm)
M.87.1.30a-b
Purchased from Green Gallery, Carmel, California,
July 1983

Philip Cornelius

United States, b. 1934
Lake Ontario, 1981
Porcelain, slab-constructed and glazed
a-b. teapot: 6¼ x 5 x 1¾ in. (15.9 x 12.7 x 4.4 cm)
c. stand: 10¼ x 5⅛ x 8¼ in. (26 x 13 x 21 cm)
Marked
M.87.1.31a-c
Purchased from Marcia Rodell Gallery, Los Angeles,
June 1981
Exhibited at Baxter Art Gallery, California Institute
of Technology, Pasadena, *Contemporary Ceramic
Vessels: Two Los Angeles Collections*, 1984

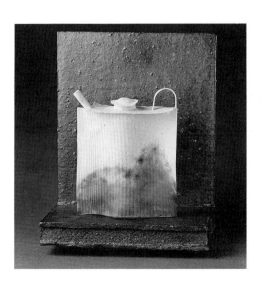

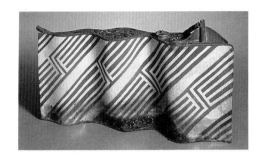

China Maru Teapot, 1985
Porcelain, slab-constructed and glazed
10³⁄₄ x 19 x 4¹⁄₄ in. (27.3 x 48.3 x 10.8 cm)
Marked
M.87.1.32a-b *
Purchased from Dorothy Weiss Gallery, San
Francisco, 1985

Kris Cox

United States, b. 1951
Teapot, 1982
Earthenware, glazed and fired, with metallic
inclusions
15³⁄₈ x 12¹⁄₂ x 3¹⁄₂ in. (39.1 x 31.8 x 8.9 cm)
M.87.1.33a-b
Purchased from Marcia Rodell Gallery, Los Angeles,
January 1982
Exhibited at Baxter Art Gallery, California Institute
of Technology, Pasadena, *Contemporary Ceramic
Vessels: Two Los Angeles Collections*, 1984

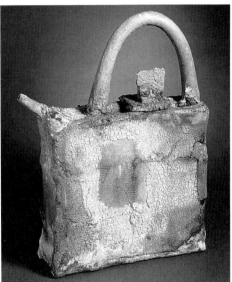

Roseline Delisle

Canada, b. 1952, active United States
Jarre Simple 3, 1986
Porcelain, wheel-thrown and trimmed, with engobe
5¹⁄₂ x 3 (diam.) in. (14 x 7.6 cm)
Marked
M.87.1.34a-b
Purchased from Garth Clark Gallery, Los Angeles,
1986

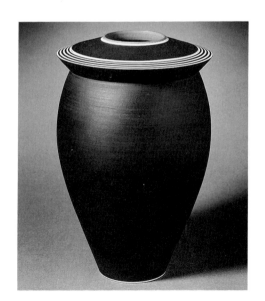

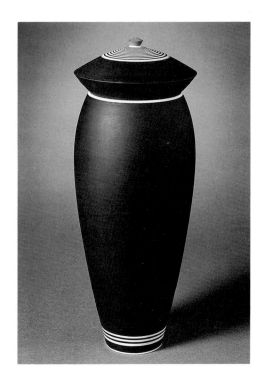

Triptyque 4, 1986
Porcelain, wheel-thrown and trimmed, with engobe
12 x 3½ (diam.) in. (30.5 x 8.9 cm)
Marked
M.87.1.35a-b *
Purchased from Garth Clark Gallery, Los Angeles,
1986

Richard DeVore
United States, b. 1933

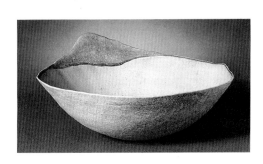

Irregular Bowl, 1976
Stoneware, wheel-thrown and hand-built, with
multiple glazes and firings
5½ x 10¾ (diam.) in. (14 x 27.3 cm)
M.87.1.36 *
Purchased from Garth Clark Gallery, October 1981
Exhibited at Baxter Art Gallery, California Institute
of Technology, Pasadena, *Contemporary Ceramic
Vessels: Two Los Angeles Collections*, 1984

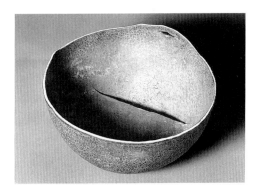

Small Bowl with Fold, 1979
Stoneware, wheel-thrown and hand-built, with
multiple glazes and firings
4 x 7½ (diam.) in. (10.2 x 19.1 cm)
M.87.1.37
Purchased from Exhibit A, Chicago, October 1979

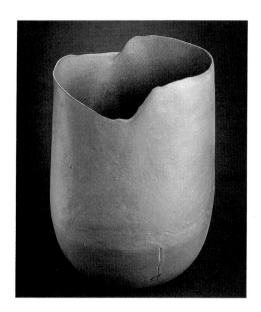

Tall Bowl, 1979
Stoneware, wheel-thrown and hand-built, with
multiple glazes and firings
15½ x 10¼ x 8½ in. (39.4 x 26 x 21.6 cm)
M.87.1.38
Purchased from Exhibit A, Chicago, October 1979

Rick Dillingham
United States, b. 1952
Tall Vase, 1978
Earthenware, hand-built, fired, broken, and
assembled, with gold leaf
16¼ x 9¾ (diam.) in. (41.3 x 24.8 cm)
Marked
M.87.1.39 *
Purchased from Mandell Gallery, Los Angeles,
December 1981
Previously owned by Arnold Lopez

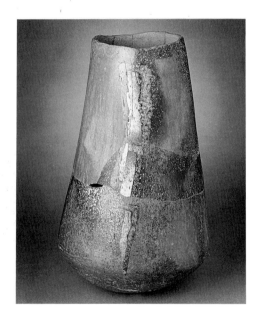

Black-and-White Sphere Vase, 1980
Whiteware, hand-built and fired, with silver leaf
9¼ x 10 (diam.) in. (23.5 x 25.4 cm)
Marked
M.87.1.40
Purchased from Craft and Folk Art Museum Shop,
Los Angeles, January 1981
Exhibited at Baxter Art Gallery, California Institute
of Technology, Pasadena, *Contemporary Ceramic
Vessels: Two Los Angeles Collections*, 1984

Ruth Duckworth

Germany, b. 1919, active United States

Bowl with Lid and Many Rocks, 1981

Porcelain, glazed and reduction-fired

3 x 8½ (diam.) in. (7.6 x 21.6 cm)

M.87.1.41a-b *

Purchased from Exhibit A, Chicago, October 1983

Exhibited at Baxter Art Gallery, California Institute
of Technology, Pasadena, *Contemporary Ceramic
Vessels: Two Los Angeles Collections*, 1984; and
Muckenthaler Cultural Center, Fullerton, California,
Ceramic Form: A Woman's Perspective, 1989

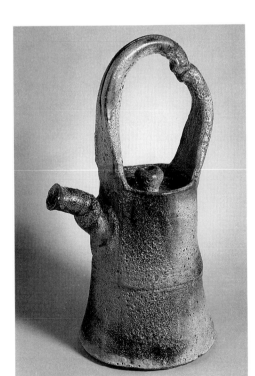

Bowl, 1975

Porcelain, slab-built and wheel-thrown, with inlaid
oxides

6 x 8 x 5½ in. (15.2 x 20.3 x 14 cm)

M.87.1.42

Purchased from Primavera, Cambridge, England

Ken Ferguson

United States, b. 1928

Teapot, 1983

Stoneware, wheel-thrown, altered, and wood-fired

23 x 13¾ x 10½ (diam.) in. (58.4 x 34.9 x 26.7 cm)

Marked

M.87.1.43a-b *

Purchased from Garth Clark Gallery, Los Angeles,
March 1983

Exhibited at Nelson-Atkins Museum of Art, Kansas
City, Missouri, *Ceramic Echoes*, 1983; and Baxter
Art Gallery, California Institute of Technology,
Pasadena, *Contemporary Ceramic Vessels: Two
Los Angeles Collections*, 1984

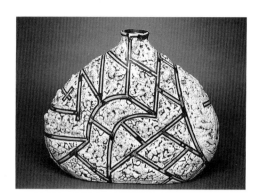

John Fleming

United States, b. 1947

Nuclear Mistake, 1979

Earthenware

9 x 11½ x 3¼ in. (22.9 x 29.2 x 8.3 cm)

M.87.1.44 *

Purchased from Janus Gallery, Los Angeles,

February 1983

Viola Frey

United States, b. 1933

Journey Teapot, 1975–76

White earthenware, with low-fire glaze

14¾ x 10½ x 5 in. (37.5 x 26.7 x 12.7 cm)

M.87.1.45a-b *

Purchased from Garth Clark Gallery, Los Angeles,

May 1983

Exhibited at Baxter Art Gallery, California Institute

of Technology, Pasadena, *Contemporary Ceramic

Vessels: Two Los Angeles Collections*, 1984

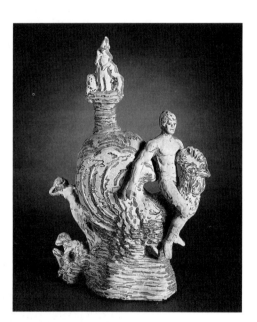

Cracker Series 11, 1979

Earthenware, assembled and glazed

2½ x 21 (diam.) in. (6.4 x 53.3 cm)

Marked

M.87.1.46

Purchased from Garth Clark Gallery, Los Angeles,

October 1981

Michael Frimkess

United States, b. 1937

Teapot, 1979

Stoneware, wheel-thrown, with copper red glaze and white slip

4¾ x 9½ x 7 (diam.) in. (12.1 x 24.1 x 17.8 cm)

Marked

M.87.1.47a-b *

Purchased from Marcia Rodell Gallery, Los Angeles, April 1982

Andrea Gill

United States, b. 1948

Fish Soup Tureen, 1984

Terra-cotta, hand-built and fired, with vitreous engobe

11 x 20 x 9 in. (27.9 x 50.8 x 22.9 cm)

Marked

M.87.1.48a-b *

Purchased from Garth Clark Gallery, Los Angeles, 1984

Exhibited at Baxter Art Gallery, California Institute of Technology, Pasadena, *Contemporary Ceramic Vessels: Two Los Angeles Collections*, 1984; and Muckenthaler Cultural Center, Fullerton, California, *Ceramic Form: A Woman's Perspective*, 1989

John Gill

United States, b. 1949

Teapot, 1983

Earthenware, hand-built and glazed

12⅜ x 16 x 6 in. (31.4 x 40.6 x 15.2 cm)

Marked

M.87.1.49

Purchased from Garth Clark Gallery, Los Angeles, 1983

Martha Gittelman

United States, 1939–88

Plate, 1982

Porcelain, hand-built

2½ x 11 x 11½ in. (6.4 x 27.9 x 29.2 cm)

Marked

M.87.1.50

Purchased from Marcia Rodell Gallery, Los Angeles, May 1982

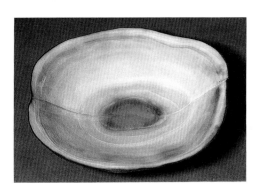

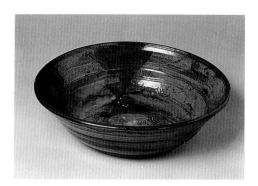

John Glick

United States, b. 1938
Large Low Bowl, 1981
Stoneware, wheel-thrown and glazed
5¼ x 18¾ (diam.) in. (13.3 x 47.6 cm)
Marked
M.87.1.51
Purchased from Hadler/Rodriguez Gallery,
New York City, June 1981

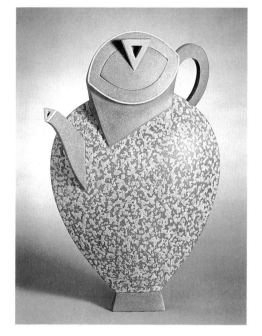

Linda Gunn-Russell

United Kingdom, b. 1953
Teapot, 1985
Red earthenware, slab-built, sanded, glazed,
and fired
12 x 7 x 1½ in. (30.5 x 17.8 x 3.8 cm)
Marked
M.87.1.52
Purchased from Garth Clark Gallery, Los Angeles,
1986

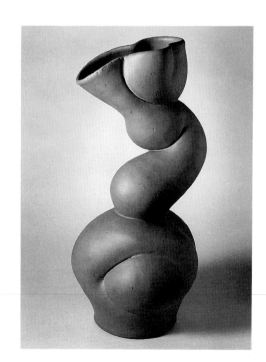

Christopher Gustin

United States, b. 1952
Pink Vessel, 1986
Stoneware, wheel-thrown, altered, sandblasted, and
reduction-fired
20½ x 10 (diam.) in. (52.1 x 25.4 cm)
Marked
M.87.1.53
Purchased from Garth Clark Gallery, Los Angeles,
1986

Dorothy Hafner

United States, b. 1952
Sonar Coffee Pot, 1983
Porcelain, slip-cast, painted, and glazed
11 x 15 x 3¾ in. (27.9 x 38.1 x 9.5 cm)
Marked
M.87.1.54a-b
Purchased from Garth Clark Gallery, Los Angeles,
1983
Exhibited at Muckenthaler Cultural Center,
Fullerton, California, *Ceramic Form: A Woman's*
Perspective, 1989

Shōji Hamada

Japan, 1894–1978
Bottle with Brush Marks, 1960s
Stoneware, wheel-thrown and glazed
7¾ x 6½ x 5⅜ in. (19.7 x 16.5 x 13.7 cm)
M.87.1.55
Purchased from Oxford Gallery, Oxford, England,
July 1984

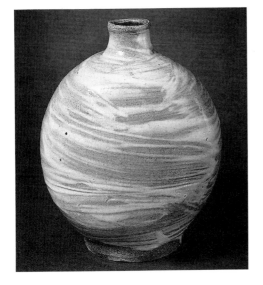

Tall Vase with Falling Leaves Design, 1970s
Stoneware, with wax resist brush strokes
10½ x 6½ (diam.) in. (26.7 x 16.5 cm)
M.87.1.56 *
Purchased from Beaux Arts Gallery, Bath, England,
July 1984

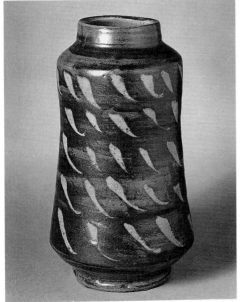

Otto Heino (United States, b. 1915)
Vivika Heino (United States, b. 1910)

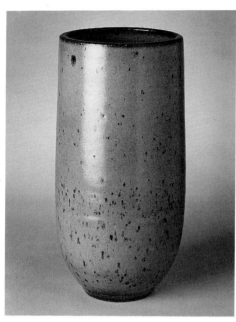

Blue Vase, 1980
Stoneware, wheel-thrown, reduction-fired, and
glazed, with iron grog
9½ x 4¾ (diam.) in. (24.1 x 12.1 cm)
Marked
M.87.1.57
Gift of James E. Smits to Gwen Laurie Smits, 1985

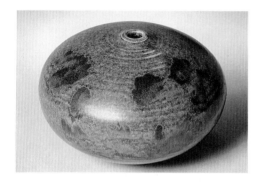

Blue Weed Vase, 1980
Porcelain, wheel-thrown and reduction-fired, with
iron blue glaze
4 x 6¼ (diam.) in. (10.2 x 15.9 cm)
Marked
M.87.1.58 *
Purchased from Craft and Folk Art Museum Shop,
Los Angeles, January 1981

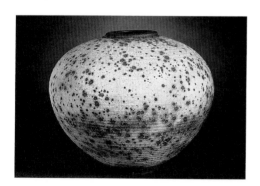

Globular-Shaped Vase, 1980
Stoneware, wheel-thrown and reduction-fired, with
Applewood ash glaze
10¾ x 12½ (diam.) in. (27.3 x 31.8 cm)
Marked
M.87.1.59
Purchased from Craft and Folk Art Museum Shop,
Los Angeles, 1980

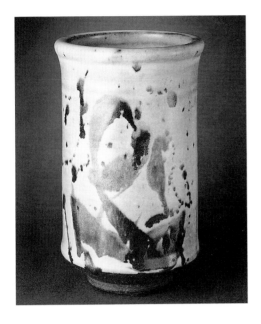

Stone-Colored Vase, 1960s
Stoneware, wheel-thrown and reduction-fired, with
iron decoration on top of glaze
7 x 4½ (diam.) in. (17.8 x 11.4 cm)
Marked
M.87.1.60
Gift of James E. Smits to Gwen Laurie Smits,
August 1985

Ewen Henderson

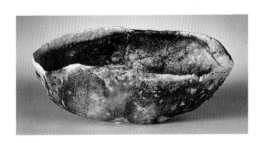

United Kingdom, b. 1934
Abalonelike Bowl, 1982
Porcelain, hand-built
3⅜ x 7 x 5 in. (8.6 x 17.8 x 12.7 cm)
M.87.1.61
Purchased from Victoria and Albert Museum Craft
Shop, London, July 1982

Anne Hirondelle

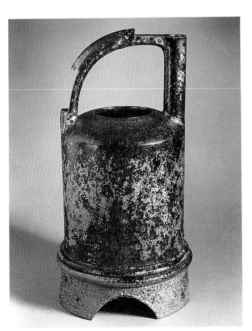

United States, b. 1944
IBEX, 1986
Stoneware, wheel-thrown, assembled, glazed,
and raku-fired, with extruded parts
15½ x 8 (diam.) in. (39.4 x 20.3 cm)
Marked
M.87.1.62a-b
Purchased from Garth Clark Gallery, Los Angeles,
July 1986
Exhibited at Muckenthaler Cultural Center,
Fullerton, California, *Ceramic Form: A Woman's
Perspective*, 1989

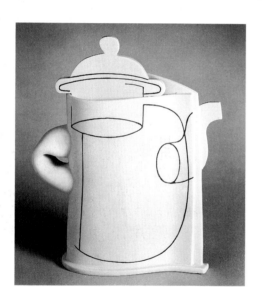

Thomas Hoadley

United States, b. 1949

Terra-cotta Vase, 1985

Porcelain

7¾ x 6 x 5 in. (19.7 x 15.2 x 12.7 cm)

M.87.1.63

Purchased from Craft and Folk Art Museum Shop,

Los Angeles, October 1985

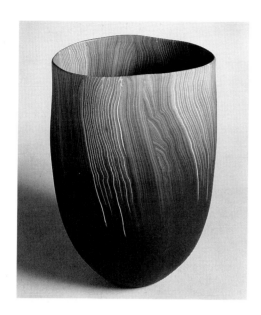

Nicholas Homoky

Hungary, b. 1950, active United Kingdom

White Teapot, 1980

Porcelain, hand-built, inlaid, and polished

7⅛ x 6¼ x 1¾ in. (18.1 x 15.9 x 4.4 cm)

Marked

M.87.1.64a-b *

Purchased from Craftsmen Potters Shop, London,

June 1980

Exhibited at Baxter Art Gallery, California Institute

of Technology, Pasadena, *Contemporary Ceramic

Vessels: Two Los Angeles Collections*, 1984

White Pedestal Bowl Vase, 1980

Porcelain, wheel-thrown, inlaid, and polished

5⅛ x 6 (diam.) in. (13 x 15.2 cm)

Marked

M.87.1.65

Purchased from Craftsmen Potters Shop, London,

1980

Warren Hullow

United States, b. 1938

Sea Form 1, c. 1980

Earthenware

10½ x 14 x 14½ in. (26.7 x 35.6 x 36.8 cm)

Marked

M.87.1.66

Purchased from Elements, New York City, May 1980

Exhibited at Baxter Art Gallery, California Institute of Technology, Pasadena, *Contemporary Ceramic Vessels: Two Los Angeles Collections*, 1984

Nils Kähler

Denmark, 1906–79

Bowl, c. 1950s–1960s

Earthenware, press-molded, impressed, and glazed

4½ x 13 (diam.) in. (11.4 x 33 cm)

Marked

M.87.1.67

Purchased in Copenhagen, 1980s

Karen Karnes

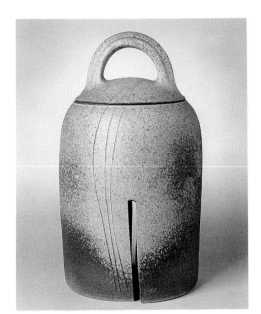

United States, b. 1925

Vessel, 1987

Stoneware, wheel-thrown, glazed, and wood-fired

16½ x 10½ (diam.) in. (41.9 x 26.7 cm)

Marked

TR.9282.5a-b

Purchased from Garth Clark Gallery, New York City, January 1988

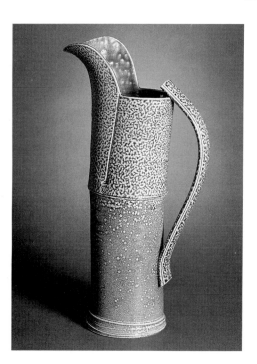

Walter Keeler

United Kingdom, b. 1942

Tall Grey Pitcher, c. 1983

Stoneware, wheel-thrown, assembled,
salt-glazed, and reduction-fired

13¼ x 7 x 4 (diam.) in. (33.7 x 17.8 x 10.2 cm)

Marked

M.87.1.68 *

Purchased from British Crafts Centre, London,
September 1983

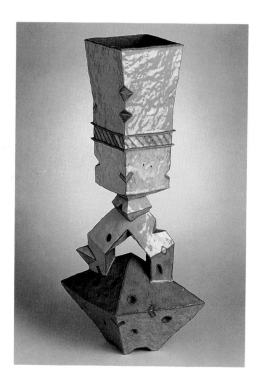

Thomas Kerrigan

United States, b. 1938

Habitat B-VIII, 1984

Terra-cotta, slab-constructed and glazed

27 x 14½ x 10 in. (68.6 x 36.8 x 25.4 cm)

Marked

M.87.1.69 *

Purchased from Dorothy Weiss Gallery,
San Francisco, May 1985

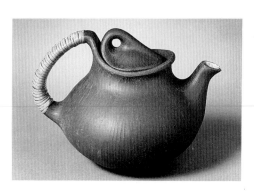

Richard Kjaergaard

Denmark, b. 1919

Teapot, c. 1950

Yixing ware, bamboo

5 x 7¾ x 5½ (diam.) in. (12.7 x 19.7 x 14 cm)

Marked

M.87.1.70a-b

Purchased from Den Permanente, Copenhagen,
mid-1950s

Karen Koblitz

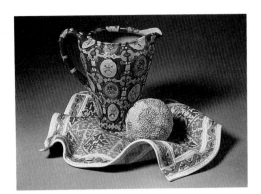

United States, b. 1951

Still Life with Pitcher and Hedge Apple, 1985

Low-fire white clay, slip-cast, slab-constructed, and

assembled, with multiple glazes

7³⁄₄ x 13¹⁄₂ x 10 in. (19.7 x 34.3 x 25.4 cm)

Marked

M.87.1.71a-b

Purchased from Asher/Faure Gallery, Los Angeles,

June 1985

James Lawton

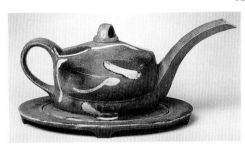

United States, b. 1954

Teapot and Stand, 1983

Earthenware

7 x 14³⁄₄ x 7¹⁄₂ in. (17.8 x 37.5 x 19.1 cm)

Marked

M.87.1.72a-c

Purchased from Garth Clark Gallery, Los Angeles,

1983

David Leach

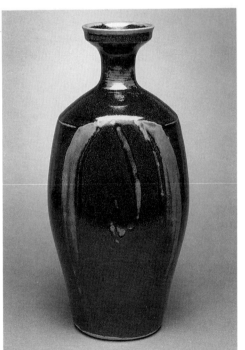

United Kingdom, b. 1911

Temmoku Bottle, 1972

Stoneware

14 x 6 x 5¹⁄₂ in. (35.6 x 15.2 x 14 cm)

Marked

M.87.1.73

Purchased from Garth Clark Gallery, Los Angeles,

August 1982

Exhibited at Baxter Art Gallery, California Institute

of Technology, Pasadena, *Contemporary Ceramic

Vessels: Two Los Angeles Collections*, 1984

Janet Leach

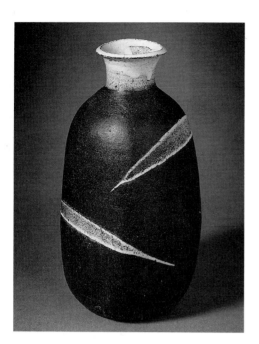

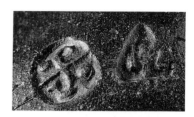

United States, b. 1918, active United Kingdom
Bottle, 1970s
Earthenware
9¾ x 5¼ (diam.) in. (24.8 x 13.3 cm)
Marked
M.87.1.74
Purchased from Leach Pottery, St. Ives, Cornwall, England, 1984
Exhibited at Baxter Art Gallery, California Institute of Technology, Pasadena, *Contemporary Ceramic Vessels: Two Los Angeles Collections*, 1984

Jennifer Lee

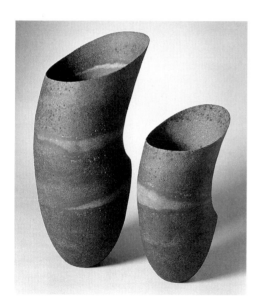

United Kingdom, b. 1956
Large Vase, 1984
Stoneware
13¾ x 8¼ x 6 in. (34.9 x 21 x 15.2 cm)
M.87.1.75
Purchased from Victoria and Albert Museum Craft Shop, London, July 1984

Small Vase, 1984
Stoneware
9¾ x 6 x 4¾ in. (24.8 x 15.2 x 12.1 cm)
M.87.1.76
Purchased from Victoria and Albert Museum Craft Shop, London, July 1984

Marilyn Levine

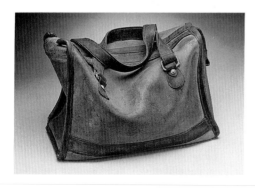

Canada, b. 1935, active United States
Two-Tone Bag, 1974
Stoneware, slab-constructed, with nylon fiber reinforcement, engobe, and lusters
9 x 14½ x 10 in. (22.9 x 36.8 x 25.4 cm)
Marked
M.87.1.77 *
Purchased from O.K. Harris Gallery, New York City, October 1982
Exhibited at Baxter Art Gallery, California Institute of Technology, Pasadena, *Contemporary Ceramic Vessels: Two Los Angeles Collections*, 1984; and Muckenthaler Cultural Center, Fullerton, California, *Ceramic Form: A Woman's Perspective*, 1989

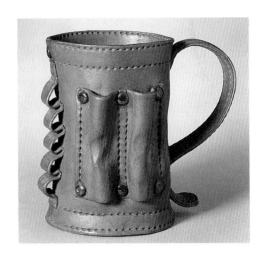

Leather Ceramic Mug, 1979
Stoneware, slab-constructed, with nylon fiber
reinforcement, engobe, and lusters
5½ x 6½ x 3½ in. (14 x 16.5 x 8.9 cm)
Marked
M.87.1.78
Purchased from Exhibit A, Chicago, 1982
Exhibited at Muckenthaler Cultural Center,
Fullerton, California, *Ceramic Form: A Woman's
Perspective*, 1989

Roy Lichtenstein

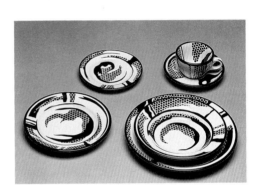

United States, b. 1923
Six-Piece Place Setting, 1966
Stoneware
M.87.1.79 dinner plate:
1¼ x 10 (diam.) in. (3.2 x 25.4 cm)
M.87.1.80 luncheon plate:
1¼ x 9 (diam.) in. (3.2 x 22.9 cm)
M.87.1.81 salad plate:
1 x 8 (diam.) in. (2.5 x 20.3 cm)
M.87.1.82 soup bowl:
1½ x 8¾ (diam.) in. (3.8 x 22.2 cm)
M.87.1.83 cup:
2½ x 4¾ x 3¾ (diam.) in. (6.4 x 12.1 x 9.5 cm)
M.87.1.84 saucer:
1 x 6 (diam.) in. (2.5 x 15.2 cm)
Marked
Purchased from Patricia Heesy Fine Art, New York
City, June 1982

Glen Lukens

United States, 1887–1967
Yellow Plate, 1930s
Earthenware, press-molded and glazed,
with added grog
2 x 13½ (diam.) in. (5.1 x 34.3 cm)
M.87.1.85 *
Purchased from Garth Clark Gallery, Los Angeles,
1981
Previously owned by Malvina Solomon
Exhibited at Fine Arts Gallery, California State
University, Los Angeles, *Glen Lukens: Pioneer of the
Vessel Aesthetic*, 1982; and Baxter Art Gallery,
California Institute of Technology, Pasadena,
*Contemporary Ceramic Vessels: Two Los Angeles
Collections*, 1984

Phillip Maberry

United States, b. 1951
Untitled Vessel, 1988
Earthenware, wheel-thrown, extruded, assembled,
and glazed
18¼ x 21 x 9½ (diam.) in. (46.4 x 53.3 x 24.1 cm)
TR.9282.4
Purchased from Garth Clark Gallery, New York City,
April 1988

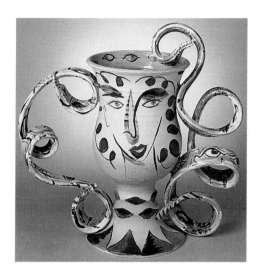

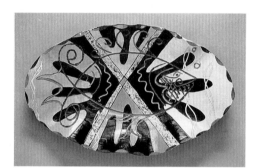

Fish Platter, 1985
Earthenware, hand-built and glazed
4 x 25 x 15 in. (10.2 x 63.5 x 38.1 cm)
Marked
M.87.1.87
Purchased from Garth Clark Gallery, Los Angeles,
January 1986

Louis Marak

United States, b. 1942
Aesthetic Craze, 1978
Porcelain, slab-built, with low-fire glazes,
underglaze pencils, china paint, overglaze decals,
and lusters
17 x 7 x 7 in. (43.2 x 17.8 x 17.8 cm)
M.87.1.188
Purchased from Dorothy Weiss Gallery, San
Francisco, July 1985
Exhibited at Renwick Gallery, Smithsonian
Institution, Washington, D.C., *American Porcelain:
New Expressions in an Ancient Art*, 1981

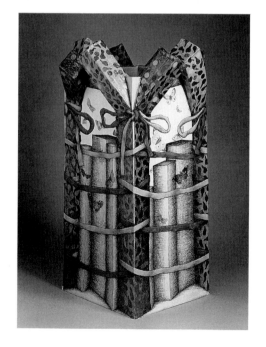

Tony Marsh

United States, b. 1953

White Vase, 1982

Porcelain, slip-cast

19½ x 11 x 6 in. (49.5 x 27.9 x 15.2 cm)

Marked

M.87.1.86

Purchased from Green Gallery, Carmel, California,
July 1983

Exhibited at Baxter Art Gallery, California Institute
of Technology, Pasadena, *Contemporary Ceramic
Vessels: Two Los Angeles Collections*, 1984

John Mason

United States, b. 1927

Untitled, 1985

Whiteware, slab-built and glazed

16 x 13 x 13 in. (40.6 x 33 x 33 cm)

Marked

T.R.9418

Purchased from L.A. Louver Gallery, Venice,
California, April 1987

Exhibited at Everson Museum of Art, Syracuse,
New York, *American Ceramics Now*, 1987

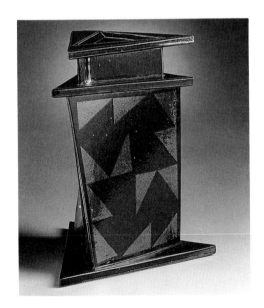

Paul Mathieu

Canada, b. 1954

Le Souci de soi (The care for the self), 1984

Porcelain, wheel-thrown and glazed

a. large plate: 1¼ x 13¼ (diam.) in. (3.2 x 33.7 cm)

b. saucer: 1¼ x 8¾ (diam.) in. (3.2 x 22.2 cm)

c. side bowl: 3 x 8 (diam.) in. (7.6 x 20.3 cm)

d. bowl: 1¾ x 9½ (diam.) in. (4.4 x 24.1 cm)

e. small plate: 1 x 9½ (diam.) in. (2.5 x 24.1 cm)

f. cup: 2⅞ x 6½ x 5¼ (diam.) in. (7.3 x 16.5 x 13.3 cm)

a-f combined: 7½ x 15¼ x 15 in. (19.1 x 38.7 x 38.1 cm)

Marked

TR.9282.3a-f

Purchased from Garth Clark Gallery, New York City, 1988

Exhibited at Walter Phillips Gallery, Banff, Alberta, *Paul Mathieu: Le Souci de soi*, 1985

Harrison McIntosh

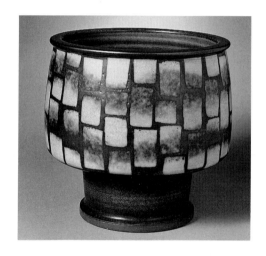

United States, b. 1914

Pedestal Bowl with Green Squares, c. 1971

Stoneware, wheel-thrown and glazed

8½ x 9 (diam.) in. (21.6 x 22.9 cm)

Marked

M.87.1.88

Purchased from Louis Newman Gallery, Beverly Hills, 1977

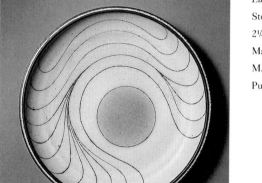

Large Plate, c. 1975

Stoneware, wheel-thrown and glazed

2¼ x 15¼ (diam.) in. (5.7 x 38.7 cm)

Marked

M.87.1.89

Purchased from Abacus, Pasadena, c. 1975

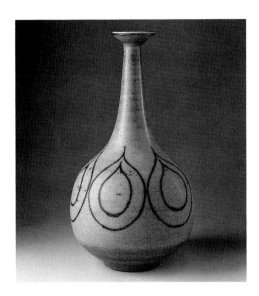

Bottle, 1974
Stoneware, wheel-thrown and glazed
12 x 6½ (diam.) in. (30.5 x 16.5 cm)
Marked
M.87.1.90
Purchased from Abacus, Pasadena, 1974

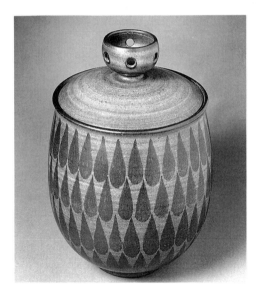

Covered Bowl, c. 1970
Stoneware, wheel-thrown and glazed
8 x 6 (diam.) in. (20.3 x 15.2 cm)
Marked
M.87.1.91a-b *
Purchased from Abacus, Pasadena, 1970
Exhibited at Baxter Art Gallery, California Institute
of Technology, Pasadena, *Contemporary Ceramic
Vessels: Two Los Angeles Collections*, 1984

Footed Cylindrical Vase, 1970
Stoneware, wheel-thrown and glazed
8½ x 4 (diam.) in. (21.6 x 10.2 cm)
Marked
M.87.1.92
Purchased from Abacus, Pasadena, 1970

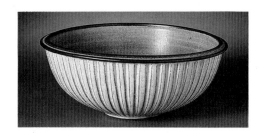

Bowl, 1974
Stoneware, wheel-thrown and glazed
3¼ x 8¼ (diam.) in. (8.3 x 21 cm)
Marked
M.87.1.93
Purchased from Abacus, Pasadena, mid-1970s

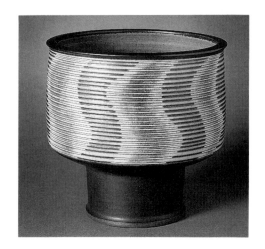

Pedestal Bowl with Zigzag Pattern, c. 1970
Stoneware, wheel-thrown and glazed
7 x 7¼ (diam.) in. (17.8 x 18.4 cm)
Marked
M.87.1.94 *
Purchased from Abacus, Pasadena, 1970

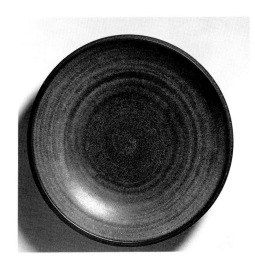

Low Bowl, 1960s
Stoneware, wheel-thrown and glazed
1¾ x 9¼ (diam.) in. (4.4 x 23.5 cm)
Marked
M.87.1.95
Purchased (probably) from Bullocks Wilshire,
Los Angeles, 1960s

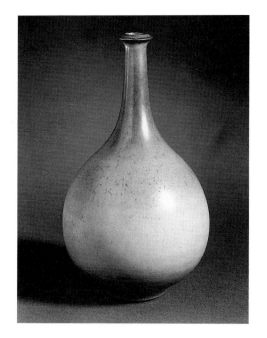

Green Bottle, c. 1970
Stoneware, wheel-thrown and glazed
9½ x 6 (diam.) in. (24.1 x 15.2 cm)
Marked
M.87.1.97
Purchased from Abacus, Pasadena, c. 1970
Exhibited at Baxter Art Gallery, California Institute
of Technology, Pasadena, *Contemporary Ceramic
Vessels: Two Los Angeles Collections*, 1984

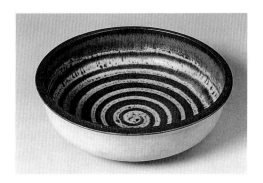

Blue Bowl with Spiral, 1970s
Stoneware, wheel-thrown and glazed
2½ x 7½ (diam.) in. (6.4 x 19.1 cm)
Marked
M.87.1.98
Purchased from Abacus, Pasadena, 1970s

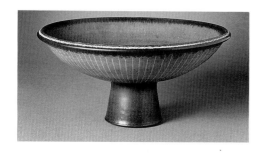

Blue Compote, 1970s
Stoneware, wheel-thrown and glazed
4 x 9 (diam.) in. (10.2 x 22.9 cm)
Marked
M.87.1.99
Purchased from Pasadena Guild of Childrens
Hospital, October 1984

Mineo Mizuno

Japan, b. 1944, active United States

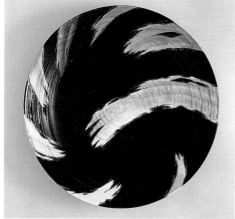

Plate, 1985
White earthenware, wheel-thrown and glazed
3 x 23 (diam.) in. (7.6 x 58.4 cm)
Marked
M.87.1.101
Purchased from *My Heart Belongs to Pasadena*
exhibition at California Institute of Technology,
Pasadena, February 1986

Gertrud Natzler (Austria, 1908–71, active United States)
Otto Natzler (Austria, b. 1908, active United States)

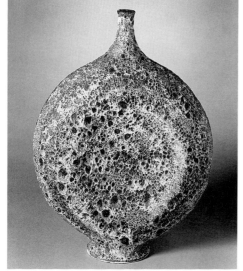

Pilgrim Bottle, 1956
Earthenware, wheel-thrown, altered, and glazed
17 x 13 x 5 in. (43.2 x 33 x 12.7 cm)
Marked
M.87.1.102 *
Purchased from Hatfield Gallery, Los Angeles,
November 1956

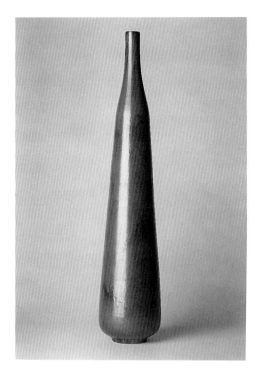

Red Bottle, 1957
Earthenware, wheel-thrown and glazed
22 x 5 (diam.) in. (55.9 x 12.7 cm)
Marked
M.87.1.103 *
Purchased from Hatfield Gallery, Los Angeles,
July 1957

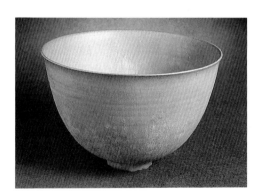

Yellow Bowl, 1960s
Earthenware, wheel-thrown and glazed
4¹/₂ x 7¹/₂ (diam.) in. (11.4 x 19.1 cm)
Marked
M.87.1.105
Purchased from Hatfield Gallery or Bullocks
Wilshire, Los Angeles, 1960s
Exhibited at Baxter Art Gallery, California Institute
of Technology, Pasadena, *Contemporary Ceramic
Vessels: Two Los Angeles Collections*, 1984

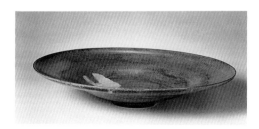

Plate with Apple-Green Glaze, 1950s or 1960s
Earthenware, wheel-thrown and glazed
2 x 11¹/₄ (diam.) in. (5.1 x 28.6 cm)
Marked
M.87.1.107
Purchased from Hatfield Gallery, Los Angeles, 1950s
or 1960s

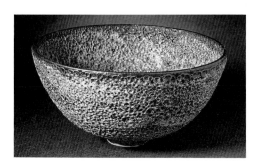

Brown Crater Bowl, 1960
Earthenware, wheel-thrown and glazed
3³/₄ x 7¹/₄ (diam.) in. (9.5 x 18.4 cm)
Marked
M.87.1.108
Purchased from Hatfield Gallery or Bullocks
Wilshire, Los Angeles, 1962

Otto Natzler

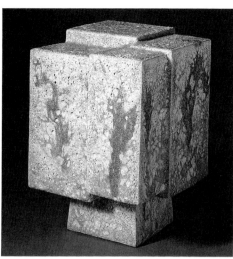

Green Lichen Cube, 1982

Earthenware, slab-constructed and glazed

12 x 9 x 9 in. (30.5 x 22.9 x 22.9 cm)

Marked

M.87.1.109

Acquired from Louis Newman Gallery, Beverly Hills, in exchange for another Natzler vessel, February 1983

Exhibited at Baxter Art Gallery, California Institute of Technology, Pasadena, *Contemporary Ceramic Vessels: Two Los Angeles Collections*, 1984

Art Nelson

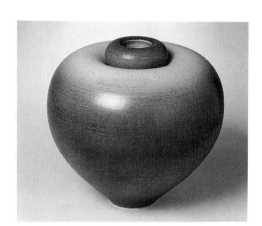

United States, b. 1942

Vessel, 1983

Stoneware, wheel-thrown and glazed

12 x 13 (diam.) in. (30.5 x 33 cm)

Marked

M.87.1.110a-b

Purchased from Garth Clark Gallery, Los Angeles, 1984

Richard Notkin

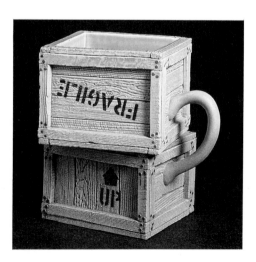

United States, b. 1948

Double-Crate Cup, 1982

Porcelain, slip-cast and glazed

3¾ x 3¾ x 3¼ in. (9.5 x 9.5 x 8.3 cm)

Marked

M.87.1.111

Purchased from Garth Clark Gallery, Los Angeles, June 1983

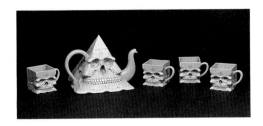

Skeleton Teapot, 1980
Porcelain, slip-cast and glazed
6 x 9 x 7 in. (15.2 x 22.9 x 17.8 cm)
Marked
M.87.1.112a-b
Purchased from Garth Clark Gallery, Los Angeles,
December 1982
Exhibited at Baxter Art Gallery, California Institute
of Technology, Pasadena, *Contemporary Ceramic
Vessels: Two Los Angeles Collections*, 1984

Four Skeleton Cups, 1980
Porcelain, slip-cast and glazed
Each: 2¾ x 3¾ x 2¾ in. (7 x 9.5 x 7 cm)
Marked
M.87.1.113-.116
Purchased from Garth Clark Gallery, Los Angeles,
December 1982
Exhibited at Baxter Art Gallery, California Institute
of Technology, Pasadena, *Contemporary Ceramic
Vessels: Two Los Angeles Collections*, 1984

Vain Imaginings, c. 1978
White earthenware, glazed and molded, with wood
and silver-plated brass
16 x 16½ x 13½ in. (40.6 x 41.9 x 34.3 cm)
M.87.1.117a-e *
Purchased from Garth Clark Gallery, New York City,
February 1985

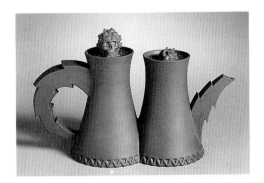

Cooling Tower Teapot (Variation #1), Yixing Series,
1983
Earthenware, slip-cast
6 x 9 x 3¾ in. (15.2 x 22.9 x 9.5 cm)
Marked
M.87.1.118a-b
Purchased from Garth Clark Gallery, Los Angeles,
July 1983

Magdalene Odundo

Kenya, b. 1953, active United Kingdom

Charcoal Burnished Pot, 1983

Red earthenware, hand-built, burnished, and reduction-fired

13 x 10 (diam.) in. (33 x 25.4 cm)

Marked

M.87.1.119

Purchased from British Crafts Centre, London, September 1983

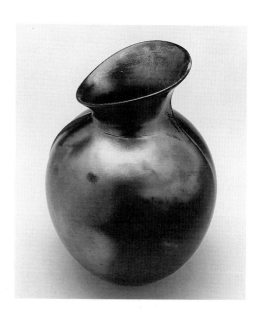

Mark Pharis

United States, b. 1947

Teapot, 1984

Earthenware, hand-built

10 x 10½ x 3½ in. (25.4 x 26.7 x 8.9 cm)

Marked

M.87.1.120a-b

Purchased from Garth Clark Gallery, Los Angeles, 1984

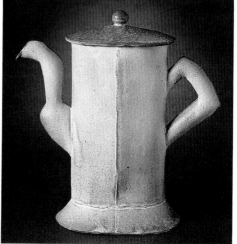

Pablo Picasso

Spain, 1881–1973, active France

Pitcher with Four Faces, 1970s

Terra-cotta, wheel-thrown, with painted design

12 x 8½ x 5 (diam.) in. (30.5 x 21.6 x 12.7 cm)

Marked

M.87.1.121

Purchased from Heritage Gallery, Los Angeles, November 1979

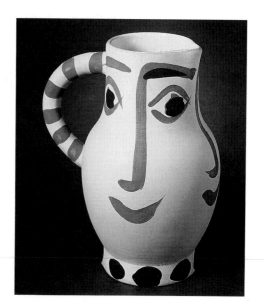

Henry Pim

United Kingdom, b. 1947
Vessel, 1985
Stoneware, slab-constructed, assembled, and glazed
10 x 16 x 7 in. (25.4 x 40.6 x 17.8 cm)
Marked
M.87.1.122
Purchased from Garth Clark Gallery, Los Angeles,
September 1985

Katharine Pleydell-Bouverie

United Kingdom, 1895–1985
Bowl, 1970s
Stoneware
3¾ x 7¾ (diam.) in. (9.5 x 19.7 cm)
Marked
M.87.1.123
Purchased from Beaux Arts Gallery, Bath, England,
July 1984

Jacqueline Poncelet

United Kingdom, b. 1947
Turtle Teapot, 1982
Earthenware
5½ x 8½ x 6¾ in. (14 x 21.6 x 17.1 cm)
M.87.1.124
Purchased from Victoria and Albert Museum Craft
Shop, July 1982
Exhibited at Baxter Art Gallery, California Institute
of Technology, Pasadena, *Contemporary Ceramic
Vessels: Two Los Angeles Collections*, 1984

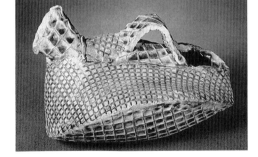

Kenneth Price

United States, b. 1935
Vase, 1956
Earthenware, wheel-thrown and incised
7¼ x 6 x 5 in. (18.4 x 15.2 x 12.7 cm)
Marked
M.87.1.125
Purchased from Garth Clark Gallery, Los Angeles,
October 1981
Exhibited at Baxter Art Gallery, California Institute
of Technology, Pasadena, *Contemporary Ceramic
Vessels: Two Los Angeles Collections*, 1984

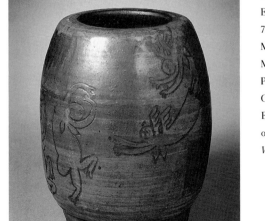

Ursula Morley Price

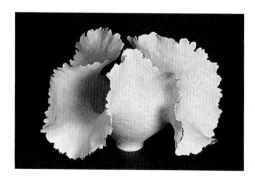

United Kingdom, b. 1936

White Bowl, 1982

Porcelain

4¼ x 7¼ x 7½ in. (10.8 x 18.4 x 19.1 cm)

M.87.1.127

Purchased from Casson Gallery, London, July 1982

Elsa Rady

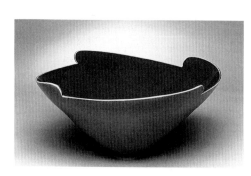

United States, b. 1943

Red Porcelain Bowl, 1979

Porcelain, wheel-thrown, trimmed, and glazed

5½ x 12 (diam.) in. (14 x 30.5 cm)

Marked

M.87.1.128

Purchased from Mandell Gallery, Los Angeles,

January 1980

Exhibited at Baxter Art Gallery, California Institute

of Technology, Pasadena, *Contemporary Ceramic

Vessels: Two Los Angeles Collections*, 1984

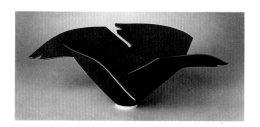

Winged Victory, 1983

Porcelain, wheel-thrown, trimmed, and glazed

5 x 14½ x 15¼ in. (12.7 x 36.8 x 38.7 cm)

Marked

M.87.1.129 *

Purchased from Janus Gallery, Los Angeles,

July 1983

Lucie Rie

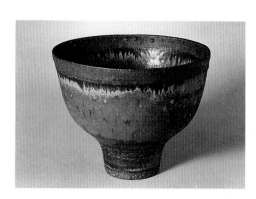

Austria, b. 1902, active United Kingdom

Footed Bowl, c. 1979

Stoneware, wheel-thrown and glazed

4¾ x 6½ (diam.) in. (12.1 x 16.5 cm)

Marked

M.87.1.130

Purchased from Primavera, Cambridge, England,

May 1979

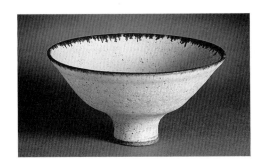

Speckled White Footed Bowl, c. 1979
Stoneware, wheel-thrown and glazed
3 x 6 (diam.) in. (7.6 x 15.2 cm)
Marked
M.87.1.131
Purchased from Liberty's of London, June 1980

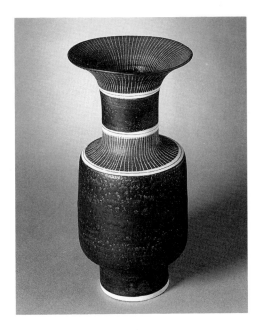

Vase, 1979
Porcelain, wheel-thrown and glazed, with white
sgraffito and inlaid decoration
7¼ x 4 (diam.) in. (18.4 x 10.2 cm)
Marked
M.87.1.132
Purchased from Oxford Gallery, Oxford, England,
May 1979

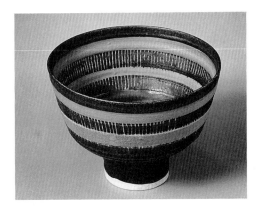

Footed Bowl, 1970s
Porcelain, wheel-thrown and glazed, with white
sgraffito and inlaid decoration
4¼ x 5½ (diam.) in. (10.8 x 14 cm)
Marked
M.87.1.133
Purchased from Primavera, Cambridge, England,
1979
Exhibited at Baxter Art Gallery, California Institute
of Technology, Pasadena, *Contemporary Ceramic
Vessels: Two Los Angeles Collections*, 1984

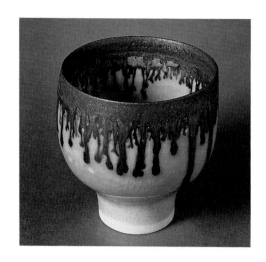

Small Yellow Footed Bowl, late 1970s
Porcelain, wheel-thrown and glazed
3¹/₈ x 3¹/₄ (diam.) in. (7.9 x 8.3 cm)
Marked
M.87.1.134 *
Purchased from Liberty's of London, June 1980

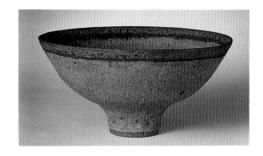

Crater Bowl, 1982
Stoneware, wheel-thrown and glazed
4¹/₄ x 8¹/₂ (diam.) in. (10.8 x 21.6 cm)
Marked
M.87.1.135
Purchased from Westminster Gallery, Boston,
October 1982

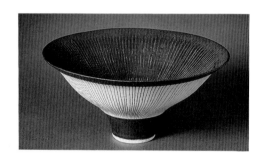

Bowl, 1970s
Porcelain, wheel-thrown and glazed, with white
sgraffito and inlaid decoration
4¹/₄ x 9¹/₄ (diam.) in. (10.8 x 23.5 cm)
Marked
M.87.1.136 *
Purchased in St. Ives, Cornwall, England, 1984

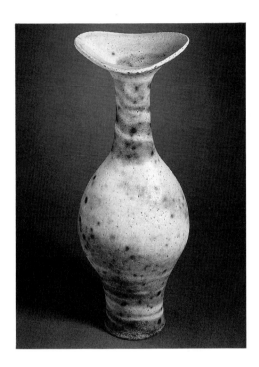

Tall Vase, 1970s
Stoneware, wheel-thrown, with brown and white clays
12½ x 5¼ (diam.) in. (31.8 x 13.3 cm)
Marked
M.87.1.137
Purchased from Beaux Arts Gallery, Bath, England, 1984

Mary Rogers

United Kingdom, b. 1929

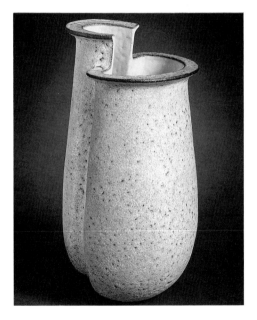

Double-Form Vase, 1984
Stoneware, pinch-built and coil-formed
10 x 5¼ (diam.) in. (25.4 x 13.3 cm)
Marked
M.87.1.138
Purchased from British Crafts Centre, London, July 1984

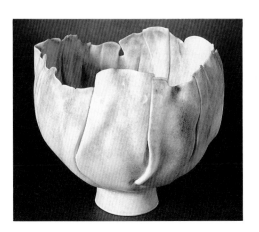

Moulded Petal Bowl, 1984
Porcelain, pinch-built, oxidized-fired, and glazed
4 x 5 (diam.) in. (10.2 x 12.7 cm)
Marked
M.87.1.139
Purchased from Beaux Arts Gallery, Bath, England, July 1984

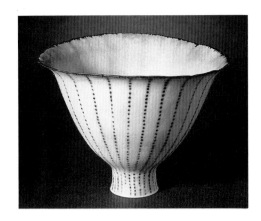

Footed Bowl, 1980
Porcelain, pinch-built, oxidized-fired, and glazed
5 x 4¹/₂ (diam.) in. (12.7 x 11.4 cm)
Marked
M.87.1.140
Purchased from Cassan Gallery, London, June 1980

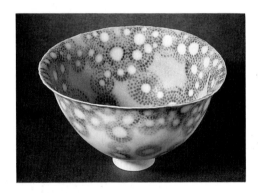

Kiwi Bowl, 1980s
Porcelain, pinch-built, oxidized-fired, and glazed
5 x 4¹/₂ (diam.) in. (12.7 x 11.4 cm)
Marked
M.87.1.141
Provenance unknown

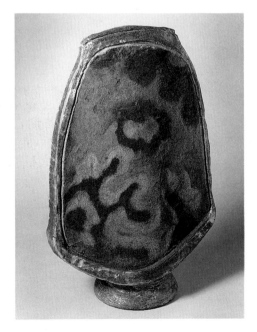

Jerry Rothman
United States, b. 1933
Sky Pot, 1961
Stoneware, hand-built and glazed
20 x 13 x 6 in. (50.8 x 33 x 15.2 cm)
M.87.1.142
Purchased from Garth Clark Gallery, Los Angeles,
December 1985
Previously owned by James Melchert

Judith Salomon

United States, b. 1952

Mat Green Vessel Box, 1986

Low-fire whiteware, slab-constructed and glazed

11¼ x 22 x 10¾ in. (28.6 x 55.9 x 27.3 cm)

M.87.1.143

Purchased from Garth Clark Gallery, Los Angeles,

September 1986

Exhibited at Muckenthaler Cultural Center,

Fullerton, California, *Ceramic Form: A Woman's Perspective*, 1989

Adrian Saxe

United States, b. 1943

Cup and Raku Base, 1984

Porcelain and raku, with metallic lusters

9 x 8 x 6 in. (22.9 x 20.3 x 15.2 cm)

Marked

TR.9282.1a-b

Purchased from Garth Clark Gallery, Los Angeles,

February 1987

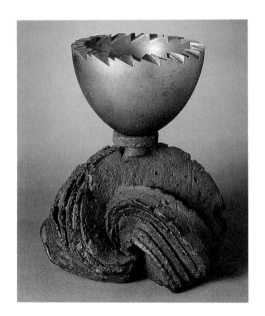

Antelope Jar, 1985

Porcelain, wheel-thrown, glazed, gilded,

and press-molded, with raku base

23 x 11¾ x 10 in. (58.4 x 29.8 x 25.4 cm)

Marked

TR.9301a-c

Purchased from Garth Clark Gallery, Los Angeles,

1987

Exhibited at Los Angeles Institute of Contemporary

Art, *Pacific Connections*, 1985; and University of

Missouri-Kansas City Gallery of Art, *Adrian Saxe*,

1987

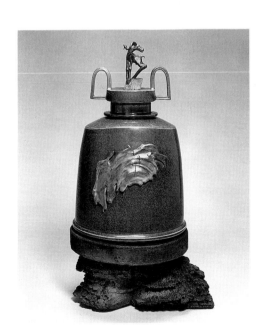

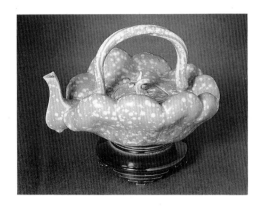

Squash Teapot, 1983
Porcelain, slip-cast, assembled, and glazed
7½ x 9 x 7¼ in. (19.1 x 22.9 x 18.4 cm)
Marked
M.87.1.144a-b *
Purchased from American Hand Gallery,
Washington D.C., 1983

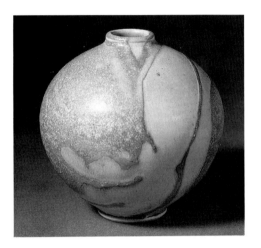

Small Globular Vase, c. 1977
Porcelain, wheel-thrown and glazed
4½ x 3½ (diam.) in. (11.4 x 8.9 cm)
Marked
M.87.1.145
Purchased in Southern California, late 1970s

David Shaner
United States, b. 1934
Bowl with Cross Opening, 1980s
Stoneware, hand-built and glazed
5½ x 10 x 10 in. (14 x 25.4 x 25.4 cm)
Marked
M.87.1.146
Purchased from Gallery Eight, La Jolla, California,
June 1983

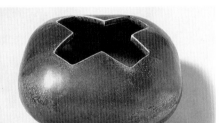

Tatsuzō Shimaoka
Japan, b. 1920
Pair of Plates, 1960s
Earthenware, wheel-thrown and glazed, with
pressed design
Each: 1 x 8 (diam.) in. (2.5 x 20.3 cm)
M.87.1.147-.148
Purchased in 1960s

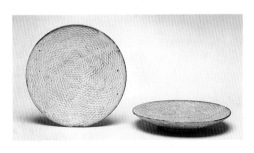

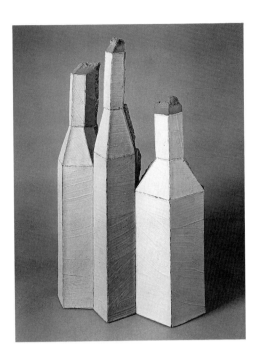

Susan Shutt

United States, b. 1951
Three Bottles, 1984
Terra-cotta, slab-constructed and glazed
11½ x 7 x 4 in. (29.2 x 17.8 x 10.2 cm)
M.87.1.149
Purchased from Garth Clark Gallery, Los Angeles,
1984

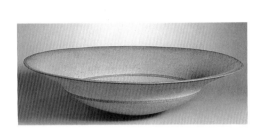

Alev Siesbye

Turkey, b. 1938, active Denmark and France
Large Platter, 1983
Stoneware, hand-coiled and oxidized-fired
5¾ x 21 (diam.) in. (14.6 x 53.3 cm)
Marked
M.87.1.152
Purchased from Garth Clark Gallery, Los Angeles,
May 1984

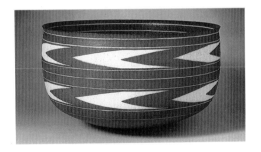

Black-and-White Bowl, 1983
Stoneware, hand-coiled and oxidized-fired, with wax
resist decoration
7 x 12½ (diam.) in. (17.8 x 31.8 cm)
Marked
M.87.1.153
Purchased from Garth Clark Gallery, Los Angeles,
1984

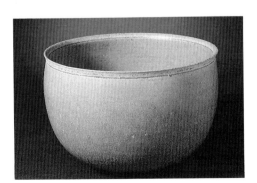

Turquoise Bowl, 1983
Stoneware, wheel-thrown, oxidized-fired,
and glazed
3¾ x 7 (diam.) in. (9.5 x 17.8 cm)
Marked
M.87.1.154
Purchased from Garth Clark Gallery, New York City,
May 1984

Anna Silver

United States, b. 1935
Vase with Handles, 1986
Porcelain, wheel-thrown, trimmed, and glazed
22½ x 7½ (diam.) in. (57.2 x 19.1 cm)
M.87.1.155
Purchased from Garth Clark Gallery, Los Angeles,
1986

Martin Smith

United Kingdom, b. 1950
Two Angular Forms, 1979
Red earthenware, glazed
4 x 11½ x 7½ in. (10.2 x 29.2 x 19.1 cm)
M.87.1.156a-b
Purchased from Liberty's of London, May 1979

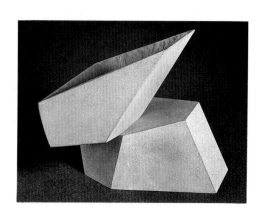

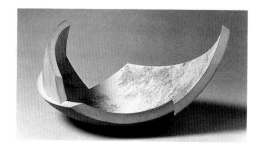

Bowl, c. 1979
Red earthenware, glazed, with epoxy
6⅛ x 13 x 9⅛ in. (15.6 x 33 x 23.2 cm)
M.87.1.157 *
Purchased from Garth Clark Gallery, Los Angeles,
1984

Paul Soldner

United States, b. 1921

Wasp-Waist Form, 1982

Earthenware, wheel-thrown, hand-built, impressed, and raku-fired

15½ x 12 x 8 in. (39.4 x 30.5 x 20.3 cm)

Marked

M.87.1.158 *

Acquired from the artist in exchange for another Soldner vessel, 1984

Robert Sperry

United States, b. 1927

Plate, 1986

Stoneware, wheel-thrown, with white slip

3¾ x 27½ (diam.) in. (9.5 x 69.9 cm)

Marked

TR.9282.7

Purchased from Cross Creek Gallery, Malibu, 1987

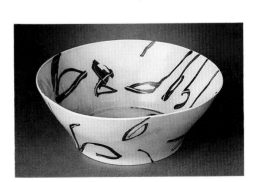

Thomas Spleth

United States, b. 1946

Bowl, 1981

Porcelain, slip-cast, with oxide decoration

4¾ x 12 (diam.) in. (12.1 x 30.5 cm)

M.87.1.159

Purchased from American Hand Gallery, Washington, D.C., June 1981

Gerda Spurey

Czechoslovakia, b. 1940, active Mexico

Getleiles #14, 1980

Porcelain, hand-built

10 x 4 x 3½ in. (25.4 x 10.2 x 8.9 cm)

M.87.1.160

Purchased from Florence Duhl Gallery, New York City, September 1986

Exhibited at Baxter Art Gallery, California Institute of Technology, Pasadena, *Contemporary Ceramic Vessels: Two Los Angeles Collections*, 1984

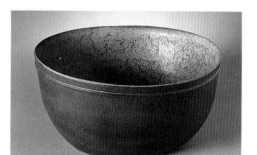

Rudolf Staffel

United States, b. 1911

Bowl, 1951

Stoneware, wheel-thrown, altered, glazed, and fired

5 x 9½ x 8½ in. (12.7 x 24.1 x 21.6 cm)

Marked

M.87.1.161 *

Purchased from Garth Clark Gallery, Los Angeles, June 1982

Previously owned by Richard DeVore

Exhibited at Baxter Art Gallery, California Institute of Technology, Pasadena, *Contemporary Ceramic Vessels: Two Los Angeles Collections*, 1984

Susanne Stephenson

United States, b. 1935

Extruded Foot Vessel, 1982

Terra-cotta, wheel-thrown, altered, and glazed, with extruded clay

17¾ x 13½ x 10½ in. (45.1 x 34.3 x 26.7 cm)

M.87.1.162

Purchased from Garth Clark Gallery, Los Angeles, November 1982

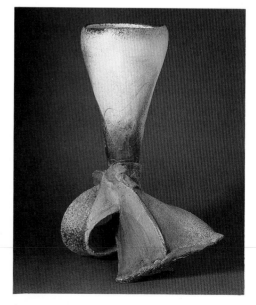

Geoffrey Swindell

United Kingdom, b. 1945
Porcelain Form, 1982
Porcelain, wheel-thrown and glazed, with enamel
and luster
4½ x 4 (diam.) in. (11.4 x 10.2 cm)
Marked
M.87.1.163
Purchased from Craftsmen Potters Shop, London,
September 1983
Exhibited at Baxter Art Gallery, California Institute
of Technology, Pasadena, *Contemporary Ceramic
Vessels: Two Los Angeles Collections*, 1984

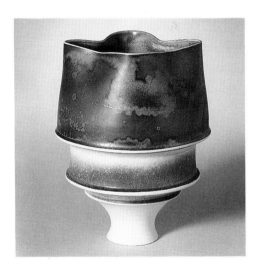

Square-Mouthed Form, 1984
Porcelain, wheel-thrown and glazed, with enamel
and luster
4¾ x 4 (diam.) in. (12.1 x 10.2 cm)
Marked
M.87.1.164 *
Purchased from the artist, Cardiff, Wales, 1984

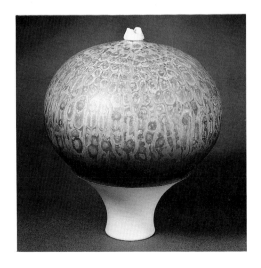

Porcelain Form, 1982
Porcelain, wheel-thrown and glazed, with enamel
and luster
4 x 4 (diam.) in. (10.2 x 10.2 cm)
Marked
M.87.1.165
Purchased from Graham Gallery, New York City,
December 1982

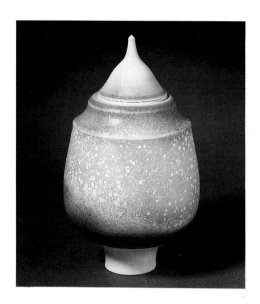

Pointed Covered Jar, 1983
Porcelain, wheel-thrown and glazed, with enamel
and luster
5 x 3¼ (diam.) in. (12.7 x 8.3 cm)
Marked
M.87.1.166a-b
Purchased from the artist, Cardiff, Wales, July 1984

Akio Takamori

Japan, b. 1950, active United States
Man with Chicken, 1985
Stoneware, slab-constructed and salt-glazed,
with overglaze and underglaze paints
17½ x 18 x 7 in. (44.5 x 45.7 x 17.8 cm)
Marked
M.87.1.167 *
Acquired from Garth Clark Gallery, Los Angeles,
in exchange for another Takamori vessel,
November 1986

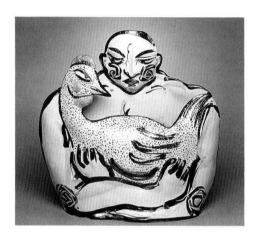

Sutton Taylor

United Kingdom, b. 1943
Luster Bowl, 1983
Earthenware, wheel-thrown, wood-fired, painted,
and reduction-fired
4¾ x 13¾ (diam.) in. (12.1 x 34.9 cm)
Marked
M.87.1.168
Purchased from British Crafts Centre, London,
September 1983

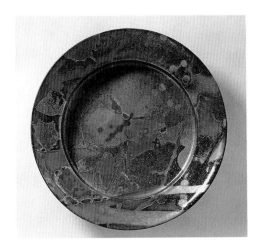

Plate, c. 1985
Earthenware, wheel-thrown, wood-fired, painted,
and reduction-fired
3 x 16 (diam.) in. (7.6 x 40.6 cm)
Marked
M.87.1.169
Purchased from Garth Clark Gallery, Los Angeles,
1985

Janice Tchalenko
United States, b. 1942
Pitcher, 1982
Stoneware
11 x 6½ x 5½ (diam.) in. (27.9 x 16.5 x 14 cm)
M.87.1.170
Purchased from Primavera, Cambridge, England,
July 1982

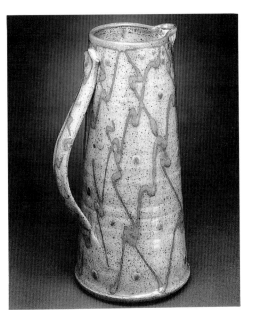

Judy Trim
United Kingdom, b. 1943
Tall Vase, 1982
Stoneware
20½ x 7¾ x 7¼ in. (52.1 x 19.7 x 18.4 cm)
M.87.1.171
Purchased from Victoria and Albert Museum Craft
Shop, London, July 1982

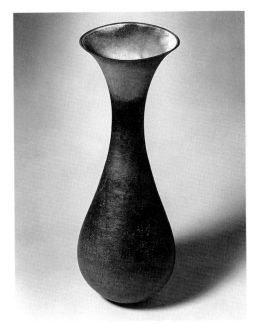

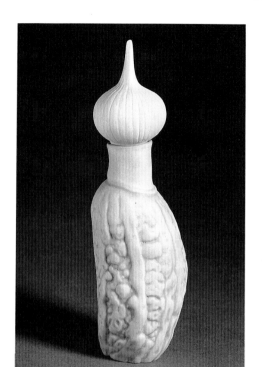

Lynn Turner

United States, b. 1943

Perfume Bottle, 1980

Porcelain, hand-built

6½ x 2 x 2⅛ in. (16.5 x 5.1 x 5.4 cm)

Marked

M.87.1.172a-b

Purchased from Craft and Folk Art Museum Shop,

Los Angeles, February 1982

Robert Turner

United States, b. 1913

de Chelly, 1983

Stoneware, wheel-thrown, altered, glazed, and
sandblasted

10 x 9 (diam.) in. (25.4 x 22.9 cm)

Marked

M.87.1.173 *

Purchased from Exhibit A, Chicago, October 1983

Exhibited at Baxter Art Gallery, California Institute
of Technology, Pasadena, *Contemporary Ceramic
Vessels: Two Los Angeles Collections*, 1984

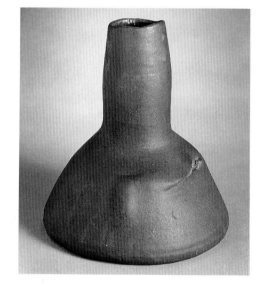

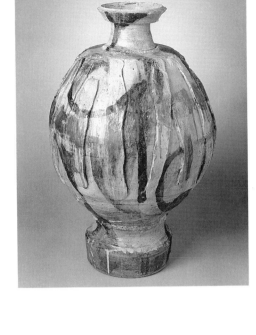

Peter Voulkos

United States, b. 1924

Standing Jar, 1958

Stoneware, wheel-thrown, with applied slabs,
glazed with cobalt and red iron oxides

22½ x 16 x 17 in. (57.2 x 40.6 x 43.2 cm)

TR.9282.2

Purchased from Garth Clark Gallery, New York City,
December 1986

Previously owned by Mitzi Landau

Tea Bowl, 1953

Stoneware, wheel-thrown and glazed

4¼ x 5 (diam.) in. (10.8 x 12.7 cm)

Marked

M.87.1.174

Purchased from Garth Clark Gallery, Los Angeles,
1981

Previously owned by Bernard Brenner

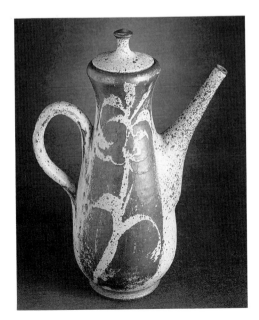

Coffee Pot, 1955

Stoneware, wheel-thrown and decorated

11½ x 8¾ x 4¾ (diam.) in. (29.2 x 22.2 x 12.1 cm)

Marked

M.87.1.175a-b *

Purchased from Garth Clark Gallery, Los Angeles,
1984

Exhibited at Scripps College, Claremont, California,
Scripps College Annual Treasury of Ceramic Art,
1955

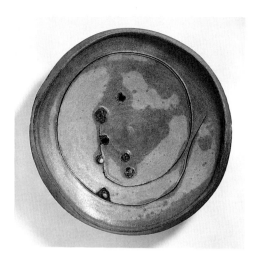

Large Plate, 1979
Stoneware, wheel-thrown and altered, with
inclusions
4½ x 21½ (diam.) in. (11.4 x 54.6 cm)
Marked
M.87.1.176
Purchased from Exhibit A, Chicago, January 1980
Exhibited at Baxter Art Gallery, California Institute
of Technology, Pasadena, *Contemporary Ceramic
Vessels: Two Los Angeles Collections*, 1984

John Ward

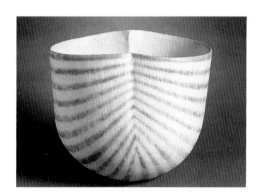

United Kingdom, b. 1943
Striped Bowl, c. 1983
Stoneware, hand-built, glazed, and fired,
with oxide decoration
7½ x 9½ x 5½ in. (19.1 x 24.1 x 14 cm)
Marked
M.87.1.177
Purchased from Victoria and Albert Museum Craft
Shop, London, 1984

Kurt Weiser

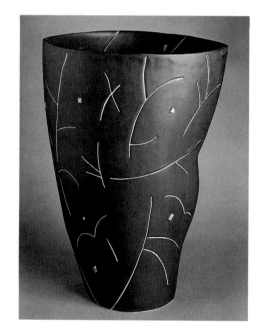

United States, b. 1950
Tall Charcoal Vase, 1982
Porcelain, slip-cast, incised, glazed, and fired,
with glaze chip inclusions
17½ x 13 x 9 in. (44.5 x 33 x 22.9 cm)
Marked
M.87.1.178
Purchased from Garth Clark Gallery, Los Angeles,
January 1982

Beatrice Wood

United States, b. 1894

Luster Glaze Footed Vessel, c. 1955

Earthenware, wheel-thrown and glazed, with lusters

6¼ x 7 (diam.) in. (15.9 x 17.8 cm)

Marked

M.87.1.179

Purchased from Garth Clark Gallery, Los Angeles,

March 1983

Exhibited at Baxter Art Gallery, California Institute

of Technology, Pasadena, *Contemporary Ceramic

Vessels: Two Los Angeles Collections*, 1984

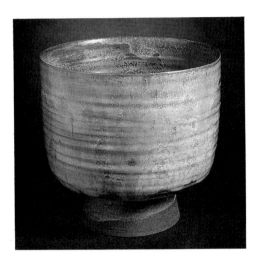

Double Bottle, c. 1970

Earthenware, wheel-thrown and assembled,

with luster glaze

9¾ x 5½ (diam.) in. (24.8 x 14 cm)

Marked

M.87.1.180

Purchased from the artist, early 1970s

Exhibited at Baxter Art Gallery, California Institute

of Technology, Pasadena, *Contemporary Ceramic

Vessels: Two Los Angeles Collections*, 1984

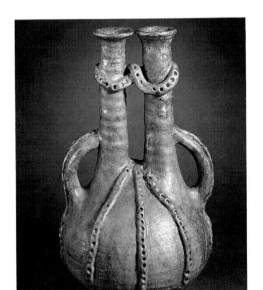

Suspicious Wife Plate, 1952

Earthenware, wheel-thrown and glazed

2¼ x 16¼ (diam.) in. (5.7 x 41.3 cm)

Marked

M.87.1.181 *

Purchased from Garth Clark Gallery, Los Angeles,

1982

Exhibited at MAIN Gallery, Visual Arts Center,

California State University, Fullerton, *Beatrice Wood

Retrospective*, 1983

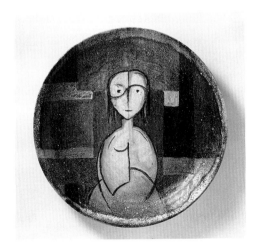

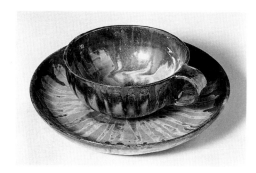

Cup and Saucer, 1982
Earthenware, wheel-thrown and glazed
a. cup: 2 x 5¾ x 4¼ (diam.) in. (5.1 x 14.6 x 10.8 cm)
b. saucer: 1 x 7 (diam.) in. (2.5 x 17.8 cm)
Marked
M.87.1.182a-b
Purchased from Garth Clark Gallery, Los Angeles, 1982

Betty Woodman

United States, b. 1930
Waterbug Breakfast Tray with Pitchers, 1982
Low-fire whiteware, hand-built, assembled, and glazed
a-b. pitchers (each): 7½ x 10 x 4¼ in.
(19.1 x 25.4 x 10.8 cm)
c. tray: 2½ x 31½ x 16¼ in. (6.4 x 80 x 41.3 cm)
Marked
M.87.1.183a-c
Purchased from Garth Clark Gallery, Los Angeles, April 1983
Exhibited at Baxter Art Gallery, California Institute of Technology, Pasadena, *Contemporary Ceramic Vessels: Two Los Angeles Collections*, 1984

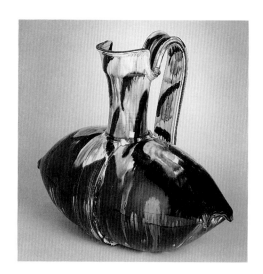

Pillow Pitcher, 1982
Low-fire whiteware, wheel-thrown, altered, assembled, and glazed
20 x 24 x 13 in. (50.8 x 61 x 33 cm)
Marked
M.87.1.184 *
Purchased from Garth Clark Gallery, Los Angeles, April 1982
Exhibited at Baxter Art Gallery, California Institute of Technology, Pasadena, *Contemporary Ceramic Vessels: Two Los Angeles Collections*, 1984

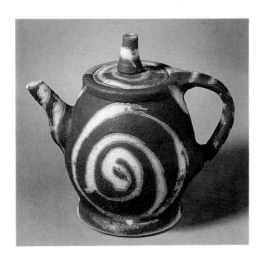

Arnold Zimmerman

United States, b. 1954

Teapot with Blue Swirl, 1982

Earthenware, wheel-thrown and glazed

7½ x 9 x 6 (diam.) in. (19.1 x 22.9 x 15.2 cm)

Marked

M.87.1.185a-b

Purchased from Garth Clark Gallery, Los Angeles,

January 1983

GLOSSARY

This glossary is designed to assist those unfamiliar with the technical terms used in describing clay materials and methods. Not all terms listed here are used in the body of this volume.

Additive

An organic or mineral material that is mixed with clay to modify the way it responds to forming, drying, and firing. Sometimes referred to as aplastic, grog, inclusion, nonplastic, or temper.

Aggregate

An inert component added to ceramic bodies. Also referred to as filler, grog, or potter's flint.

Aging

The process of storing a prepared ceramic material, often a wet, plastic clay body, to improve its working properties by allowing a thorough wetting of its particles. This leads to slow compression and bacterial action (called souring) which further increases the workability of the clay.

Alumina

Oxide of aluminum found in bauxite and clay.

Aplastic

Particulate matter in a clay body that has no effect on plasticity. One of several terms used for temper, but lacking implications of either natural occurrence or deliberate addition by the potter. See Additive.

Art pottery

Pottery made from 1870 to 1920 by manufacturers who wished these limited-run, hand-decorated pieces to be used as art objects and not functional crockery.

Ash

Residue from the burning of leaves, straw, hay, or other matter often used as the primary ingredient in some high-fire glazes. Popularized by non-Western cultures, it has become a convenient source for glazes that appear oriental.

Ball clay

An extremely fine-grained, plastic, sedimentary clay that fires white or near white in color. It is usually added to porcelain and other whiteware bodies to increase plasticity.

Band

A decorative or functional element that encircles a clay vessel.

Base

See Foot.

Bat

A slab, disk, or board of plaster, fired clay, asbestos, or other slightly porous material on which wet clay is either worked or placed to dry. Can be a detachable part of the wheel head.

Batch

A term used in glaze calculation to describe a glaze made up of chemicals that have been specifically measured in order to accomplish a desired effect.

Binder

A substance, usually organic, added to a clay or glaze to increase its strength.

Bisque (or biscuit)

Unglazed ware that has been fired to a temperature sufficient to harden but not mature the body. This firing is usually followed by another at a higher temperature for the glaze. The purpose of the first firing is to harden the greenware enough so that additional work can be performed.

Body

A blend of clay and other elements that comprises the substance from which ceramics are formed. Often referred to as clay body or paste (in porcelain work).

Bone ash

Calcium phosphate (usually from ground calcified cow bones) used as flux and to form the glass content in bone china.

Bone china

A hard, translucent whiteware made by the English from a soft-paste porcelain developed in the eighteenth century. The body contains up to 50 percent bone ash and is not very plastic; it also tends to warp.

Band ➤

Burnishing

A method of producing a luster on a fired or unfired (when leather hard) clay surface. The look is achieved by rubbing the piece with a hard, smooth object to compact and align the surface particles so that they give off a more uniform sheen. See Polish.

Calcareous

Of or like calcium carbonate, calcium, or lime.

Calcination

To burn to ashes.

Calx

The ash powder formed from the calcination of minerals.

Casting

A process of forming clay objects by pouring a clay slip into a hollow plaster mold and allowing it to remain long enough for a layer of clay to thicken on the mold wall. After sufficient hardening, the puddle of slip in the center of the mold is poured off, the mold is opened, and the clay object is removed. It is allowed to dry and then fired. This method allows for the creation of numerous forms from a single mold. Also referred to as slip casting or solid casting.

Ceramics

(1) Objects made of clay and formed by the application of heat; (2) the art, field, study, or technique of producing such articles; and (3) in art and archaeology, high-fired, usually vitrified, cooking and serving utensils and art objects (as distinct from pottery).

China

A loosely applied term referring to whiteware bodies fired at low porcelain temperatures. They are generally vitreous and may be translucent.

China clay

See Kaolin.

China paint

See Enamel.

Clay

A malleable material made from decomposing rock. Generally free of vegetable matter, this material often contains other impurities that affect color and firing temperatures. Clay is classified into various types, such as ball clays, fire clays, and slip clays.

Clay body

See Body.

Cleavage

The tendency of some minerals to split along planes determined by their crystalline structure.

Cockspur

See Spur.

Coiling

A hand method of forming pottery by building up the walls with ropelike rolls of clay and then smoothing over the joints. This method leaves imperfections in the surface that attest to a hand-built genesis. Variations include ring building, spiral coiling, and segmental coiling. It is the oldest method of vessel production, predating the invention of the potter's wheel.

Collar

The part of a vessel between the shoulder and rim, typically characterized by a marked constriction from the maximum diameter. See Neck.

Colorant

A chemical element that contributes color to a mixture. Unglazed, low-fired pottery is colored chiefly by carbon, iron, and manganese, whereas a broader range of colors is possible with glazes. See Pigment, Stain.

Combing

A method of decoration where a coarse comb or feather is dragged over clay, clay slip, or glaze.

Cone

(1) A support, in the form of a cone, for an object being fired; and (2) a scale for measuring the temperature of a kiln. For the latter, supports are made in the form of a pyramid and given an index number corresponding to a certain melting point. When the predetermined temperature is reached, the tip of the pyramid sags until it is level with the base. Such cones are principally employed in order to measure temperatures in those kilns where this factor is not controlled automatically. Also known as Orton cones, pyrometric cones, and Seger cones.

Firing Temperatures
Cones 022–15: 605° to 1435° C
 Cone 07: 990° C (low-fire earthenware matures)
 Cone 02: 1125° C (earthenware matures)
 Cone 9: 1285° C (stoneware matures)
 Cone 13: 1350° C (porcelain matures)

All temperatures are approximate. (Source: Kenny, John B. *The Complete Book of Pottery Making.* 2d ed. Radnor, Pennsylvania: Chilton Book Company, 1976.)

Crackle glaze

A glaze containing minute cracks in the surface. The cracks are decorative and occur when the body and glaze surface cool at different rates. Rubbing additional glaze into the crevices accentuates the effect.

Crawling

The action by which a glaze separates from the body during drying or firing, leaving unglazed areas.

Crazing

An excessive crackle in the glaze that penetrates to the body. It can be remedied by adjusting the glaze or body composition to obtain a more uniform contraction ratio.

Creamware

Lead-glazed earthenware made from a cream-colored body. The body contains calcined silica, is both light and durable, and can be worked as thin as porcelain.

Critical moisture content

See Critical point.

← Collar

Casting

Crackle glaze

Critical point

The point in the drying of a clay article at which shrinkage water has been removed, shrinkage has largely ceased, and the piece is rigid and leather hard. Also referred to as the critical moisture content.

Crystalline glaze

A glaze characterized by crystalline clusters of various shapes and colors embedded in an otherwise more uniform glaze of zinc or calcium. A slow cooling cycle is necessary for the development of the crystals.

Deflocculant

A soluble material added to clay slip to increase its fluidity; a liquefier. It allows the slip to have a high proportion of clay compared with the water content, allowing the slip to be poured into molds. See Casting, Flocculation.

Delftware

An English term for the tin-glazed earthenware first made in the late sixteenth century to imitate porcelains imported from China. See Faience, Maiolica.

Dipping

Glazing pottery by immersing it in a large pan or vat of glaze. This results in an even covering of glaze without brush or spray drips.

Docking

Soaking a freshly fired article in cold water for a short period of time to prevent or reduce spalling of the ware if it contains calcareous inclusions.

Dryfoot

To clean the foot of a glazed piece before firing so that it will not fuse to kiln furniture during firing.

Dunting

Cracking that occurs in a fired ware if it is cooled too rapidly.

Earthenware

Nonvitreous, opaque, low-fired ware usually red or tan in color. The bisque firing temperature is normally 1125° C; the glaze, 1080° C.

Eggshell porcelain

Translucent, thin-walled porcelain often made by slip casting.

Enamel

Pigments that fuse at approximately 750° C which are applied after the glaze firing over the ground color or fused glaze. The comparatively low firing temperature of enamels permits the use of a far wider and often more saturated range of colors than is possible with pigments that require higher firing temperatures. Sometimes referred to as china paint, on-glaze decoration, or overglaze enamel.

Engobe

A prepared slip that may contain clay, feldspar, flint, a flux, and/or colorants; it is usually applied to damp or bisque ware as decoration. Engobe also helps to smooth a vessel's surface.

Extendability

The ability of a material to be deformed without cracking or forming planes of weakness.

Faience

Tin-glazed earthenware, originally the French version of maiolica, named after Faenza in Italy. The term generally includes any glazed earthenware as well as Egyptian paste figures. It need not refer to historical ware. See Delftware, Maiolica.

Fat clay

A plastic clay such as ball clay.

Feldspar

Any of a group of crystalline minerals used as the primary fluxing agent in clay bodies and glazes.

Feldspathic glaze

A glaze containing a high percentage (50 to 100 percent) of feldspar in its composition.

Fettle

To trim rough edges, casting or mold marks, and other imperfections from dry or leather-hard ware before firing. See Trimming.

Filler

See Aggregate.

Film water

Water that surrounds and separates platelets in a clay/water mass and makes the mass plastic.

Firebox

Combustion chamber of a gas-, oil-, or wood-fired kiln, usually directly below the kiln chamber.

Fire clay

A clay having a slightly higher percentage of fluxes than pure clay (kaolin). It fires tan or gray in color and is used in the manufacture of refractory materials (such as bricks, muffles, and other structural elements) for industrial glass and steel furnaces. It is often quite plastic and may be used by studio potters as an ingredient of stoneware bodies. See Sagger clay.

Fire cloud

A darkened area on a vessel's surface resulting from the deposit of carbon in the pores during an uneven firing; characteristic of firings in which fuel and vessels are in immediate proximity. This aesthetic was popularized by Far Eastern potters. See Flashing.

Firing

Method of hardening soft clay bodies by heating. The term *low-fired* generally refers to earthenware; *high-fired* refers to porcelain. See Cone for approximate firing temperatures.

Fit

The dimensional adjustment of a glaze in relationship to a clay body to better align the thermal expansion and contraction ratio.

Flashing

The result of fire in a kiln touching ceramic wares and changing the color of their surfaces in an unpredictable manner. See Fire cloud.

Flint

See Silica.

Flocculation

The agglomeration of particles in a suspension, such as a slip, causing the suspension to thicken or settle. See Deflocculant.

Flues

Passageways around the kiln chamber through which hot gases pass from the firebox to the chimney.

Flux

A substance in a clay body, slip, or glaze that lowers the melting point of the mixture and promotes vitrification.

Flywheel

A heavy wheel used for regulating the speed of the machine to which it is attached.

Foot

The part of a vessel that is in contact with the surface it rests on during normal use; usually a ringlike projection formed by tooling or by adding a coil. Also referred to as the base.

Frit

A mixture of two or more materials, fused by heating to a melt, which, after rapid cooling, is ground into a powder and used as an ingredient in glazes. Ingredients in a frit are usually individually soluble in water or weak acid and may be toxic (lead, for example) unless fritted.

Frit china

A glossy, partly translucent ware produced by adding a glass frit to the body.

Gilding

A soluble form of gold in a resinous liquid that is painted on a clay work. After firing, a consistent film is left on the piece.

Glass

A silicate mixture that has been heated to a melt and cooled to a solid without crystallizing.

Glaze

A liquid suspension of finely ground minerals that is applied by brushing, pouring, dipping, or spraying on the surface of bisque-fired ceramic ware. After drying, the ware is fired to the temperature at which the glaze ingredients will melt together to form a glassy surface coating. This coating may be translucent or opaque, colored or not colored, smooth or textured, shiny or mat, depending upon its composition and the temperature to which it was fired.

Glaze fire

A firing cycle to the temperature at which glaze materials will melt to form a glasslike surface coating. This is usually at the point of maximum body maturity and is considerably hotter than the bisque fire. Also referred to as glost fire.

Glost fire

See Glaze fire.

Greenware

Ceramics that have been formed but not yet fired.

Grog

Hard, fired clay that has been crushed or ground to various particle sizes. It is used to add texture or to reduce shrinkage in ceramic sculptures and products such as terra-cotta tiles, which, because of their thickness, have drying and shrinkage problems. Finely crushed grog is also used in throwing bodies to help the clay stand up and maintain its shape. From 20 to 40 percent grog may be used, depending upon the amount of detail desired and whether the pieces are freestanding or pressed in molds. See Additive, Aggregate.

Ground

Underlying color or texture. This can also refer to an intermediary glazing of enamel colors utilizing enamels that fire at a lower temperature than the glaze, but higher than the enamels used for painting. *Bleu céleste* and *rose pompadour* grounds on Sèvres soft-paste porcelain are of this type.

Gum

Natural gums (such as gum arabic or gum tragacanth) are used in glazes as binders to promote better glaze adhesion to the body. Binders are necessary for fritted glazes containing little or no raw clay. They are also useful when a bisque fire accidentally goes too high or in reglazing. The gum burns off completely during firing.

← Foot

Hardness

The resistance of a material to mechanical deformation, especially indentation, scratching, abrasion, or crushing; also the elasticity of a material. Many hardness tests exist for ceramic materials.

Hard paste

See Hard-paste porcelain.

Hard-paste porcelain (*pâte dure, grand feu*)

Porcelain that is fired until it vitrifies. Also referred to as hard paste. Unlike soft-paste porcelain, it only needs a single firing.

Inclusion

See Additive.

In-glaze decoration

Decoration applied to the glazed but unfired surface of ware so that during firing oxides in the pigment may sink into the glaze, as in maiolica and delftware.

Jigger

To form an article of ceramic flatware by means of a rotating mold and profile tool; also the machine by which such a process is accomplished. Usually the mold has the contour of the interior and the profile tool has the contour of the exterior, but sometimes the term is used interchangeably with *jolly* without specifying the article formed or which surface is shaped by which apparatus.

Jolly

Forming a vessel using a spinning mold of plaster that shapes the outside of the piece. The opposite of jigger, which, using the same method, forms the inside of the vessel.

Kaolin

A pure refractory clay used in glaze and porcelain bodies that fires to a pure white. Kaolin is named after Kaoling, the mountain pass "high on the hill" in China from which the clay was originally taken. Also referred to as china clay.

Kiln

An enclosed or partially enclosed structure for firing ceramic materials. Kilns may be labeled on the basis of their construction or firing characteristics. Some important types of kilns are:

(1) bottle—an updraft kiln with a narrow chimney, shaped like a bottle;

(2) clamp—an open-topped updraft kiln of semi-permanent construction, usually with intermixed fuel and ware;

(3) climbing—a kiln set along a slope to aid the draft;

(4) continuous—a kiln with a moving track on which ware is fed into the firing atmosphere;

(5) cove—an updraft kiln usually having no permanent parts;

(6) down draft—an enclosed intermittent kiln in which the heat is passed to the top of the kiln, then the draft carries it down through the ware;

(7) intermittent (or periodic)—a kiln that is loaded, fired, cooled, and unloaded before a new batch is fired;

(8) muffle—a kiln constructed so that the ware is not directly subjected to the radiant heat from the flame or heating element;

(9) pit—a clamp kiln that is partially buried in the ground;

(10) salt—a kiln used only for salt glazing;

(11) tunnel—a type of continuous kiln; and

(12) updraft—a kiln in which the heat or flame passes upward through the ware and then is vented outside.

Kiln furniture

Refractory shelves and posts upon which ceramic ware is placed while being fired. See Prop, Sagger, Spur.

Kiln wash

A protective coating of refractory materials applied to kiln furniture to prevent excess glaze from fusing the ware to the furniture. An inexpensive and effective wash can be made from equal parts of flint and kaolin. See Parting agent.

Lead glaze

A low-temperature, transparent (or tin-opacified) glaze in which lead oxide, the major flux, contributes to a clear brilliancy.

Leather hard

A term used to describe clay that has dried sufficiently to be firm and can be handled without deforming but is still soft enough to incise and carve.

Lip

The edge or margin of the opening of a vessel; sometimes refers more specifically to a modification of the vessel's rim to allow for pouring.

Luster

A type of metallic decoration thought to have been discovered in Egypt and further developed in Iran during the ninth through the fourteenth centuries. A mixture of metallic salt, resin, and bismuth nitrate is applied to a glazed piece, which is then reduction fired at a low temperature (the temperature, however, must be sufficient to melt the metal and leave a thin layer on the decorated portions).

Lute

To join two leather-hard pieces of a vessel by using slip as a glue.

Maiolica

Earthenware covered with an opaque tin-lead glaze, best known from fifteenth- to nineteenth-century Europe. The name comes from the island of Majorca, from which Italy obtained these wares in trade, but the term is commonly used as a technological class without reference to origins of the ware. See Delftware, Faience.

Mat glaze

A glaze with no gloss but pleasant to the touch, not to be confused with an incompletely fired glaze.

Maturity

The temperature or time at which clay or a clay body develops the desirable characteristics of maximum nonporosity and hardness or the point at which glaze ingredients enter into complete fusion, developing a strong bond with the body, a stable structure, maximum resistance to abrasion, and a pleasant surface texture.

Mishima

A Japanese decorating method by which an incised design is filled with a contrasting clay or slip.

Mold

A form or box, usually made of plaster of Paris, containing a hollow negative shape. The positive form is made by either pouring clay slip or pressing soft clay into the mold, which then absorbs water from the clay allowing it to harden and later be removed. See Casting.

Mouth

The opening of a vessel.

Muffle

A thin-walled box used to protect ware from direct contact with flames. Unlike a sagger, it is attached to the kiln wall and is not movable. Made from fire clay, it transfers heat by radiation and conduction.

Lip

Mold

Mouth

Neck

The part of a vessel between the shoulder and rim, typically characterized by a gradual constriction from the maximum body diameter. See Collar.

Nonplastic

Material in a clay, whether naturally present or added by the potter, which by virtue of generally large particle size lacks the property of plasticity and often reduces the stickiness of the clay. See Additive.

One-off

Works made from conception to completion by a single potter.

On-glaze decoration

See Enamel.

Opacification

A process of making a clay body opaque.

Orton cone

See Cone.

Overglaze

Color applied on top of other glazes and containing coloring oxides or ceramic stains, a flux, and some type of binder. The fluxes are necessary to allow the color to melt into the harder glaze beneath. The lower temperatures at which most overglazes are fired (about cones 016-013) allow the use of colorants that are unstable at higher temperatures.

Overglaze enamel

See Enamel.

Oxidation firing

A firing atmosphere produced by either completely combusting the fuel used to heat the chamber or by isolating the ware from the combustion gases through the use of saggers. Generally, an oxidizing atmosphere does not react with the colorants and mineral components to alter their appearance or produce variable colors. Electric kilns always give an oxidizing fire. See Reduction firing.

Oxide

A chemical combination of oxygen with another element. Two types are important to the potter: metallic, used as fluxes, colorants, and opacifiers; and nonmetallic, used as volatiles and in vitrification.

Paint

The action of applying a pigment (not the colorant itself).

Parting agent

A material like sand, ash, or dry clay sprinkled over a mold or working surface to prevent wet clay from sticking. See Kiln wash.

Paste

Bodies composed of two or more ingredients used in making European-type porcelains.

Peephole

A hole placed in the firebox, kiln chamber, or muffle flues of a kiln through which one can observe the cones or the process of combustion.

Pigment

Any substance that lends color to a glaze or clay body. See Colorant.

Plasticity

The property of a material that enables it to be shaped when wet and to hold this shape when the shaping force is removed.

Polish

A glossy luster on the surface of an unglazed ceramic article, produced by rubbing the leather-hard surface with a yielding tool. The process lacks the individual parallel facets characteristic of burnishing.

Porcelain

A hard, high-fired, nonabsorbent clay body that is white and translucent. See Hard-paste porcelain, Soft-paste porcelain.

Porcelain body

A clay body made up of kaolin, silica, and feldspar.

Porosity

The relationship of the open pore space to the bulk volume of a clay body, expressed as a percentage.

Potter's flint

See Aggregate.

Potter's wheel

See Wheel.

Pottery

(1) Low-fired, nonvitrified objects, including cooking, serving, and storage vessels (as distinct from high-fired ceramics); and (2) an enterprise within the ceramics field concerned with the manufacture of such products.

Primary clay

A clay deposit formed by the weathering of its parent rock and found at its geological site of formation (as opposed to secondary clay). Also referred to as residual clay.

Production pottery

Machine-made ceramics produced in large numbers of uniform shapes. Machines do most of the decorating and glazing too, although some pieces may be hand-decorated. Hand decoration implies a more artistic (and thus more expensive) product, but this is not always the case.

Profile

An illustration of a ceramic object based on a vertical cross section, showing wall thickness and details of the lip, rim, and base configuration.

Prop

A kiln shelf support made of refractory material. See Kiln furniture.

Neck

Profile

Pug mill

A machine designed to mix and extrude clay in a plastic state.

Pyrometer

An instrument for measuring heat at high temperatures. It consists of a calibrated dial connected to wires made of two different alloys, the welded tips of which protrude into the kiln chamber. When heated, this welded junction sets up a minute electrical current, which registers on the indicating dial.

Pyrometric cone

See Cone.

Raising

Forming a shape out of clay on a wheel by lifting the clay with the help of the rotary action of the wheel and the pull of the hands.

Raku

Earthenware that originated in Japan and is associated with the tea ceremony. Raku ware is prepared in a unique way. The glazed, preheated bisque is placed in a red-hot kiln with long-handled tongs. The glaze matures in fifteen to thirty minutes, and the ware is withdrawn and cooled immediately. It is then placed in a container of combustible materials such as leaves or straw. Upon ignition of the material, incomplete combustion is created by shutting off the oxygen, thereby creating excess carbon that affects the clay and glazes in various ways.

Reduction firing

A firing atmosphere in which the kiln has insufficient oxygen to completely burn the fuel gases. The carbon monoxide and other hydrocarbon gases present in the kiln atmosphere chemically react with oxides contained in the clay, glazes, and metallic colorants and remove or "reduce" some of the chemically combined oxygen, resulting in altered color and surface in the finished products. See Oxidation firing.

Refractory

(1) The quality of resisting the effects of high temperatures; and (2) materials, high in alumina and silica, that are used for making kiln insulation, muffles, and furniture.

Residual clay

See Primary clay.

Rib

A tool fashioned from wood or metal that is used by a potter in fashioning certain shapes while the pot is rotating on the wheel.

Rilling

The spiral ridges or striations around the interior or exterior surface of a vessel thrown on a wheel formed by finger pressure in raising the clay. Also referred to as throwing marks.

Rim

The area between the lip and neck of a vessel; sometimes used interchangeably with lip, especially if there is no change of orientation between the lip and neck.

Sagger

Round, boxlike container made of fire clay used in kilns. Glazed ware is placed in a sagger to protect the glaze from combustion gases. The sagger keeps direct flame off the ware, helps to ensure an even temperature, and permits stacking of pieces (within saggers) on top of one another. See Kiln furniture.

Sagger clay

A refractory clay able to withstand the thermal shock of repeated firings. Used for saggers and other kiln furniture, its plasticity makes it suitable for inclusion in stoneware bodies. See Fire clay.

Salt glaze

A glaze developed by throwing salt into a hot kiln. The salt vaporizes and combines with the silica in the body to form sodium silicate, a hard, glassy glaze. A salt kiln is of a slightly different construction and is limited in use to the salt glaze.

Secondary clay

A clay deposit that has been moved by water or wind from its original location and redeposited (as contrasted with primary clay).

Seger cone

See Cone.

Sgraffito

Decoration achieved by scratching through a colored slip or glaze to show the contrasting body color underneath.

Shard

A fragment of pottery.

Shear

A type of stress or force in which parts of a body slip or slide relative to each other.

Shivering

A defect caused by compressive stress, resulting in incomplete coverage or peeling of the glaze.

Short

A term used to describe clay that lacks plasticity.

Shoulder

The upper part of the body of a restricted vessel; that portion between the maximum diameter and the neck or mouth.

Shrinkage

Contraction of the clay in either drying or firing. In the firing cycle the major body shrinkage for stoneware clays begins at approximately cone 9. Earthenware clays will begin to fuse and shrink at slightly lower temperatures.

← Shoulder

↙ Rim

Silica

Silicon dioxide, occurring naturally as sand, quartz, and flint. A major element in glazes and an essential component of ceramic materials.

Silicate

A salt derived from silica or silica acid.

Single fire

A firing cycle in which the normal bisque and glaze firings are combined. The advantages are a great saving of fuel and labor and the development of a stronger bond between the body and glaze. These advantages are partially offset by the need for greater care in handling the ware plus the danger of cracking if, in glazing, the raw pieces absorb too much moisture. In a salt glaze, however, these disadvantages do not occur.

Sintering

A firing process in which ceramic compounds fuse sufficiently to form a solid mass upon cooling but are not vitrified. An example is low-fire earthenware.

Slab construction

A hand-building method in which forms are created by joining flat pieces of clay. The pieces are thinned and flattened with a rolling pin or slab roller.

Slip

Clay combined with water to a fluid consistency either for slip casting, for joining parts, such as a handle, to a vessel, or for decorating the surface of wet or leather-hard ware. Slip may be colored. Also referred to as slip clay or slurry.

Slip casting

See Casting.

Slip clay

See Slip.

Slurry

See Slip.

Soaking period

The time during which the highest temperature of firing is sustained.

Soft paste

See Soft-paste porcelain.

Soft-paste porcelain (*pâte tendre, petit feu*)

A clay body that matures to vitreous or porcelain hardness at a lower firing temperature than hard-paste porcelain. Must be fired unglazed and then refired for glazing.

Solid casting

See Casting.

Souring

See Aging.

Spalling

To crack or change with temperature. Often seen in reference to fire bricks used in forming a kiln chamber. Because fire bricks are thick enough to develop differing surface temperatures, they may crack while the kiln is in use.

Spray booth

A boxlike booth for spraying glaze equipped with a ventilating fan to remove spray dust, which, whether toxic or not, is harmful when inhaled.

Sprigging

A type of press-molded, bas-relief decoration which, after forming, is attached to leather-hard ware with slip.

Spur

A small clay tripod used for holding glazed ware in a kiln. Such a support prevents ware from sticking to the kiln's shelves during firing. Sometimes referred to as a cockspur, stilt, or trivet. See Kiln furniture.

Stain

Sometimes a single coloring oxide, but usually a combination of oxides plus alumina, flint, and a fluxing compound. This mixture is calcined and then finely ground and washed. The purpose is to form a stable coloring agent not likely to be altered by the action of the glaze or heat. While stains are employed as glaze colorants, their chief use is as overglaze and underglaze decorations and body colorants. See Colorant.

Stilt

See Spur.

Stoneware

A high-fire ware (above cone 6) with slight or no absorbency. It is usually gray in color but may be tan or slightly reddish. Stoneware is similar in many respects to porcelain, the chief differences being increased plasticity and the color, which is the result of iron and other impurities in the clay.

Strain

Elastic deformation owing to stress; change in dimension per unit dimension.

Studio pottery

Handcrafted wares created by an individual or a small number of potters; opposite of production pottery. While pieces are all one-off in nature, they may be made in large quantities.

Style

A visual representation specific to a particular time and/or place that transmits information about the identity of the makers and the context of use. Style usually refers to decorative or surface embellishment but may also refer to technological traits.

Temmoku

A Japanese term for a stoneware glaze high in iron that creates a streaked surface ("hare's fur") or a mottled appearance ("oil spot").

Temper

Any substance added to clay to improve its working abilities. Used to assist forming and uniform drying, but also affects firing. See Additive.

Tensile strength

The ability of a material to withstand a tensile load (forces pulling in opposite directions).

Terra-cotta

(1) An earthenware body, unglazed, usually red, relatively coarse and porous, and low fired; and (2) sculptural or architectural articles made from such an earthenware body.

Terra sigillata

An earthenware associated with Roman Europe. Although the name means "stamped" (from *sigillum*), the term is sometimes used to refer to a red earthenware slip or slip glaze having the same properties as its ancient counterpart.

Throat

The point of maximum diameter restriction of a neck or collar on a vessel.

Throwing

The process of making a symmetrical, circular clay object on a rotating wheel. Centrifugal force and the pressure of the potter's hands control the form into which the plastic clay is squeezed/moved. On drying, a thrown form may be turned or trimmed on a lathe or the original wheel to get a smoother surface or to modify the profile.

Throwing marks

See Rilling.

Tooling

See Trimming.

Trailing

A method of decorating by applying slip with a rubber syringe.

Translucency

The ability of a thin porcelain or whiteware body to transmit a diffused light.

Trimming

A method of removing clay from a leather-hard pot, usually while it is rotating on a potter's wheel. Also referred to as tooling or turning. See Fettle.

Trivet

See Spur.

Turning

See Trimming.

Underglaze

Colored decoration applied to the raw or bisque ware before the glaze coating.

Viscosity

The nonrunning quality of a glaze; caused by glaze chemicals that resist the flowing action of the glaze flux.

Vitreous

Pertaining to the hard, glassy, and nonabsorbent quality of a body or glaze.

Vitrification

(1) The formation of glassy, nonporous material in a clay body; and (2) the term used to describe the highest temperature to which a clay body can be fired without deformation or decomposition.

Volatiles

Unstable elements that change and cause further chemical modifications in a body or glaze.

Wadding

Soft or fibrous material used for padding against abrasion or breakage.

Waist

Diminution of the diameter of a vessel that occurs in the piece's midsection. See Collar, Neck.

Ware

(1) A ceramic material in the raw, bisque, or fired state (for example, greenware, earthenware, stoneware, etc.); and (2) pottery with shared characteristics.

Warping

Distortion of a pot in drying (because of uneven wall thickness or air temperature) or firing (when a kiln does not heat uniformly).

Waster

A vessel damaged in manufacturing, particularly in firing.

Wax resist

A method of decorating pottery by brushing on a design with a hot melted wax solution or a wax emulsion. This prevents an applied stain or glaze from adhering to the decorated portions. The wax may be applied to either the raw or bisque ware, over or between two layers of glaze.

Wedging

Kneading plastic clay with the fingers and heels of the hands in a rocking spiral motion, which forces out trapped air pockets and develops a uniform texture.

Wheel

A pivoted device capable of sustained rotation (usually by means of a flywheel) upon which a potter builds a vessel. The wheel uses centrifugal force to produce high rotation speeds that aid in shaping the clay piece into its final form. May be driven mechanically (by kicking or turning with a stick) or electrically. Also referred to as potter's wheel.

Wheel head

The part of the potter's wheel where the bat sits. Usually horizontal, but can be at an angle for bowl throwing.

Whiteware

Ceramics that are essentially white or creamy in color. Refers to low-fire white earthenware adopted from commercial uses to those of the studio potter.

Yixing ware

Fine-grained stoneware developed in China during the Cheng-te period (1506–21) of the Ming dynasty and used for making various utilitarian objects, most commonly, teapots. This ware was exported to Europe during the seventeenth and eighteenth centuries and served as important models for Meissen and other European porcelain factories.

← Throat

← Waist

Wedging

BIBLIOGRAPHY

Alinovi 1982.

Alinovi, Francesca. "Artist's Decor." *Domus*, no. 626 (March 1982): 40–41.

Andreson 1982.

Laura Andreson Collection: Pottery from throughout the World. Exh. cat. Los Angeles: Frederick S. Wight Art Gallery, University of California, 1982.

Benezra 1985.

Benezra, Neal. *Robert Arneson: A Retrospective*. Exh. cat. Des Moines: Des Moines Art Center, 1985.

Bennett 1980.

Bennett, Ian. *British Twentieth-Century Studio Ceramics*. Exh. cat. London: Christopher Wood Gallery, 1980.

Bernstein 1986.

Bernstein, Melvin H. *Art and Design at Alfred: A Chronicle of a Ceramics College*. Philadelphia: Art Alliance Press, 1986.

Bertoni 1984.

Bertoni, Christina. "Spotlight." *National Council on Education for the Ceramic Arts (NCECA) Journal* 5 (1984): 67.

Briers 1988.

Briers, David. "Walter Keeler—Serious but Not Solemn." *Ceramic Review*, no. 112 (July/August 1988): 28–33.

Britton 1984.

Britton, Alison. "Hans Coper 1920–1981." *American Craft* 44, no. 3 (April/May 1984): 36–39, 93.

Burstein 1982.

Burstein, Joanne. "Philip Cornelius: The Container Continuum." *American Ceramics* 1, no. 4 (Fall 1982): 12–17.

Clark 1979.

Clark, Garth. "Introduction." In *Harrison McIntosh: Studio Potter*, 3–4. Exh. cat. Alta Loma, California: Rex W. Wignall Museum-Gallery, Chaffey Community College, 1979.

Clark 1981a.

Clark, Garth. *American Potters: The Work of Twenty Modern Masters*. New York: Watson-Guptill, 1981.

Clark 1981b.

Clark, Garth. "Cracks in the Sidewalk: A Chronological Study of the Art and World of Viola Frey." In *Viola Frey*, 7–16. Exh. cat. Sacramento: Crocker Art Museum, 1981.

Clark 1982.

Clark, Garth, ed. *Michael and Magdalena Frimkess: A Retrospective View 1956–1981*. Exh. cat. Los Angeles: Garth Clark Gallery, 1982.

Clark 1984.

Clark, Garth. "Alev Ebüzziya Siesbye: Floating Volumes." *Ceramic Arts* 2, no. 1 (Spring 1984): [5–7].

Clark 1987.

Clark, Garth. *American Ceramics: 1876 to the Present*. Rev. ed. New York: Abbeville Press, 1987.

Cooper 1986.

Cooper, Emmanuel, and Eileen Lewenstein, eds. *Potters*. London: Craftsmen Potters Association of Great Britain, 1986.

Delisle 1988.

"Faces: Roseline Delisle." *Southern California Home and Garden* 1, no. 1 (May 1988): 18–19.

Dunas 1987.

Dunas, Michael, and Sarah Bodine. "The Precarious Scale of Justice: Richard Notkin's Precious Protest." *American Ceramics* 5, no. 3 (1987): 16–23.

Dunham 1982.

Dunham, Judith. "Paul Soldner." *American Craft* 42, no. 5 (October/November 1982): 24–28.

Elliott 1981.

Elliott, Gordon. "Geoffrey Swindell." *Ceramics Monthly* 29, no. 7 (September 1981): 72–76.

Falk 1985.

Falk, Lorne. "The Care for the Self." In *Paul Mathieu: Le Souci de soi*, 7–13. Exh. cat. Banff, Alberta: Walter Phillips Gallery, 1985.

Forde 1983.

Forde, Ed. "Adrian Saxe." *American Ceramics* 2, no. 3 (1983): 64–65.

Frayling 1987.

Frayling, Christopher. *The Royal College of Art: One Hundred and Fifty Years of Art and Design*. London: Barrie and Jenkins, 1987.

Frimkess 1982.

Frimkess, Michael. "From a Whiteware to a Stoneware Mentality." In Clark 1982, 6–11.

Goldberg 1979.

Goldberg, Vicki. "Voulkos Clay Revolutionary." *Saturday Review* (March 31, 1979): 36–37.

Harrington 1985.

Harrington, LaMar. "Robert Sperry and His Formative Years: The Growing of a Tap Root." In *Robert Sperry: A Retrospective*, 4–9. Exh. cat. Bellevue, Washington: Bellevue Art Museum, 1985.

Harrod 1987a.

Harrod, Tanya. "Free Spirit." *Crafts*, no. 85 (March/April 1987): 32–35.

Harrod 1987b.

Harrod, Tanya. "Martin Smith." *American Ceramics* 5, no. 3 (1987): 53.

Haslam 1984.

Haslam, Malcolm. *William Staite Murray*. Exh. cat. London: Crafts Council in association with Cleveland County Museum Services (Cleveland Gallery), 1984.

Herman 1981.

Herman, Lloyd E. *American Porcelain: New Expressions in an Ancient Art*. Exh. cat. Washington, D.C.: Renwick Gallery, Smithsonian Institution, 1981.

Homoky 1981a.

"News and Retrospect: Nicholas Homoky." *Ceramics Monthly* 29, no. 3 (March 1981): 69.

Homoky 1981b.

Homoky, Nicholas. "Mixing Metaphors." *Crafts*, no. 52 (September/October 1981): 12–15.

Houston 1981.

Houston, John, ed. *Lucie Rie*. Exh. cat. Norwich, England: Sainsbury Centre, 1981.

Jan 1985.

Jan, Alfred. "On Viola Frey." *Michigan Quarterly Review* 24, no. 3 (Summer 1985): 422–24.

Kangas 1983a.

Kangas, Matthew. "Kurt Weiser." *American Ceramics* 2, no. 2 (Spring 1983): 70–71.

Kangas 1983b.

Kangas, Matthew. "Rudy Autio: Montana Artist." In *Rudy Autio*, 5–19. Exh. cat. Missoula: University of Montana, 1983.

Koplos 1982.

Koplos, Janet. "Alternations: The Ceramics of Susanne Stephenson." *American Craft* 42, no. 6 (December 1982/January 1983): 16–19.

Kuspit 1986.

Kuspit, Donald. "Robert Arneson's Sense of Self: Squirming in Procrustean Place." *American Craft* 46, no. 5 (October/November 1986): 36–45, 64–68.

Levin 1982.

Levin, Elaine. *Glen Lukens: Pioneer of the Vessel Aesthetic*. Exh. cat. Los Angeles: Fine Arts Gallery, California State University, 1982.

Levin 1985.

Levin, Elaine. "Portfolio: Marilyn Levine." *Ceramics Monthly* 33, no. 3 (March 1985): 41–46.

Levin 1988.

Levin, Elaine. *The History of American Ceramics: 1607 to the Present*. New York: Harry N. Abrams, Inc., 1988.

Levine 1972.

Levine, Marilyn. Interview by Nancy Foote. "The Photo-Realists: Twelve Interviews." *Art in America* 60, no. 6 (November/December 1972): 84–85.

Lippard 1988.

Lippard, Lucy R. "Visual Arts/Betty Woodman." *Boulder Daily Camera* (February 12, 1988): 15D.

Marak 1988.

"Louis Marak." *Ceramics Monthly* 36, no. 2 (February 1988): 40.

McCloud 1984.

McCloud, Mac [Malcolm McClain, pseud.]. "Otis Clay: 1956–1957." In *Earth and Fire: The Marer Collection of Contemporary Ceramics*, 13–14. Exh. cat. Claremont, California: Galleries of the Claremont Colleges, 1984.

McCloud 1985.

McCloud, Mac [Malcolm McClain, pseud.]. "Harrison McIntosh." *American Craft* 45, no. 2 (April/May 1985): 22–25.

McCloud 1988.

McCloud, Mac [Malcolm McClain, pseud.]. "John Mason." *Ceramics Monthly* 36, no. 1 (January 1988): 46–48.

Melcher 1979.

Melcher, Victoria Kirsch. "Tradition and Vitality: The Ceramics of Ken Ferguson." *American Craft* 39, no. 6 (December 1979/January 1980): 2–7.

Moes 1979.

Moes, Robert. *The Brooklyn Museum Japanese Ceramics*. Exh. cat. New York: Brooklyn Museum, 1979.

Natzler 1968.

Natzler, Otto. *Natzler Ceramics*. Los Angeles: Los Angeles County Museum of Art, 1968.

Naumann 1983.

Naumann, Francis M. "The Drawings of Beatrice Wood." In *Beatrice Wood Retrospective*, 9–20. Exh. cat. Fullerton: MAIN Gallery, Visual Arts Center, California State University, 1983.

Naylor 1985.

Naylor, Gillian. *The Bauhaus Reassessed: Sources and Design Theory*. New York: E. P. Dutton, 1985.

Nordland 1983.

Nordland, Gerald. *Richard DeVore 1972–1982*. Exh. cat. Milwaukee: Milwaukee Art Museum, 1983.

Odundo 1984.

"Kenyan Heritage." *Crafts*, no. 67 (March/April 1984): 24–29.

Orient 1985.

Orient, Anatol. 1985. "Linda Gunn-Russell." Anatol Orient Gallery, London. Photocopy.

Perreault 1982.

Perreault, John. "Fear of Clay." *Artforum* 20, no. 8 (April 1982): 70–71.

Perrone 1987.

Perrone, Jeff. "Exquisite/Coarse." In Saxe 1987, 5–11.

Rawson 1983.

Rawson, Philip. "Echoes: An Introduction." In *Ceramic Echoes: Historical References in Contemporary Ceramics*, edited by Garth Clark, 13–19. Exh. cat. Kansas City, Missouri: Nelson-Atkins Museum of Art, 1983.

Rawson 1984.

Rawson, Philip. *Ceramics*. Philadelphia: University of Pennsylvania Press, 1984.

Saxe 1987.

Adrian Saxe. Exh. cat. Kansas City: University of Missouri-Kansas City Gallery of Art, 1987.

Schjeldahl 1987.

Schjeldahl, Peter. "The Smart Pot: Adrian Saxe and Post-Everything Ceramics." In Saxe 1987, 13–17.

Slivka 1961.

Slivka, Rose. "The New Ceramic Presence." *Craft Horizons* 21, no. 4 (July/August 1961): 30–37.

Slivka 1978.

Slivka, Rose. *Peter Voulkos: A Dialogue with Clay*. Boston: New York Graphic Society in association with American Crafts Council, 1978.

Slowinski 1988.

Slowinski, Dolores S. "Susanne Stephenson: Color and Form." In *Sustained Visions: John and Susanne Stephenson (The Work of Susanne Stephenson)*, 4–7. Exh. cat. Detroit: Detroit Focus Gallery, 1988.

Smith 1987.

Smith, Martin. "Martin Smith Speaking on His Own Work." *Fusion: Fourth International Ceramics Symposium* 10, no. 2 (Winter 1987): 16–17.

Sozanski 1985.

Sozanski, Edward J. "A Ceramic Artist Continues to Awe." *Philadelphia Inquirer* (April 11, 1985): 5D.

Staffel 1977.

Staffel, Rudolf. Interview by Paula and Robert Winokur. "The Light of Rudolph [*sic*] Staffel." *Craft Horizons* 37, no. 2 (April 1977): 24–29, 61, 64.

Stephens 1981.

Stephens, Suzanne. "Pattern on Pattern." *Progressive Architecture* 62, no. 9 (September 1981): 165–67.

Takamori 1988.

Takamori, Akio, and Peter Ferris. "Vessel Concepts." *Ceramics Monthly* 36, no. 2 (February 1988): 27–30.

Wechsler 1981.

Wechsler, Susan. *Low-Fire Ceramics*. New York: Watson-Guptill, 1981.

Westphal 1985.

Westphal, Kenneth. "A World of Physics and Feeling." In *Robert Turner: A Potter's Retrospective*, 4–12. Exh. cat. Milwaukee: Milwaukee Art Museum, 1985.

Wildenhain 1986.

Wildenhain, Marguerite. *Pottery: Form and Expression*. Palo Alto, California: American Crafts Council in association with Pacific Books, 1986.

Wilson 1986.

Wilson, William. "The Art Galleries." *Los Angeles Times* (March 7, 1986): sec. 6, p. 18.

Yanagi 1984.

Yanagi, Sōetsu. *The Unknown Craftsman: A Japanese Insight into Beauty*. Adapted by Bernard Leach. New York: Kodansha International/USA Ltd., 1984.

Birks, Tony.

Hans Coper. New York: Harper and Row, 1983.

Lucie Rie. London: Alphabooks/A and C Black, 1987.

Clark, Garth, ed.

Ceramic Art: Comment and Review 1882–1977. New York: E. P. Dutton, 1978.

Hamer, Frank, and Janet Hamer.

The Potter's Dictionary of Materials and Techniques. Rev. ed. New York: Watson-Guptill, 1986.

Hamilton, David.

The Thames and Hudson Manual of Pottery and Ceramics. New York: Thames and Hudson, 1982.

The Thames and Hudson Manual of Stoneware and Porcelain. New York: Thames and Hudson, 1982.

Hopper, Robin.

Functional Pottery: Form and Aesthetic in Pots of Purpose. Radnor, Pennsylvania: Chilton Book Company, 1986.

Jensen, Robert, and Patricia Conway.

Ornamentalism: The New Decorativeness in Architecture and Design. New York: Clarkson N. Potter, 1982.

Leach, Bernard.

A Potter's Book. 10th American ed. Hollywood-by-the-Sea, Florida: Transatlantic Arts, Inc., 1965.

Piccolpasso, Cavaliere Cipriano.

The Three Books of the Potter's Art which treat not only of the practice but also briefly of all the secrets of this art, a matter which until to-day has always been kept concealed. 1548. Translated by Bernard Rackham and Albert Van de Put. London: Victoria and Albert Museum, 1934.

Rice, Prudence M.

Pottery Analysis: A Sourcebook. Chicago: University of Chicago Press, 1987.

Savage, George, and Harold Newman.

An Illustrated Dictionary of Ceramics. New York: Van Nostrand Reinhold, 1974.

Selz, Peter.

Funk. Exh. cat. Berkeley: University Art Museum, University of California, 1967.

C L A Y T O D A Y

Contemporary Ceramists and Their Work

was set 10 on 13 in Caslon.

This typeface was designed in 1722 by William Caslon (England, 1692–1766). He learned letter cutting after working as a gun engraver in London. Basing his letters on Dutch types, Caslon refined them, adding a calligraphic touch. The typeface has been described as "friendly to the eye" and is representative of English typography traditions.

This book is printed on 127gsm New Age Matte Paper.

Virginia Cartwright

Teapot

1983

Adrian Saxe

Squash Teapot

1983

Editor: Gregory A. Dobie
Designer: Amy McFarland
Photographer: Jeffrey Conley
Typesetter: Andresen Typographics
Tucson, Arizona
Printer: Dai Nippon Printing Co., Ltd.
Tokyo, Japan